The
Artist's
Guide to
New
Markets

■ ■ ■ ■ ■ ■ ■ ■ ■ ■ ■ ■

Opportunities to Show and Sell Art Beyond Galleries

■ ■ ■ ■ ■ ■ ■ ■ ■ ■ ■ ■

PEGGY HADDEN

ALLWORTH PRESS
NEW YORK

Published by Allworth Press

An imprint of Allworth Communications

10 East 23rd Street, New York, NY 10010

Cover design by Douglas Designs, New York, NY

Book design by Sharp Des!gns, Inc., Lansing, MI

ISBN: 1-880559-75-7

Library of Congress Catalog Card Number: 96-79671

Printed in Canada

This book is dedicated to artists everywhere, and especially to all the artists who helped me write it.

Contents

Part I. The New Markets

Acknowledgments

I would like to express my appreciation to the institutions and museums who allowed me to reprint their Calls for Proposals, and my gratitude to the many fine people in government and the military who joined me in exploring art opportunities in those areas. Thanks to Lillian Lent, Evan Morley, and Ted Gachot for many hours of helpful counseling. Special thanks to my friend Susan Brownmiller for her assistance with and enthusiasm for this project. Without her help, this book would not have been written.

Introduction

et's assume that you bought this book because you are an artist and are interested in finding new ways to sell your artwork. As an artist, you may feel that your future depends solely on the commercial gallery system to sell your work. This concept is both inexact and self-limiting. Inexact, because galleries are by nature unable to reach everyone who, at a given moment, wants to buy art. Many art buyers never enter a gallery. Self-limiting, because galleries are also physically unable to give residence to every artist who wants to exhibit with them.

For perhaps the first time, today an artist has many choices in building a successful art career. Many artists have in the past used galleries (or, more precisely, the lack of gallery representation) as an excuse for the state of their livelihood. Today, your survival as an artist with a record of artwork sold may depend much more on you than on one or several galleries.

Catching on to the new trend, an article in the *New York Times*

Magazine described the changes that have recently taken place in what they called the new "do-it-yourself art world."

Much of the gallery system suffered losses in a crash during the early nineties, so much that this system will not likely recover in the form in which it had been previously known. Many well-known galleries closed their doors for good and new freelance dealers and entrepreneurs came forward to fill the void. With "neo-galleries" located anywhere from Web pages on the Internet to vacant real estate, these new dealers are selling art and seeking out collectors with prices in the low hundreds, not thousands, of dollars. Whatever your price range, the openings to sell your work are there! As an artist, a lot of information that I have gathered from the world around me has helped me to find places to sell my work. Certainly, galleries are the first place one thinks of for this purpose, much as one goes to a car showroom to buy a car. But all of us know that there are many ways to purchase a car besides through a car dealership, and the same holds true for selling art.

Like many artists, I have had good and bad experiences with galleries, and I'll probably have more. But it is time to begin to talk about the alternatives to galleries. For the times when galleries are not the right solution, we must find other options that allow us to develop our careers outside of the gallery system.

Yet for many of the artists I meet when I conduct workshops, the first and most often asked question is: "How do I get into a gallery? If I get into a gallery my career will be moving." To say to them, "Once you get into a gallery, your troubles may just be beginning," always falls on deaf ears. Getting into a gallery might be a great way to start a career, but to hang all of one's career hopes on a single opportunity is a poor survival tactic.

An art career is not a long alley with one door at the end marked "gallery." It's more like a sprawling marketplace on a busy day, with a million people bustling about intent on their own affairs and not united against any newcomer who brings wares to town to sell. The "them against us" mind-set that so many artists adopt is incorrect and out-of-date.

Galleries may or may not always be there for you. They may or may not treat you as you might like, asking your opinion where it counts. But if you have quietly gained the ability to work and sell, you'll have confidence and that will help you in your dealings with galleries, too.

Last year, there were twenty thousand students studying art in New York City's art schools and art departments of postsecondary schools alone, not to mention healthy art schools all across the country. Tomorrow they will be your competition. Do you have the skills you'll need to put yourself ahead? Can you afford to wait?

This book will provide you with a wide choice of leads for selling your art through new and different markets. If the market that's right for you is not there already, this book will show you how to get it started and make sure it grows. From creating your own highly successful open studio events to exhibiting art in corporate spaces, the aim here is to show you how many artists have turned their ingenuity to selling and showing their work outside of a gallery framework. This approach will incorporate targeting résumés and using proposals as powerful tools for shaping art careers that will be more flexible in today's art world, than was ever possible in the past.

New art markets can be anywhere that you sell and show your work beyond a gallery. They can exist below the ground (on the walls of a subway station), up in the air (in a corporate tower), or even in cyberspace. Through acquiring the skills to promote your own work, opportunities will present themselves for you to imagine new ways to see your art and where it might go. Among the markets we'll explore in this guide are:

- museums
- art fairs
- private commissions
- restaurants
- corporate exhibition spaces
- libraries
- framing shops

- professional offices
- interior designers
- cruise ship auctions
- private clubs (e.g., country, swim, and field clubs)
- art conventions
- transportation areas
- airports
- banks
- university galleries
- public offices
- chambers of commerce
- furniture showrooms and design centers
- new government opportunities
- civic centers
- churches and synagogues
- real estate projects
- charitable events
- nonprofit art spaces
- nursing homes and senior citizen centers
- magazines
- greeting cards and stationery
- licensing opportunities
- markets overseas
- the Internet

This guide will help you in two ways. First, it will offer you access to many new markets with names and addresses where you can write or call to pursue a sale or an exhibition. Second, it will give you examples from artists who have invented new markets for themselves. By presenting these examples, I hope to encourage each of you to search out new places for your work—even if those places are now only in an embryonic stage, or don't exist at all yet. You will develop a nose for good ways to exhibit and sell artwork just by being aware of how other artists have experimented with opportunities and turned them into real resources. As you follow their

examples, keep in mind situations in your own life where you can make a call or write a letter that will open doors for you. Every artist has a constituency, just as politicians do, a core group of those around you who care about you and your career. These are people you see every day, but maybe you don't see them as art lovers or as potential buyers of your work. Nevertheless, they can help you get your art career moving. I've included a number of blank "notes pages" at the end of this book–space for collecting ideas and listing contacts, which will be only the beginning of the notes you make to yourself regarding sale and exhibition opportunities.

The sky's the limit, but you have to have a plan. Look at your past art sales and analyze them for clues to selecting your target audience. Who buys your art most often? Doctors? Lawyers? Banks? If no one group is outstanding, then think about your past buyers individually. In what ways are they alike? What did they mutually like about your artwork? Was it the color–maybe they all like bright, cheerful colors. Or was it the strong architectural quality, the straight lines in your drawings? Maybe it was really simpler than that. Perhaps they all selected work that was framed, rejecting work that would require them to make a trip to the framer. If that is the common thread, then, listen to it. Does it mean that if you had more work in a finished framed condition, you would sell more? More and more, this seems to be the case when dealing with professionals who work long hours and can only eke out time for sleep and to be with their families. Does work of a smaller size sell better than the billboard masterpieces you've been struggling over? I used to paint large "serious" paintings and I still have some of them. When I moved to a smaller size in my newer work, it seemed to fit well into offices and my sales went soaring. Remember that your reason for painting a painting will never be a collector's reason for buying it. Spend enough time studying these elements, however tenuous they may seem, so that you can plan intelligently what the next move for you will be. Markets exist in all sizes, indoors and out.

Finally, what this book will do is allow you more creative time

in the studio, by putting those new markets at your door and giving you a firm grip on your future. The people you'll read about in these pages are real and they've confronted major challenges dealing with showing and selling their art. I think your time with them will be well rewarded.

■

Part I
The New Markets

Why You **Must** Pursue New Markets

our opportunities to be represented by a major gallery can be thwarted by many things. You may not live in or near a major city, you may work in a style that is not currently being sought by galleries, or you may not have the very large chunks of time necessary to promote your work to gallery directors (or you may not even want to).

Luckily, as artists, we now have many ways to show and sell our work besides the traditional gallery system. Over the last few years, gallery representation has become but one of many ways to present and sell art.

In thinking of ways to shape our art careers, artists are moving in many diverse and new directions that will earn us an independent sales structure that won't disappear overnight. The reasons why this is necessary come from within the gallery system itself. In order to understand this more clearly, a closer look at the gallery system is essential. We should begin by realizing that there are actually several gallery systems operating at one time. Top-tier galleries, or those with more colorful histories and/or celebrated directors, are

at the peak of a large pyramid of different kinds of art galleries. These are almost impossible for artists to break into from the outside, as they usually wait until an artist has an established track record with a smaller gallery before inviting that artist to become part of their list of exhibiting artists. Sometimes these galleries actually return artists' slide packets unopened and marked "Unsolicited Material." Your efforts are better put somewhere else.

Along with this plateau of the most well-known galleries are many other well-financed and profitable operations that have been in existence for shorter, but still considerable, lengths of time—some as long as twenty years. An organization of art dealers called the Art Dealers Association of America (ADAA for short) has published a directory that may be able to help you determine where on the "pyramid" a gallery fits in. Send your request to:

Art Dealers Association of America
575 Madison Avenue
New York, NY 10022

With the rise of SoHo as a center of gallery activity in New York City, many changes occurred. Suddenly, large amounts of real estate, in the form of leftover warehouses and manufacturing lofts, became fashionable. Because they required renovation, some of them were acquired cheaply. This made the opening of a gallery not as expensive as it had been when most of the art world was centered uptown in higher rent areas. Many younger gallery personnel with limited capital entered the gallery scene. Also, the sons and daughters of several reputable dealers wanted to try to make a name for themselves. Having the money to open a gallery did not, however, bring with it the expertise to make it last.

"Dealers" with little or no experience in actually selling art started appearing, sensing the opportunity to make money by offering exhibits to artists for fees. These are the so-called vanity galleries. Besides charging a fee for exhibiting, these dealers quickly moved on to asking artists to pay costs for gallery-sitting and to share exhibition space with several other artists. Sometimes the end

result looked less like an exhibition and more like a retail store. These operations quickly became known, their shows are virtually never reviewed, and their value to the serious artist is almost nonexistent. Sometimes subtle shades of difference exist between these strata of galleries. For example, a small but seemingly reputable gallery demanded that a friend of mine pay all of the expenses for showing his art—this included trucking, postcard announcements, and mailing, as well as the cost of wine for the opening party .

Another artist I know was approached by a gallery owner looking for artists who would exhibit and pay the rent while the owner took a summer vacation. It was a respectable gallery and the price was right. The arrangement was for a onetime only show, and the dealer was familiar with this artist's work, so he was confident that his gallery's reputation would not be hurt by a show of inferior work. The artist hired a gallery-sitter to give her the distance she sought from the daily operation of the gallery. Since that incident—which I have often been assured is not so rare—I have wondered if shows in summer months were genuinely endorsed by galleries, or merely convenient ways of paying the rent. For the artist, I guess, no harm is done, but this arrangement is not ideal in that it is not lasting. It should be mentioned here that in urban centers like New York, summer exhibitions are thought to be less serious than winter shows, when more influential members of the art world are in the city and get a chance to see them.

Often in the past, unscrupulous dealers have been able to take advantage of artists who were less interested in the business side of selling art than in creating beautiful work. Brian Foy echoed a common complaint of artists when he wrote online in the Fine Art Forum of CompuServe, "Once I had a painting in a gallery and the gallery closed without telling me. I never saw the painting or the gallery owner again." This sort of lament flourishes in an atmosphere where we don't ask enough questions and are content to see any dealer who professes to be an art lover as an honest person—"one of us."

Unfortunately, so many artists will do anything to exhibit that

some would-be art dealers can't ignore the temptation to cheat us. Other situations also cause one to shudder. An artist I know had worked long and hard to make it into a top gallery, only to see the gallery hire a new director who was unsympathetic to her work. At an initial meeting with the new director, she was told that she could not expect another showing of her work while he was the director. Suddenly, she was a nonperson. The gallery had many of her works, and she did not want rumors to circulate that she had been dropped by the gallery, yet she was without a site for showing new work.

In my own experience with a small gallery, the cacophony of contention for the director's attention among the gallery's artists grew so loud that it became almost a health issue—and I felt I had to withdraw. Every day, whichever artist yelled loudest got the director's attention. Who would choose to stay in such an environment at the expense of their health? There are some very real reasons why gallery membership may not be the best business solution for an artist.

Another area, consisting of co-op galleries, is not the center of our inquiries here. These galleries, which are run by members, select new participants who help operate the gallery and agree to pay monthly dues in return for the guarantee of shows, which occur roughly every two years. They are particularly popular in academic circles, where art teachers face the artist's version of "publish or perish."

While there are many businesslike and honest galleries, you still hear tales of age discrimination, gender preference, and unstable financial situations that may lead to galleries opening and closing within a single season. An even more upsetting trend is the absorbing of galleries by larger corporations, such as major auction houses whose boards of directors determine which artists are selected and what type of work will be shown. In the introduction to this book, I talked about some of the economic changes that have occurred in all galleries, particularly in the last few years.

Other art world players are changing how they conduct business as well. Eight major museums are now working with QVC, the cable

home-shopping channel. In this experimental alliance, QVC will offer televised tours of the museums–among them, the Metropolitan Museum in New York City, the Smithsonian in Washington, DC, and the Museum of Fine Arts in Boston–and the museums will allow QVC to sell items related to their exhibitions. Viewers will order the merchandise from QVC. The arrangement offers QVC the opportunity to be seen as a more civic-minded and, thus, higher-end retailer. At the same time, the televised museum tours will give many Americans a first-time look inside some of the country's museums, which may encourage more actual attendance for these institutions. This innovative marketing on the part of museums that have faced extensive cuts in funding was an event that could have been foretold by interested museum-watchers. Yet for artists, who have always spoken of museums in hushed tones, this kind of marketing comes without warning. Times are changing.

A more surprising development has been taking place within the art world media. For too long, the monthlies devoted to covering the art world have given us reviews that came months after the exhibitions themselves had closed. Writers for big art world publications have to turn in reviews up to four months before they hit the stands. The reviews were forced to be out-of-date by the time they were read. A new publication, *Review,* under the leadership of former gallery owner Bill Bace, has changed all that. Since it began publication in April 1996, *Review* has taken an opposite tack. Printed on newsprint, this new journal is not the sort of coffee-table adorner that fashionsetters of the art are used to. Somewhat scruffy, it *is* being read in cafés all over the gallery district, and it *does* have one up on the glossies. It is current, with a wonderful list of reviewers writing about art that can be seen in exhibition at the same time one is reading about it. Will this upstart cause changes within the sacred halls of art world journalism? It already has. Word is, the big art magazines are previewing exhibitions before they go on the walls so they can go to press with more current data. But there's a problem here: where is the curator? Does the shape and balance of any exhibition matter?

But *Review* has even another trump card to play—it offers several reviews that give differing viewpoints on the same exhibition. The one-review policy of the glossies which hung over the heads of all artists, both known and unknown, is a threat of the past. The walls of reviewing are definitely coming down, with no more one-publication, one-review standards.

I've already mentioned the surprising changes that have occurred in the gallery world itself. "Neo-dealers" and artists who represent each other, as well as seasonal shows in downtown hotel rooms, have surely altered the pristine white-walled gallery spaces of SoHo forever. This, coupled with the mass exodus of many galleries to a new neighborhood, Chelsea, will further enlarge the boundaries of an art world that just won't be confined.

All of these events should make you see that developments in the art world no longer happen in the airless "gentlemen's club" atmosphere that used to be. With policies of showing and selling art at prices that start at several hundred dollars, the prized, but limited circle of wealthy collectors has been democratically enlarged to include anyone who is captivated by a piece of art. For more than one reason, art world institutions are being redefined.

Certainly, it is not a large leap from what the museums and art media are doing to solidify their financial futures to what individual artists can do to sell art and keep making more. We are entering the twenty-first century—we must stop living by sixteenth-century rules. It is time to plan a strategy and make your move.

■

Let's Talk About Selling Your Work

"'ve worked to create my art, and now I have to look for ways to sell it, too." Does this sound familiar to you? All of us at different times are faced with having to be both the creator of the work and its vendor, too. Galleries are not always there to do the selling. An artist representative is another possibility, but its hard to determine if they're reputable. As artists, we are left with what may seem at first a weak third choice—selling the art ourselves.

The idea of selling your own artwork may take some getting used to. Like most of us, you probably came through art school concerned only with things like color theory, art history, and what distinguishes one school or movement from another. Or you may have discovered your love of art through outside means, like one well-known printmaker who started out as a guard at a museum. Either way, it was never mentioned that you might have to someday sell your art as well as create it. The realization of this dual role can be totally stymieing.

A new mind-set is necessary, but, at the same time, you do not want to disturb the mind-set that made you an artist in the first place. It's just a matter of wearing different hats. You already have different hats for various parts of the life you lead. When you go into the polling booth, you are acting as a citizen and when you visit your child's school you are acting as a parent.

May I suggest that you read *Getting Business To Come To You*, an idea-packed volume by Paul and Sarah Edwards and Laura Clampitt Douglas. It was written for new entrepreneurs, but perhaps its most rewarding gift to artists is that it explores the mind-set necessary to successfully sell your work if you've had no experience. They discuss the idea of *attracting* business, which has more appeal for some of us than *selling*.

They suggest that you begin by thinking of ways in which your work will benefit others and enrich their lives. This idea is an idea that we artists can easily connect to, as we have all been exposed to works that have enriched our lives. Maybe your work will offer an opportunity for a busy patron to take a little time each day for introspection.

They also recommend putting yourself in your buyer's shoes. Think how you react when you are the object of a sale. What do you like to know about an item you are considering buying? Do you have a place or particular use for this item? If you knew that certain others had made a purchase of this type, would you buy? Marketing experts tell us that art buyers are anxious to look good to friends and associates—might this sale do that? When you talk to a potential buyer, try making them see how having this artwork could make his or her life better. Much art is sold under the flag of "helping out the artist," but, in fact, much more would be sold if the seller assumed the role of helping the buyer to improve the quality of his or her life. By devising a manner which potential buyers "warm" to, you will also allow yourself to maintain your dignity. Even when an artist has not been initially successful at marketing his or her work, this mind-set can help create ways to attract buyers to the art and sales to the artist.

Think about what your art has to offer that is special and unique. This is something with which we artists are familiar—defending our artistic turf. We've all done this thousands of times, in conversations in our heads or with a few trusted friends. It's really about why we make what we make. It may have to do with the texture, the color, the shapes, the materials. It may sort out a way of seeing, a vista, a point of view.

Try to figure out what your potential buyers have been drawn to, why owning your work seems attractive. It may or may not be the same reason why it is important or attractive to you. That's not important. Go back in your mind to people who have bought from you before. What do they have in common? If you think about it, these people are still your prospects for another sale. Maybe they liked the size of your work; maybe it was something that fit into their lives; maybe it brought back memories of their childhood. Try to see, just for a moment, not as an artist, but as an art *owner*. Maybe you own art by another artist. I have a piece by Claire Seidl in my living room. It's actually the only piece in that room that is not my creation. And I love it, but its not in the style of what I make, nor is it close to my art, nor do I know the artist. Still, I like it and enjoy it every day. I see it as a window into someone else's sensibility. Now think of your buyer. Will your work offer them peace of mind? That's a valuable commodity. Henri Matisse once said that he painted for tired businessmen. Would a tired businessman enjoy living with your art? I sold a small piece to a lawyer with a large international clientele. He has told me since the sale that he likes to look at my work when he's working out a problem. Art that is a challenge attracts a certain kind of buyer. They understand that it will take lots of looking to form decisions about the work.

It isn't enough to know that someone has bought a piece of my work, I enjoy hearing that it's still on their walls years later and that they still enjoy living with it. At my day job, its a pleasure to go into the offices of people who have bought my work and find that, although they may have changed the plants, the window blinds, and the color of the walls, the artwork is still there. They've obviously

changed what they didn't want to live with any longer, yet there's my piece. It's always a silent compliment.

Artists who may be shy, become assertive and successful at selling their own work. Nobody knows your work as well as you do, and over time you can learn to sense why people are attracted to it. Don't forget that people may need to categorize your art–to pigeonhole you–even though this oversimplifies your work. This can be frustrating for any artist, but it is often an inescapable part of getting people to grasp, recognize, and appreciate your artwork. You may need to participate in this by showing them limited styles of work initially. As buyers get to know you better, it will be easier for them to enjoy all the different parts of your work and its variations. Your own passion about your work is one of your best assets.

Start looking for buyers among your constituency–the people you see every day. An art buyer doesn't have to be a wealthy collector with buckets of money to spend. This doesn't mean that you have to lower your prices, either. Offering a piece to a friend on an installment plan may be good business if he or she has expressed interest and you are sure you'll see him or her on a regular basis. Ask for at least one-third of the full price as a deposit. Then, arrive at a comfortable monthly amount and you've made a sale.

One artist complained to me that what she finds so frustrating is that once she makes a sale, afterwards she seems to go back to square one again. Art sales are not like shoe sales, accomplished in a few minutes. To solve this dilemma, I recommend that you have several buyers that you are bringing along toward buying artwork at all times. Sometimes it literally takes months before someone is ready to buy. That's why it makes sense to work on a whole string of potential customers at the same time. And let's face it, buyers are not necessarily driven to buy art at any given time. We have to help it come about. Sometimes major events, such as your new exhibition will be an excellent time to put the ball in motion towards a sale. Think about it. There you are with your potential buyer and a large choice of your work on view. He or she is helping you celebrate an occasion–sort of like a birthday. His or her attention is

fixed on your art. You aren't intruding, he or she is focused on your work. It isn't a bad time, there aren't necessarily others clamoring for his or her attention. Not only that, but others may be within earshot saying kind things about the artwork. I watched an artist pull this off beautifully at a group show not long ago. After she had introduced me to a couple who had come to the exhibit with her, she whispered to me, "I think we're ready to buy tonight!" referring to her guests. There was obviously serious planning afoot here. If you've laid your groundwork well, this may be an excellent time to close a sale.

Prospects, we are told, tend to be lazy. You will have to think of ways to make it easy for them to have your art. Do some of the heavy lifting here—make it easy for them to locate you, let you know what they need to make a decision, then settle down and complete it. This is when the sale is yours. It may include going to their home to hang the art, presenting it framed, arranging transportation for the work, and helping them select the wall it will be hung on. Buyers appreciate being told how to take care of their new purchase. I know of artists who actually have a care sheet, which they give to new buyers. It details places where hanging the work might be dangerous (such as direct sunlight) and includes instructions on how to clean and dust the work.

All of this comes from thinking about ways to help your buyer make his or her selection. A thank you note a week later saying "I hope you are enjoying having your new artwork," is a great reason for your buyer to think of you when he or she wants to buy art again.

Too many artists see themselves like rug dealers. Once the check has cleared they want to be out of sight. Wrong. Some artists mistakenly feel that once a buyer has made a purchase, the conversation is ended. Nonsense! A buyer has more reason to buy again than a potential client who has never bought before. They now have an investment in seeing you succeed. Last December, I had calls from two former buyers. One had decided that she loved my piece in her office so much that she wanted some of the same artwork at home. The other caller was preparing his home for holiday entertaining

and wanted to have some new art. Between the two of them, they bought six pieces and really put a nice cap on my yearly sales figure. And I didn't even make a phone call!

The art world can seem a byzantine place, with secret passages, connections that are hidden from view, and private alliances that never see the light of day. This will not surprise many of you. It was ever thus, where large amounts of money were to be made. Even just understanding who is married to whom can explain why things work the way they do. Sometimes its hard not to take it all personally, but the truth is, the way things happen sometimes has very little to do with you.

However, some aspects of the art world are becoming easier to see and study. One of these is the matter of who and where certain prestigious art collectors are. If you are particularly interested in gaining access to well-known collectors, periodicals that specialize in the arts can be helpful—spotlighting major collectors and giving a thumbnail sketch of where and what these collectors collect. These buyers are usually well screened from public view, but if you have a desire to locate and pursue them, your best bet is to keep up with art magazines that focus on these individuals. A good publication for collector analysis is the Two Hundred Best Collectors issue of *Artnews,* which is available once each year.

Whoever your collectors are, you will want to put them on your most recent mailing list and keep them apprised of your latest activities. (For more on this, see chapter 11.)

■

Selling Your Work
to a Museum

Most artists are scared stiff of museums. Among the myths with which our particular field is burdened, few loom larger or are more secretive than the exact process by which a museum acquires an artist's work. Plain and simple: How is it done? Can it be accomplished by the artist alone, without clout in today's art world? Certainly, the rewards are formidable. Museum acquisition bestows credibility and accolades on the merits of our work. It boosts our prestige among our peers. And it doesn't hurt the old résumé, either.

So why is the path so obscure? First, it is rarely written or talked about. Artists who have succeeded in getting their work into museums aren't talking. Museum curators and staff, frequently underpaid and working long hours, enjoy the mystique that their institutions bestow in lieu of higher salaries. All of this, we can blame on somebody else.

However, it must also be said that many artists, in their reverence for and fear of museums, unconsciously forfeit any participation of their own in the process of getting their work acquired.

Beliefs like "the museum will find me" or "you need friends on the board" or "you have to travel in those circles" might be factors in *some* acquisitions, but, my dear artist friends, they are also myths that enable you to *not* participate and to sit in your studio and complain.

At this point a role model would be helpful. Enter Susan Kaprov, who lives in Brooklyn Heights, not far from New York City's highly competitive art world. She is not represented by a gallery and she rarely goes to SoHo. She *is* represented in the permanent collections of fifteen museums, in this country and in Europe—large museums of national stature, among them, the Museum of Modern Art and the Metropolitan Museum of Art in New York City, the Yale University Art Gallery in New Haven, Connecticut, and the Corcoran Gallery in Washington, DC. And she did it by herself.

How did she accomplish this? Kaprov is nothing if not succinct. "Hard work and the direct approach," she said. I urged her to elaborate.

First, she telephones a museum and asks whether it has an active acquisition policy. (If its acquisitions have been put on hold, or they don't actively acquire new work, there is little that can be done.) Next, she gets the name of the senior curator or the person in charge of art in the category into which her works fit. She then determines if the museum has public viewing days.

In fact, Kaprov approached her first museum on a dare. She went on one of that museum's public viewing days, without an appointment! Did she take slides, a portfolio? No, she took a small piece of her work, tucked under her arm. She says that this very direct approach is often disarming, opening the doors of even a very busy curator. Often, foreign artists traveling in the United States will use this method with gallery owners or curators who will give them a quick five-minute look because they've traveled a great distance. And even without a common language, it sometimes works.

Having work of a very original quality is one of the things that helps. "If they know they don't have anything like it, that's another reason why they'll take it," says Kaprov.

I had believed that museums would expect a significant discount on the price of the work, but Kaprov says that in almost every case the museum paid the price she quoted. The works she sold were "under $2,000" apiece. She will only offer a discount if there's some kind of trade-off—an assurance, for example, that the work will be shown and not just buried.

"After one museum buys, there is a cascading effect—you call up another one, mention your recent museum sale and even if they've never heard of you, they'll look," says Kaprov. She believes slides are "a big waste of time, unless they are for a grant, then you have to send them—it's the process they use," or for large works such as public art, which the curator might otherwise never see if the artwork is in a distant location. Kaprov estimates that "about half" of the museums she approaches buy her work.

There are many different kinds of museums and no hard and fast guidelines by which they acquire work. In fact every museum has its own criteria of what new work it will take, and it can depend upon considerations as mundane as storage space. Certainly, availability of funds for acquisitions—or lack of them—sometimes determines policy. A museum may sponsor an exhibition of solicited work for which there might be one or several purchase awards. The drawback to purchase awards is: if your $2,500 piece is selected for a purchase award of $900, you will either have to decline the award, or part with your work for $900 plus whatever "good will" there is in having your work owned by the museum.

University museums might want artwork for teaching purposes or artwork with particular regional importance. Some museums acquire works only through the bequests of patrons' wills, making for spotty and eclectic permanent collections. There is also the deaccessioning process whereby museums sell works they no longer want to own. Sometimes by selling works they are able to continue to buy new work. You should not assume that once your work is in a museum it will remain there forever, but you may find that having it owned by a museum opens enough other doors that it is worth the risk.

If you have a patron who is willing to donate your work to a museum, first help him or her by drafting a letter to the museum director, which the patron should sign. This letter should include a slide, a description of the work, its provenance (history of owner-ship), and any particular reasons why the museum might want to acquire it. For the patron, the tax-deductibility status of the work is generally higher than if the artist donates it. To find the fair market value, you will need the services of an appraiser. (It may also be of value to consult Publications 526, 551, and 561, which are available at no charge from the Internal Revenue Service.) Often dealers also act as appraisers, but be sure that anyone you choose for this function belongs to an association of appraisers and is reputable.

If you received an artist-in-residence appointment at a college or art center, ask if they have a policy of buying visiting artists' work for their permanent collection. Don't let the opportunity be missed because you didn't ask. Sometimes, print studios and workshops will ask for a piece of work that has been made there for its permanent collection. This work is rarely bought, but it's still a good investment because it will receive many viewings as part of the collection.

A fund has been established to facilitate the purchase of works by senior American artists for museums and universities as well as nonprofit institutions that collect and display American art. If you know an institution that would love to own your work, a letter from the institution, stating its desire to own the work, is required. Deadlines are March 1 and October 1. Application guidelines are available from: Richard A. Florsheim Art Fund, Board of Trustees, University of South Florida, P.O. Box 3033, Tampa, FL 33620-3033, Attention: August Freundlich, President; (813) 949-6886.

Interior Designers Need You!

ometimes, people with whom we went to art school are exactly the folks who can help us find new markets most easily. I'm thinking of the students who slaved away in the classrooms down the hall, learning to be interior designers.

I spoke with the people in the national headquarters of the American Society of Interior Designers (ASID) in Washington, DC. They can help artists get in touch with interior designers in various parts of the country. You can also buy mailing lists of members of ASID in your area. The membership lists are rentable on a single-use basis and come as pre-printed address labels. The national office of ASID is able to sort lists of their nineteen thousand members as you want—by city, state, geographical area, or zip code. The mailing lists cost $100 per thousand names, and you may pay for them by check or credit card. Your order will be filled within two weeks. Marisa McCarthy, manager of ASID's Service Corporation, can provide exactly the lists you need. For information, call (205) 546-3480.

Here's how some designers around the country find and work with artists.

Rosalyn Cama, ASID

Rosalyn Cama Interior Design Associates
31 Audubon Street
New Haven, CT 06511

When Rosalyn Cama needs an artist, her needs are very specific. She specializes in designing health care facilities, and when she seeks artwork for installation, she must keep in mind the patients these facilities will serve.

"I have to be careful of content when I choose something," Cama explains. "For children's needs, we don't want abstracts, which can be misconstrued. In geriatric assignments, we'll avoid anything that might be upsetting. We usually start with an art consultant and go through her slide files. If we get announcement cards in the mail from artists and we're looking for something specific, we'll try to reach them. Artists paint murals for us, and we're always looking for new ones! We also use *The Guild*, which is a big book full of craftsmen and artists. (*The Guild* is described later in this chapter.) I like art that looks like it was planned, not something that was stuck on the wall at the end of a design project. If we have artwork that we feel really belongs and there is no budget for it, we'll take the funds out of the furniture budget to pay for it."

Susan Bradford, ASID

Bradford Design, Ltd.
1042 Lanier Boulevard
Atlanta, GA 30306

Susan Bradford is a commercial interior designer who specializes in retail stores. One of her clients sells fireplaces, and, Bradford says, this brings on an immediate need for art to hang above the fireplace: "I need to be aware that the work above the fireplace will often be sold together with the fireplace, and so my art needs are dictated to some degree by the price the artist asks. Buying directly from artists here would be out of the range of the budget that is given

to me. For these works, I often use a vendor who frames the work and makes a whole package of it. I do also use faux-finish painters to create special effects on bookcases, floors, and wood trim."

Michael Love, ASID
The Quantum Design Group
200 Lexington Avenue
New York, NY 10016

Michael Love is a commercial/residential designer who works in the heart of the New York City design market. Her office is located in one of the market's busiest buildings. She is past president of the New York Metro chapter of ASID, and because of her ideal location, she has access to lots of artists.

Love says she rarely uses art, but employs artists to do *trompe l'oeil*—a type of painting that "fools the eye" with real-looking effects using perspective—on the walls of her various projects. She has sometimes used art consultants, gets lots of exhibition announcements, and admits that on occasion she has tracked down an artist whose card she liked. She used sandblasted folk art pieces on a Banco Nationale de Panama project, and says she likes art that works with the overall design. "But," she says, "I don't believe that the pink in the painting has to match the pink in the sofa."

BJ Peterson, FASID
BJ Peterson Interior Design
8687 Melrose Avenue, Suite G-671
West Hollywood, CA 90069

BJ Peterson can find artists when she needs them because she always tries to be available to look whenever an artist wants to show a portfolio. She also finds art by going to estate sales and galleries, reviewing the list of artists she has dealt with in the past, and from calling on a few galleries in the Pacific Design Center where she has her offices. She works on both residential and commercial jobs.

For her residential installations, Peterson often uses artists to paint directly on the walls. Sometimes she has them work on canvas and then shapes it onto the wall. She also commissions work to hang on the wall, having the artist first show a portfolio to the client for their okay. Once the client agrees to a commission, the artist receives a 50 percent deposit to purchase supplies and begin work. For a chain of restaurants, Peterson used murals because, "you get a lot of effect at a good cost." She thinks restaurants are a good opportunity for artists because they rotate the artwork frequently, allowing artists to show new things. She would like to use more sculpture.

Peterson urges artists to get good photos of their interiors work because it can influence new clients and other interior designers. "Sometimes," she says, "seeing artwork in an interior can make the new client realize how good it would look in *their* home."

Charles Gandy, ASID and Bill Peace, ASID

Gandy/Peace, Inc.
3195 Paces Ferry Place
Atlanta, GA 30305

"We commission a lot of artists," says Bill Peace. "Say an artist had a painting we liked, but it was the wrong size for the space where we intended to use it. If it could be rendered for our space, we'd ask to have it done that way." In its mostly contemporary design practice, Gandy/Peace has successfully used paintings, sculpture, wall hangings, and some crafts such as turned wooden bowls. While they make contact with most of their artists through galleries, Peace is not opposed to being solicited by individual artists. They sometimes keep slides, but send them a postcard and let them know when you're having a show.

Magazines: Interior Design and Beyond

I found a new place for showing my art that had completely escaped my attention until I ran into a chum from my art school days. Stanley Hura, whom I had not seen for a long time, works as an interior designer. After he sent me a Christmas card, we got together to catch up on what was new. He told me he was working on the interior design of a house in Connecticut that was to be photographed for *Home* magazine. I asked where the designers got the artwork for these homes.

"Actually," Stanley said, "it's sort of hit or miss. I sometimes call an art consultant I know who borrows an artist's work. Say, why don't you bring me some slides?" And that was all it took. My work was featured in *Home*, a nationally distributed magazine, in a spread of a stunning Connecticut house with interiors done by someone with whom I had gone to school.

My work was shown as the ultimate in decorating choice, and my name was listed both on the pages of the spread and in the back of the magazine in a resources box. The work was photographed by a very talented interiors photographer and thousands of people saw it. I didn't get calls or sell anything through the magazine, although artists sometimes do, but I *did* get a nice credit for my résumé and something to talk up for months. I would do it again.

Tim Drew, the managing editor at *Home* magazine, has some professional tips about how artists should think about magazines: "First I would say, be familiar with the audience who reads the magazine you want to send slides to. Is this where they should go? If the work is very modern—abstract, say—it might be better sent to *Architectural Digest* than to a more traditional decor magazine like mine.

"I think the best way to reach the magazine is to send your slides to the features editor, who plans the location shots. Most magazines also use a stylist, who works freelance and gets everything from the furniture and rugs to fresh flowers or vegetables if it's for a kitchen shot. That person would also plan for art that might be used in a location shot. They are credited at the edge of a photo or somewhere in the text. Artists might call the magazine directly, probably again

the features editor, and ask to be given the address of the stylist. Then send either slides, a brochure, or even good color photocopies of the artwork with an SASE to the stylist."

Tim mentioned one situation where his magazine was doing a piece on the Arts and Crafts movement and used work by an artist who happened to work in a similar style. "The man whose house we were using was redecorating and he fell in love with this artwork. He bought several works from the artist," Tim says. "We get a wide response at the magazine from readers when unusual artwork or crafts are used. Artists and craftspeople as well are always surprised by the response we get."

Should artists send slides directly to an editor? According to Tim, "Unsolicited materials are just another thing for us to take care of or file away. It's not the cost of the postage that we worry about, but it's just another job for us to do. We are inundated with public relations mailings about new products. An artist's slides can be lost, so it is perhaps better to send something that you won't want back right away."

Is there any point to putting people at the magazines on an artist's mailing list? "I think so," says Tim. "Then it's something we can keep. And if it's a show in the area where we are, or where we'll be, we love to go to see art."

How far ahead of publication should artwork be presented? "Figure we are six to eight months ahead of what is on the newsstand," Tim says. "Sometimes artists call to see if we received their packages and if their art is being considered. This is almost impossible to answer. So please be patient with us. Sometimes we'll have something for a while, and then a little light will go on and it's the perfect thing—just what we want to use."

Debora Meltz, an arts writer I know, says she sends a brochure to both the editor in chief and the art director of a magazine. "You never know what the art director may be thinking of doing with your work, and what the editor in chief may be thinking could be for an entirely different project."

Debora says that brochures aren't as expensive as slides, nor is

there the problem of getting your work returned. The SASE problem is eliminated and the image will stay with them for a longer time than a slide. Debora also thinks art directors aren't really set up to look at slides, which is another reason she uses brochures. "Art directors will hold them up to the light," she says, "or put them on a light table, but either way, they miss all of the detail that makes a painting or a drawing so important. If they get a brochure, they can see what you're presenting to them in a way that gets them hooked right away on your work. *Then*, they may see that they should set up a projector and make the effort."

Look in the front of a current issue for the names of a magazine's editors and art directors, which will be listed on the masthead. Debora says that even several years later she has been approached by magazine editors who had seen her brochure. If you don't have a brochure, she says a good color postcard will do. She has had several magazines use her work as illustrations for articles and was paid handsomely. The work was returned to her after transparencies were made to use for reproduction.

Think about which magazines might be interested in your work, and don't limit yourself. Debora advises, for example, that if your work has strong spiritual qualities, it may attract religious or spiritual magazines. Although she is not of the same faith, she has sold work to magazines who saw her brochures and solicited her to send slides.

A friend of Debora's who painted large (twenty-two-by-thirty-inch) pastels, did a mailing of her brochure and got a commission for twenty of her drawings from a restaurant in Texas. She was paid almost $1,000 for each one and had two years to complete them.

Debora cautions artists to be very careful what they are signing when they allow their art to be published. "Be sure," she says, "to ask for one-time only use so it won't be reproduced in different places over and over."

Don't overlook magazines that feature artists' works on their covers. Magazines like *Art Calendar* and *Sunshine Artist* and artists' supply catalogs like Light Impressions (for more information, call Anna Quimby, marketing coordinator, at (716) 271-8960, extension 3031) offer fine opportunities to heighten your artistic profile by publishing artwork submitted by artists. You will not be paid for these showcases, but your work will be widely seen. Karen Wheeler, the art director for *Sunshine Artist*, says artists should submit good slides that can be scanned and an SASE for return of the work. She says that the magazine works about three to four months in advance on its covers and is glad to receive submissions from artists. Address these to:

Sunshine Artist
2600 Temple Drive
Winter Park, FL 32789
Attention: Cover Design

Or send one or more eight-by-ten-inch vertical photos, your résumé, and an SASE to:

Art Calendar
P.O. Box 199
Upper Fairmount, MD 21867-0199
Attention: Editor

Design Centers and Furniture Showrooms

Nearly all art ends up in a home setting. With exception of the few works that go into museums, most art purchased in galleries goes into the home of the buyer. In fact, the idea of exhibiting on white walls in empty galleries is only a few decades old. Pictures of galleries in the 1940s show couches and end tables along with the art. Art has always been shown with other furnishings, whether in palaces or middle-class housing. It helps to visualize what it will be like to live with a piece of art in a residential environment.

When Stanley Hura, my art school friend, took a buying trip to

an interior design center in Dania, Florida, he found two art galleries tucked in among rug dealers and fabric showrooms. The Windsor Gallery has been in the design center at Dania for eighteen years, and Robert Windsor, the owner, told me that he shows art from "all over the world." All of the artwork is contemporary, and he finds having a gallery in a design center works well. He is also very open to receiving slides sent by artists with an SASE. You can reach him at:

The Windsor Gallery
1855 Griffin Road
Dania, FL 33004

No Florida artists, please!

Robert Windsor warns artists to visit galleries located in design centers to determine if the work is high quality. He says that art quality is a big issue in design centers and there are some galleries where it is lacking. This is one time when a personal visit may be necessary to be sure that your work will be shown with other artists whose work you admire.

Karen Giorlando is the manager of Rosenbaum Fine Art, which has six locations nationally. She says that Rosenbaum shows about fifty artists working in a wide variety of styles. This includes local artists, who may be commissioned to create pieces for an interior designer who wants unusual artwork.

Whether you find a gallery in a design center to be a good sales situation, or you want to try to make connections with interior designers yourself, it doesn't really matter. The atmosphere is definitely receptive to artists now. However you choose to reach them, don't forget them! Someone who has hired a designer to pull their interiors together usually has sufficient funds available to buy artwork. By working with a designer, someone who has never bought art before can become educated about color, texture, and surface and

may gain the confidence to purchase art for the first time. Certainly, the attention they are focusing on their surroundings makes showing art to them now seem natural, where it may not have been as easy to do before. Let the interior design industry help you gain new customers.

Commissions

How many times have you heard someone say, "I always wanted to commission a painting–but I don't know exactly how that works." If you are like most of us, you didn't pursue it because: (a) you were more interested in something else at the time; (b) you felt that commissions were only for realistic art and that's not what you do; or (c) you were unsure that what you would paint would please your client.

Commissions have kept certain kinds of artists in the black for years now. They work in all kinds of media, from abstract and representational painting to photography, drawings, and sculpture. Commission projects are not any more difficult than any other kind, but a few well-thought-out conditions will make it easier for you and your client.

First, you should ask for a deposit of one-quarter to one-third of the total price up front. You can explain that this is for the supplies the project will require, and also that as the commission will take you away from other projects, so you must require a commitment in the form of a deposit.

The most successful commission agreements happen when the client has bought work from you already and has a sense of what he or she will be getting. (As I mentioned earlier, showing your portfolio to interior designers can help them to see what kind of work you specialize in so they can keep you in mind as a resource when they are planning a space.) Unless the work is large or irregular in shape, it is wise to actually create two or three works, similar but different, for the client to choose from. If the work is large, you can create a sketch or maquette of what you plan, which the client

can okay. Ask the client to initial the sketch he or she wants to commission. An artwork a buyer asked me to do for a wedding present (I completed four for him to choose from) pleased him so much that it ended up hanging in his dining room and something else, which he bought from Tiffany, was substituted for a wedding present. Later, I sold another client the second of the original four, which was like a bonus sale.

A friendly letter of agreement will help keep faulty memories at rest when it comes time to present the invoice for payment. You should always find out what kind of frame is desired and present the finished commission framed and ready to be hung so that the buyer has a satisfied, complete feeling about the project.

I think commissions would happen a lot more frequently if artists would *let* them happen. The next time it comes up in conversation, don't automatically rule it out with a wave of the hand. If it's something you think you can do and the agreed price makes it worth it, give it a try. Plan to give yourself enough time, but not so much that the buyer's original enthusiasm wanes. Another idea: if you have regular patrons, mention that you are available for commissions for gifts they may need. They'll keep you in mind and maybe tell friends as well. If other people admire your work, tell them that you also do commissions. Buyers may need a special gift and be ready to spend the money anyway, so it might as well be profit for you.

Sourcebooks

Another way to earn commissions is by showing samples of your work in an artist's sourcebook—an annual book used by decorators, architects, and art consultants. Often these are hardcover books intended to be kept for years. A good example of this type of publication is *The Guild,* which I mentioned earlier in the chapter. Every year, six thousand art and design professionals and seven thousand architectural firms are given copies by the publisher of *The Guild* at no charge. A catalog of artists who can produce commis-

sioned artwork for a particular space, the book is divided into sections according to types of art product—such as art for walls, furniture, accessories—and each artist has a page showing two or three different works and how they may be used in room settings.

Two versions of *The Guild* are published annually—one for use by designers and another for architects. While the artist must pay for the coverage, or page, for many artists it is well worth it in the long run.

Marcy Pesner is the owner of Beagle Tiles in Brooklyn, New York. A sculptor, she turned to tile making as a business, and her lovely tiles adorn floors, walls, and the cabinets she also makes. Pesner has taken pages in *The Guild* for years and says that she still gets calls from readers of editions that were published eight years ago (attesting to the long shelf life these books have). Responses have come from as far away as Japan and India. "I actually think I might do better from the architectural version as my work is built into the structure," she says.

Pesner also says that the publishers make it very easy for artists to afford being included in *The Guild*, offering several different payment plans that can be spread out over time. It cost her approximately $1,700 for a page, plus another $350 for one thousand tear sheets, which she uses to further advertise her tiles. "And," she says "you can get a break if you order your layout early, such as free tear sheets. The publishers ask that you supply professional photos according to several page layouts, which they send to you. You are also responsible for preparing the copy that appears on your page, so you know it will be exactly what you want to say about your work. There is a jury process, which eliminates any work that is not the best quality. *The Guild*'s publishers really have it down to a science, so that the books look good and are kept for years. They really seem to make every effort so that the artist's work will be shown off to best advantage."

To contact *The Guild* for further information, write to:

The Guild
228 State Street
Madison, WI 53703
(800) 969-1556

Sourcebooks are not all equal and do not all cost the same, so you should be sure to ask lots of questions. You will want to know about circulation of the books (how many are printed and how many given free to designers, art consultants, etc.), to see paper and color reproduction samples, and to find out how many artists will be included.

Retail Store Windows

Large retail stores have a history of hiring artists to make statements in their windows, using art combined with the store's products. In recent years, one of the leaders in this endeavor has been Barneys New York, a retail chain of men's and women's fashion wear.

According to Simon Doonan, executive V.P. of creative services for Barneys New York, "Barneys has a long history of involvement in the art community, and artists can work with us in several ways. Because we work from a window schedule that helps us see what merchandise will be in the store when, we plan several months ahead all of the time. Our Christmas windows get worked on year-round.

"If we like something, artists often loan us their work to be displayed in the windows without changes. Artists also send us color copies of their work, which we keep in a file that we check when we are looking for something in a specific style. If they send things they want returned, they should include an SASE. Naturally, it's easier for us to have things sent which don't have to be returned, and we prefer that.

"We find that larger, more graphic or sculptural work comes

across better in the windows. If it's subtle or conceptual, it gets lost. Things with a pop element work better. Certain kinds of art can be diminished by a window, so it's important for the artist to think about whether she or he really wants to show in a window setting.

"Artists have gone on from our windows to a gallery or sales situation, but we like to think that that was inevitable, that we were just part of a process that was going to happen to that artist anyway.

"We use lots of artists, because at peak season, the windows are up for only a week at a time. The selling season when new merchandise is in the store is short. We have used artists more than once, for instance for our Red Windows. We used four hundred artists for that window display, which was a fund-raiser for the Little Red Schoolhouse (a nonprofit school in New York).

"In our branch stores, we offer a pared-down version of the artists' windows. In our mall locations we try to do a simpler version. We find that people in malls are overstimulated and don't really look at the windows the way they do on a street, where they may stand and look at a window for a long while. We have tie-ins with some museums, as at our store in Seattle, and we recently did windows in Houston that celebrated the Robert Rauschenberg retrospective."

Several artists have become well known for their window installations, including Candy Pratt, to name one. When she began doing the Bloomingdale's windows a few years ago, the windows received so much notoriety that crowds would form outside Bloomie's on the night that new windows were to be unveiled. The same is true of Barneys's windows for the holiday season. They have been reviewed as art by *New York* magazine for several years and to be caricatured in the windows is an honor sought after by nearly all of café society.

Retail windows using fine art seem to fall into two categories: those that simply put two-dimensional art in the background while clothes, shoes, or whatever they sell is placed in front, and those that allow a complete scene to be built into the window with little

or no focus on the merchandise. Either is a valid way to operate and you will have to analyze every store you are considering to see which approach will work best for your art.

Real Estate

David Wine of Related Management Corporation in New York City is one real estate man who found a way to have art tell his story when his company bought Tribeca Tower in downtown Manhattan.

"Although Tribeca Tower was originally marketed as a condominium, its location in Tribeca placed it in a district known for its artist community and good restaurants," Wine explains. "I felt that Tribeca Tower as a building didn't respond to what was most positive in the area. My goal was to try to reposition the building so that it would tie in more closely to downtown, so that the potential resident could feel like part of the neighborhood. Normally, we do this with the design of a logo, with our advertising, with the building's brochures, and inside the building with the way the rental office looks and the style of the model rooms; also in the personality of the public spaces like the lobby, the exercise room, the facilities."

Wine hired the Rockwell Group, builders and designers who have created some of New York City's most lavish and interesting restaurants (Nobu and Vong, among others) to redesign the entrance and lobby of the building. Rockwell engaged cabinetmakers and architectural craftspeople, who designed cement lighting fixtures built into the walls and carved furniture and trim designs, giving the space an artist-created air.

Next, the model rooms were addressed. In checking out the Tribeca Tower neighborhood, Wine had noticed that just down Duane Street was an organization/gallery called Art Initiatives. A twelve hundred-member artists' group connected exclusively by newsletter, Art Initiatives also operates a slide file of its members' work and a street-level gallery space. It also finds exhibition spaces that it curates (among these are spaces in Trinity Church and the

New York Law School). Wine realized that he might not be able to buy fine art because of budget constraints, but maybe he could borrow it.

He approached the Art Initiatives's executive director, Gail Swithenbank, with a plan. Together they and the model-room designer spent several sessions looking through the slide file, selecting artwork for model apartments. Related Management then borrowed the selected artwork for a set period and paid a fee to the artists. Later that week, the work was taken to Tribeca Tower by the artists, where it was received by Related's staff, hung, insured, and maintained. The artists received $100 for each loaned piece (up to three pieces). Related Management paid for cards and a catalog, designed by Art Initiatives, to be printed.

The *Art in Residence* show was to be on view for one year. But the entire project was so successful that at the end of four months all of the apartments were rented! David Wine says that he firmly believes that using the artwork in the marketing presentation helped to rent the apartments faster and for higher rates. Art was sold, and many happy artists made lots of contacts through the project.

Now, David Wine is at work on another project that incorporates art: a large building on the south side of Union Square, which will feature an Art Wall one hundred feet high by sixty feet wide. For this project, Wine sought the assistance of the Public Art Fund, a nonprofit arts group that initially made the call for project proposals. Other groups, including the Municipal Arts Fund, got involved and at this point nominations have been narrowed down to four artists. All are receiving funds for their work preparing the final proposals. The building and the Art Wall promise to bring landmark scale art to Union Square before long.

Consultants, Corporations, and You

E very gathering of artists produces another lurid tale of an artist's woes in working with an art consultant. Personally, I have found them to be, by and large, reputable and fair. How to work with art consultants in the most professional way is what we will explore here, followed by corporations and what they can do for your art.

Art Consultants

Before becoming involved with an art consultant, you must ask for references, much as you would for any major purchase you were about to make. If you are in doubt, a telephone call to the Better Business Bureau will tell you if there have been any complaints about a particular consultant. I do not recommend that you engage in an arrangement with a consultant about whom you know absolutely nothing. However, after checking and armed with the names of several consultants, I think you'll agree with me that they are easier to reach and do business with than most gallery owners.

Art consultants can offer the artist a nongallery alternative that may turn out to be as lucrative, yet avoid the emotional wear and tear that preparing exhibitions for a gallery entails. For one thing, the consultant might be located in another part of the country. Although the geographical distance will require long-distance phoning and faxing as well as shipping, it may allow you to keep your sanity and dignity throughout the whole transaction.

You can, and should, work with several consultants at one time. Often from one city to the next, they will recommend each other to you, which is a shortcut on the checking and cross-checking described above. After all, why would they recommend someone in their own field if that person were not reputable? Consultants often specialize in certain fields, such as health care institutions, cruise ships, churches, or hotels. I work with several consultants in different cities, as well as one whose dealings are exclusively in the Far East.

To initiate a working relationship, send the consultant your slide package plus a cover letter, résumé, and *retail* price list. In the cover letter, indicate who referred you or where you found the consultant's name. State your interest in working with him or her, and mention any corporate sales you have had. Specify any customer groups to which you seem to appeal, such as banks, consumer food companies, etc. If you have worked with other reputable consultants, mention them—it can reassure the consultant of your professionalism.

Indicate in your letter that you would welcome a studio visit if he or she is located near you, or that you would be happy to come and show examples of your work. If this is geographically impossible, you can offer to follow up the initial slides with a portfolio.

Close by saying that you will call in a week to follow up and arrange an appointment. One week later, call to see if there is sufficient interest in your work to merit an appointment. Don't wait longer, as you'll give a better impression of promptness; and if the consultant receives lots of mail (he or she almost certainly does), the strong impact your packet first made won't be forgotten.

Appointments with consultants are much more relaxed than with gallery personnel. The *most* a consultant can do is to offer to show your work in future slide presentations; the *least* is to tell you that your work would not be appropriate for the clients he or she currently has. Avoiding personal likes or dislikes, it is a more straightforward business transaction than having a gallery owner pass judgement on your work in a face-to-face encounter.

Sample Price List

Here is a sample of a typical price list you might give to an art consultant. Note that it says "Retail Price List" and is dated. Also, that framed works are listed separately and that notes regarding the commissions and group sales are included. You want to provide *retail* prices—that is, the price for which the work will finally be sold to the collector. Thus, regardless of the commission arrangement you work out with the consultant, your work has a stable, single price *on the market*. This is to your advantage, and you should maintain your prices, no matter what. If you get the reputation for producing work that varies in price, you will always have difficulty getting the price you ask.

Retail Price List - Peggy Hadden

Works on Paper. Effective 6/1/97. All prices include dealer's commission. Prices for groups of three or more are negotiable.

Astarte	$700	Gwydnno	$700
Phrygia	$700	Coyote	$700
Sulep	$700	Slow Passages	$700
Sujata	$700	Mithra	$700
Accommodation	$700	Galatia	$700
Stagira	$700	Miletus	$700
Minos	$700	Blue Pheasant (framed)	$900
Seljuk II (framed)	$900	Ahura (framed)	$900
Concurrence (framed)	$900		

One of the major complaints art consultants make is that many artists are amateurish or unpolished in their business dealings. Problems include frequent price changes, poor recordkeeping, and failure to communicate vital information, such as an address change. It is important to present a businesslike demeanor when concluding a working agreement, so that an art consultant will see you as serious and organized. Failure to accomplish this can bring you problems in future dealings.

An Exception

Like all rules, the rule of maintaining your prices has an exception. Art consultants often work at selling several pieces of your work at one time to one customer. In *this* event, the consultant may ask you to reduce the price on an individual piece to make a group of three pieces cost slightly less than if they were purchased separately. For example, if your original price per work is $350, but the client wants three of them, you might be asked to sell the three for $1,000. It is probably to your advantage to do so.

It is good market strategy to mention that discounts can be arranged in the sale of three or more pieces. Many consultants' sales involve several pieces and this offer gives them an incentive to work with you. On the price list, state that all prices include dealers' commissions. Also note any works that are currently framed or where other expenses have been incurred, and be sure to figure these into your retail price. Even though consultants prefer to do their own framing, if the piece they want has been framed for a show or other event, you've still paid for the frame. If you include this expense in your price in the first place, you will not be upset later when the piece is sold and reframed by the consultant.

Another aspect to be considered in working with art consultants is the size of your work. Because they often work with clients who are looking for art for lobbies, reception areas, and conference

rooms, art consultants usually prefer to show larger work. Many will not even consider work smaller than twenty-four inches square. When my thirty-by-sixty-inch works were shown, they sold well. When my work went through a small phase–eight by ten inches–I was politely told to call back when my work got bigger. Like those decorators who sell "books by the yard" for people's libraries, this seemed like art sold by the yard! The consultants were apologetic, but pointed out that it took as much time and energy to sell small work as large, and larger work usually brought a higher price. I found other outlets for selling my small works, but I include this anecdote so you won't be surprised. When I'm ready to work larger, I'll contact those consultants again.

Let's not forget subject matter. Consultants have no objection to trends in abstraction or realism, but say they cannot sell nudity or politically sensitive art.

A consultant might want only your slides at first, as most of them work with their clients by first showing a carousel slide presentation of the kinds of work they have available. Needless to say, the quality of your slides is crucial here. A future sale depends on sharp, clear images that are well lit and have solid black or white backgrounds. If the client shows an interest in your work (he or she will probably be interested in several artists), the consultant will then ask you for several pieces *on consignment*. At this point, you should draw up a list of all works taken by the consultant for consideration.

The consignment list is a legal document that makes the consultant responsible for the works until they are returned or sold and you are paid. The list contains retail prices and the amount of commission to be paid. It is signed by the consultant and copies are kept by both parties. It should be dated and state clearly "Received on Consignment." The artist should keep all consignment records in one notebook to avoid loss and to quickly see what works are out of the studio. Not long ago, I received a package of five of my works on paper from an art consultant on the West Coast. I'd forgotten they were still there. I had been so excited by her sale of three other

pieces of mine that I had failed to check my consignment list to see what else she still had. It's a good thing that she is honest—I would never have remembered they were there!

Generally, a consultant will not take more than six to eight works. I would be loath to part with more than that for several reasons. Certainly for security, but also because these works will be out of circulation for some time (weeks, maybe months) and I wouldn't want to miss other sale or exhibition possibilities.

Art consultants are paid for their services in several ways. Some charge the client a fixed fee, with no commission taken from the selling price of the artwork. Some work with the retail prices set by the artists and then take commissions from those prices—up to 50 percent is common. Art consultants who take their clients to galleries are paid by the gallery—usually 10 percent—after the client has paid the full retail price. Yet another arrangement is for the consultant to charge the client an hourly fee and also to receive a 10 percent commission from the artist on work sold.

Artists must be careful to avoid giving different prices for the same work to different consultants or dealers who might be competing for the same sale. If slides of your work are shown at two different prices, needless to say, your work would be sold for the lower price. This would also alienate the consultant who was underbid.

Working successfully with art consultants is best accomplished by being well organized, always following up, and keeping complete and accurate records. Be sure to contact everyone who should be advised if you have an address or phone number change—and don't forget zip and area codes.

Also periodically check on work that is out on consignment. You'll find that you gain respect from consultants for doing this, though it might seem hard to do at first. It paid off recently for a friend of mine. He called some consultants to say that he'd be coming down to Florida in a few weeks to visit them and check on works he had left with them the year before. Within a week, they called him back to report that they had sold several of his works that very

weekend! Call and say you are making a periodic check on all work that is out and ask when would be a good time to stop by. The consultant is more likely to accept this as standard professional practice if you do it regularly, and knowing that you check in periodically will keep him or her on the straight and narrow. Calling beforehand is more professional than suddenly showing up at what could truly be an inopportune time.

When you visit the consultant, take your consignment list with you. If you find any discrepancy between what your list says and the work you see, ask for an explanation. If you are told that a piece is out being viewed for possible sale, get a date when its return or sale confirmation is expected and when you can stop by to view it or get paid. Check for damage and bring anything that has changed to the consultant's attention. Works on paper are particularly fragile and might require showing and storage in clear plastic covers.

If you find that works you've left on consignment are not ever being shown—and the consultant's assistants aren't familiar with your work or your name—take them back. I know this isn't easy to do, but you might be able to find another buyer. At any rate, you won't be deluding yourself about possible sales when none are forthcoming. This system of keeping up with your work is absolutely professional, and you should check all work that is out of the studio on loan or consignment at least once a year.

I've gathered a list of art consultants followed by their company name, if different, and their addresses. I urge you to contact as many as you feel you can work with. Remember, your experience with art consultants depends largely on making sure you are dealing with reputable people. It also depends on your business practices, such as the ones mentioned here, to convey your professionalism. Caveat emptor!

Doris Adelstein	The Aesthetics Collection
305 West Fullerton	1060 Seventeenth Street
Chicago, IL 60614	San Diego, CA 92101

Chickie Alter
Alter Associates
122 Cary Avenue
Highland Park, IL 60035

Architectural Arts Company, Inc.
6410 Dykes Way
Dallas, TX 75230-1816

Margery Aronson
2423 Knob Hill North Avenue
Seattle, WA 98109-2049

Art Acquisitions, Inc.
413 Wacouta Street
Gilbert Building, Suite 550
St. Paul, MN 55101

Art Sources, Inc.
927 Lincoln Road, Suite 212
Miami Beach, FL 33139

Artlook
790 Cleveland Avenue South,
 Suite 217
St. Paul, MN 55116

Artsource
244 Kearny Street, Seventh Floor
San Francisco, CA 94108

Temme Barkin-Leeds
Barkin-Leeds, Ltd.
6 Harris Glen
Atlanta, GA 30327

Jean Bell
Corporate Art Source
2960-F Zelda Drive
Montgomery, AL 36101

Kathleen Bernhardt
Corporate Art Source
900 North Franklin, Suite 200
Chicago, IL 60610

Judy Birke
484 Whitney Avenue
New Haven, CT 06511

Thea Burger Associates, Inc.
Box 182
Geneva, IL 60134

Aileen Colton
4915 Roma Court
Marina del Rey, CA 90292

Contemporanea Art Consultants
526 Lancaster Street
Jacksonville, FL 32204
(Uses artists from southeastern states only.)

Contract Art, Inc.
P.O. Box 520
Essex, CT 06426

Sharyn Crockett-Peet Curatorial
 Services
1213 East Las Olas Boulevard
Fort Lauderdale, FL 33301

Janet Disraeli
The Art Collector
4151 Taylor Street
San Diego, CA 92110

Diane Dunning
Dunning Associates
5500 Wissachickon Avenue,
 Suite 805C
Philadelphia, PA 19144

Jean Efron Associates
2440 Virginia Avenue NW,
 Suite 1210
Washington, DC 20037

Carey Ellis Company, Inc.
2444 Times Boulevard
Houston, TX 77050

Deborah Schiller Hadl
3710 South Robertson Boulevard,
 Suite 210
Culver City, CA 90232

Brenda Harris
Administrative Arts, Inc.
PO Box 547935
Orlando, FL 32854-7935

Joan E. Kaplan Fine Art
121 East Seventy-ninth Street
New York, NY 10021

Eileen Kunzman Fine Art Services
128 Glen View Road
Birmingham, AL 35222

Mary Lanier
6 Morton Street
New York, NY 10014

Suzanne F. W. Lemakis
1 Court Square, Eighth Floor
Long Island City, NY 11120

Betty Levin
Corporate Art Directions
41 East Fifty-seventh Street
New York, NY 10022

Elizabeth Levine and Associates
565 West End Avenue
New York, NY 10024

Suzie Locke
Locke & Associates
4254 Piedmont Avenue
Oakland, CA 94611

Mary MacGowan
10 Hills Avenue
Concord, NH 03301

Marion Maienthau
Marion/Art
200 East Sixty-sixth Street
New York, NY 10021

Markel/Sears Fine Arts, Inc.
560 Broadway
New York, NY 10012

Andrea Marquit Fine Arts
38 Newbury Street, Fourth Floor
Boston, MA 02116

Margaret Mathews-Berenson
325 East Seventy-ninth Street
New York, NY 10021

Maribeth McKee
Fine Art Company
29300 Clemens Road
Cleveland, OH 44145

Beatrice Medinger
Viart Corporation
120 East Fifty-sixth Street
New York, NY 10022

Emily Nixon
Nixon Art Associates
33 N. Michigan Avenue, Suite 3500
Chicago, IL 60601

Janice Oresman
1001 Park Avenue
New York, NY 10028

Randolph & Tate
2095 Broadway, Suite 404
New York, NY 10023

Bernice Rhodes Art Consulting
 Specialists
6500 Old Dominion Drive
McLean, VA 22101

Connie Rogers, Inc.
152 East Ninety-fourth Street
New York, NY 10128

Nancy Rosen, Inc.
180 West Fifty-eighth Street
New York, NY 10019

Randy Rosen Arts Associates
240 East Eighty-second Street,
 Suite 2A
New York, NY 10028

Shelly Ross
401 South First Street, Suite 1201
Minneapolis, MN 55401

Estelle Schwartz
400 East Fifty-sixth Street
New York, NY 10021

Joyce Pomeroy Schwartz
17 West Fifty-fourth Street
New York, NY 10019

Judith Selkowitz Fine Art
530 Park Avenue
New York, NY 10021

Alice R. Snyder, Inc.
1521 Wrightsman Street
Pittsburgh, PA 15217

Regina Trapp
Trapp Associates, Inc.
124 East Ninety-first Street
New York, NY 10028

Carola van den Houten
Modernart Consultants, Inc.
390 West End Avenue
New York, NY 10024

Barbara Volkman
Volkman Berdow Associates
345 East Eighty-sixth Street,
Suite 16C
New York, NY 10128

Sue Wiggins
ArtSouth, Inc.
4401 Cresson Street
Philadelphia, PA 19127

Corporations

Corporations are good friends to the art world, and they can be helpful to you as an individual as well. Many of them have an in-house curator who cares for their art collections and plans exhibitions.

One of the great new markets for showing your work is in a corporate space. Some of these corporations don't have in-house curators and you may have to get an exhibition on your own, but believe me, it's worth doing. This is one of the least-pursued, least-understood, least-appreciated gallery venues around. I recently did a count of corporations near me that have full-time gallery spaces and full-time art people in charge of them. The length of the list was surprising.

Large corporations work in many different ways where exhibiting art is concerned. A large insurance company near me has art consultants who decide what the themes of the shows will be. Then, they look for paintings and pieces of art to go with each theme. Another corporation has a competition once a year for all of the exhibitions it will offer. Still others have an open-ended exhibition policy and are looking all year long. Some really have no policy at

all. They are simply waiting for you to propose an exhibition. You will be well advised to investigate a corporation's policy before you spend valuable time preparing a presentation for them. This is when the in-house curator is your information source.

Why does a corporation want to patronize art? Maybe for the image it earns as a caring member of the community. Perhaps for the vision of a corporation that shows concern for its employees and the quality of living it inspires. Marjory Jacobson is a Boston art consultant who, in her book on corporate art collecting, *Art For Work*, describes the Cartier Corporation' s aims this way: "Cartier had done extensive market research and discovered that 75 percent of today's young consumers had a strong interest in contemporary art. Of that percentage, Cartier expected at least 10 percent to eventually become Cartier customers. Therefore, it made good business sense to develop a reputation as a sponsor of something these consumers felt so strongly about."

In an age when large industries are suffering from the image of giant takeovers, potential employees and local bigwigs are impressed to see a company show concern for the lifestyles of people who work there. According to Jacobson, "When they made overtures, such as providing arts exhibitions," they found that "their shareholders, their customers, and their communities approved of and applauded their support of culture."

Major corporations are not just in cities either. Every locality has a few big industries. If you have a connection within one, take advantage of who you know and ask about the exhibition possibilities there.

What kinds of arts are applicable? To be honest, certain kinds of art don't make it in a corporate environment. Corporations steer clear of political art, nudity, religious themes, or anything that might be offensive to any of their employees or their other corporate partners. In short, what they do prefer are landscapes, florals, scenic work, or abstract work that is colorful and not too jolting. Animals, Americana, and history play well. Right now, black-and-white photography is very popular in corporate viewing areas.

Is the public invited–and if not, does it matter? That depends on the space. At Paine Webber's corporate headquarters on the Avenue of the Americas in New York City, art exhibitions by nonprofit groups greet visitors entering the lobby and can also be seen, through large glass windows, from the street. In other corporations, exhibition spaces are sometimes along corridors and in conference rooms, which are accessible only to employees. Sometimes exhibit spaces are within cafeterias and lounge areas, again for company employees only. This should not be a reason to rule them out. Employee-only exhibitions that will be seen by those going to and from the cafeteria every day will get a lot of attention and good possibility of sales.

The fact that your work will not be seen by the passing public may not be what you had in mind, but you will have other opportunities to show at more public spaces. (Check out Mary Pat Dorr's experience with house tour audiences in chapter 10.) You should still send out a postcard with an image of your work on it to everyone on your regular mailing list, and state something that makes clear that this is a show exclusively for the employees of the XYZ corporation. Adopt a stance of "just to let you know what the artist is up to" and let the exclusivity work for you. There is nothing more impressive than a notice of something to which you have *not* been invited.

If you are played up in the company's in-house newspaper as a visiting artist, save some copies and send them to similar companies with an exhibition proposal and cover letter. Banks love to know what other banks are up to, and one invitation will become many if you play these corporate types one against the other. Take advantage of an opportunity to offer a lunchtime chat to employees about your work, with a question-and-answer period following it. This will give you both a chance to get acquainted and to overcome any standoffishness.

What benefits exist for the artist showing in a corporate space? As an artist who has had some luck selling to corporations, I am familiar with these. First, there are the possible sales. If your work

is of the type and size to fit in office spaces, you may make multiple sales, either to individuals or to the company's planning and interior design office. If your work is larger, don't forget that there are conference rooms, lobbies, and entrances that can use bigger pieces. Three of my works hang in a conference room at the national office of Coopers & Lybrand in New York City and another three are in a reception area at First Interstate Bank in Los Angeles. Coopers even let me frame them as I wished, and paid for the frames!

There are any number of nice things a corporation can do to help you mount your show. They may offer a budget for the mounting of an exhibition, or they may offer to just "be helpful" as you install your work. Some corporations will pick up your work and deliver it to their site and take it back again, eliminating costly trucking expenses. Corporations often provide staff for security at the opening and cater the celebration. Don't forget that most large companies have in-house printing facilities (black and white more often than color) that can reproduce your statement, résumé, and price list. Big businesses often make it a habit to buy a piece from the artist for their permanent collection. You can look into this discreetly and make overtures to the company's representative. (For example, "That piece looks so great there, it's as if it were meant to be!")

Other perks? Corporate shows look great on your résumé and impress art consultants. After you have the first one, expect to get more if you pursue them, because corporations will note that your work passed muster with their peers and will be pleased to have you show for them, too. As I mentioned earlier, this will give you yet another alternative to showing in a gallery, where you won't have as much, if anything, to say about how the work is hung.

You may receive offers to rent your work, and it could be to your advantage to do so. If such an offer is made, and no sale can be worked out, be sure the renter signs a contract regarding who is responsible for damages and the length of your art's stay. When the time is nearly up, check again. The prospect that the art is leaving may be enough to close a sale, while neglecting to follow up may

cause the corporation to expect the artwork to be there forever—so why buy it? The length of the loan, your right to make a substitution if a sale occurs from somewhere else, and your right to inspect the condition of the artwork periodically, should all be worked out in writing.

All in all, corporate settings can be great places to show and sell art—and introduce your work to a group of people who may have been so work oriented that they've never taken time to get to a gallery. These people can easily afford to buy art. My friend sells as much to the support staff at her day job as to the partners. I have sold seven pieces to a gentleman in an office who never gets to galleries. Now he's my patron. Doing business with big business is good for you, your art, and the companies, too. And once you sell to a big company, they're on your team!

Some well-known corporations and their curators are listed below. (Referrals of new curators and art consultants for future editions of this book would be welcomed.)

Diane Bliss, Director of the Art
 Program
American Express
World Financial Center
200 Vesey Street
New York, NY 10285-4800
212-640-3106

AT&T
Natalie Jones, Fine Arts Administrator
Corporate Art Program
5000 Hadley Road, Room 1B42
South Plainfield, NJ 07080
908-668-3574

BankAmerica Corporation
Bonnie Earls-Solari, Director
Art Program #3021
Bank of America
P.O. Box 37000
San Francisco, CA 94137
415-622-3456

Bank of Boston
Lillian Lambrechts, Director
Art Program
100 Federal Street
Boston, MA 02110
617-434-2200

Chase Bank
Stacey Gershon, Associate Curator
Two Chase Plaza, Nineteenth Floor
New York, NY 10081
212-552-7504; fax: 212-552-0695

CIGNA
Melissa E. Hough, Chief Curator
Art Program
Two Liberty Place, TLP07
1601 Chestnut Street
P.O. Box 7716
Philadelphia, PA 19192
215-761-4907

Coca-Cola Co.
Carla D. Olsen, Manager
Fine Art Department
P.O. Drawer 1734
Atlanta, GA 30301
404-676-2121

Donaldson, Lufkin, and Jenrette, Inc.
Margize Howell, Curator
277 Park Avenue
New York, NY 10172
212-892-3000

Equitable Life Assurance Society
Pari Stave, Curator
Fine Art Program
787 Seventh Avenue
New York, NY 10019
212-554-1704

Forbes Magazine
Margaret Kelly Trombly, Director
62 Fifth Avenue
New York, NY 10011
212-620-2389

Hallmark Cards, Inc.
Keith F. Davis, Director
Fine Arts Program
2501 McGee Trafficway
Kansas City, MO 64108
816-274-5111

Microsoft Corporation
Deborah Paine, Art Collection
 Administrator
One Microsoft Way
Redmond, WA 98053
206-936-5029; fax: 206-936-7329
e-mail: *dpaine@microsoft.com*

PepsiCo, Inc.
Katherine Niles, Manager
Art Program
Public Affairs Department
Anderson Hill Road
Purchase, NY 10577
914-253-2900

Pfizer, Inc.
Ingrid Fox, Curator
Art Program
325 East Forty-second Street
New York, NY 10017-5755
212-573-1128

Prudential Insurance Company of
America
Helene Zucker Seeman, Director
Art Program
745 Broad Street
Newark, NJ 07101
973-877-6000

The Reader's Digest Association, Inc.
Marianne Frisch, Curator
Fine Arts Program
Pleasantville, NY 10570
914-238-1000

Safeco Insurance Company
Julie Anderson, Curator
T-8 Safeco Plaza
Seattle, WA 98185
206-545-6100

Joseph E. Seagram and Sons, Inc.
Carla Ash, Curator
375 Park Avenue
New York, NY 10152
212-572-7379

3M Association, Inc.
Charles Helsell, Curator
Fine Arts Program
St. Paul, MN 55144
612-737-3335

For more about corporations with art collections, an ideal guide is *The ARTnews International Directory of Corporate Art Collections,* now in its eighth edition. It provides the artist with a listing on diskettes of over twelve hundred corporate collectors, complete with mailing address, personnel involved with collecting, descriptions of the collections, and current review policies. It can be ordered from:

International Art Alliance
P.O. Box 1608
Largo, FL 34649 USA
813-581-7328; fax: 813-585-6398

The cost is around $110 and worth every cent. Right now, these discs are available only for DOS or Windows, but Macintosh users

and noncomputer users can order a spiral-bound edition at an extra charge. Call for details.

For more on both art consulting and corporate art collecting, there are two excellent books that can help you: *Art for Work* by Marjory Jacobson (Harvard Business School Press, Cambridge, Massachusetts) and *Corporate Art Consulting* by Susan Abbott (Allworth Press, New York City).

■

Art in Public and Semipublic Places

P ublic places, such as churches and synagogues, often have programs that include exhibitions, plays, and concerts. Irene Zweig, an artist from the Washington, DC area, has had two good experiences with synagogues, one near her home and one in the Midwest.

"The Goldman Art Gallery in Rockville, Maryland, is part of a complete and varied community center. They offer senior citizens services, a school, classes in crafts, and many different activities," says Irene. "My husband and I are Jewish but we don't belong to that congregation. I think they would prefer to show Jewish artists, though. They have a regular art gallery, with a full-time director who selects all of the work shown there. They present art exhibitions every month, and the gallery is open regular hours.

"My experience was a good one. They hang the show for you and provide insurance. The area where you show is quite beautiful. Artists pay for the show's postcard, but they will do a bulk mailing for you to their mailing list and yours, too. With the uncertainty of bulk mailings at certain times of the year, you may want to go

THE ARTIST'S GUIDE TO NEW MARKETS

ahead and send cards to those you particularly want to reach by first class mail. The synagogue provided the opening and timed it to coincide with a concert intermission so lots of people got to see both. The two events are usually timed this way and it gives you the chance to meet lots of people who might not get to your event by itself. The work can be about Jewish themes or not. I do abstract, colorful work that relates thematically to quilting. They have a community newspaper at the center and they did a feature article on the show."

Irene's other experience with a synagogue was in Overland Park, Kansas, a suburb of Kansas City. The Art Gallery in the Jewish Community Center is operated in much the same way as the one in Rockville, Maryland.

"My husband is from Kansas," Irene explains, "and I became aware of the gallery on a visit. The art they show is selected by committee. After our visit, I wrote to them and sent slides. It took quite a while, but finally I heard from them and they gave me a show. Again, they had insurance and hung the show for me. That place also has a lovely exhibition space and I had another good experience there. We shared the shipping costs and they also provided for a bulk mailing of exhibition cards. The artist's major expense in both places would be framing and an exhibition card. Also, maybe shipping if you live a great distance from either one."

The Interchurch Center in New York City is a unique nineteen-story office building devoted entirely to not-for-profit agencies. It is located near Columbia University, Barnard, Teachers College, Union Theological Seminary, and Riverside Church. The National Council of Churches, socially committed service organizations, and some administrative offices of Columbia University make up the directory of the Interchurch Center. A full schedule of programs take place on the main floor of this building which includes a four-hundred-seat chapel, a lounge/conference center, an international gift shop, full dining services, and two professional art exhibition spaces—a two-thousand-square-foot gallery and twenty lobby display cases. The Treasure Room Gallery is a square space with a

professional display lighting system similar to that used by the Metropolitan Museum of Art. The corridor cases are a series of large, lighted cases lining the main-floor corridors. Each case is approximately thirty-six inches wide by forty-six inches high. Exhibitions are presented on a four-week rotating basis throughout the year. The Interchurch Center is open to the public on weekdays, 9:00 A.M. to 5:00 P.M., free of charge, and is completely accessible to the handicapped.

Proposals are accepted throughout the year and can be mailed or delivered to the address given below. Applicants are asked to submit materials according to an attached checklist, and group exhibitions are asked to have one person responsible for organizing the proposal. The panel on exhibits meets five times annually to review and select exhibits. There is usually a two-year schedule in place. A $50 installation fee is required upon receipt of the acceptance letter. Artists are also responsible for related exhibition expenses such as publicity and receptions. You may write for an application to:

The Interchurch Center
475 Riverside Drive, Room 253
New York, NY 10115
Attention: Dorothy Cochran, Exhibits Designer, or Rev. Mary McNamara, President

Check around your locality for mixed-use, not-for-profit buildings that might consider such programs as those mentioned here. Every community has similar organizations and they are often housed together with promising exhibition spaces.

The Cathedral of St. John the Divine in New York City (Amsterdam Avenue at West 110th Street) has in the past, provided an art gallery for patrons and visitors. The cathedral is, however, in the midst of receiving a new archbishop, and plans for continuing the gallery are still undecided. Check with the cathedral's business office for the latest information.

Transportation Areas

For people who must travel often, train stations, bus terminals, subway stations, and smaller facilities like bus shelters are part of everyday life. For artists, they are unique, site-specific canvases receptive to creative work that will be seen by many more viewers than have ever graced a gallery. Sometimes the work is permanent, sometimes only temporary while building changes are in progress. Either way, opportunities exist for enterprising artists to make art, get it seen, and maybe even get paid for it!

Most often, the artwork that appears on public transportation sites is solicited and executed under the direction of an agency, such as the New York Metropolitan Transit Authority's Art for Transit or the Metropolitan Boston Transit Authority's Arts on the Line. You may telephone them to get a schedule for works being planned or for seminars on exactly how you should apply. (Once when I called, I reached a technician who helped me with information and sources on ways to greatly enlarge historical photos and have them laminated onto walls so they will be protected from wear and possible vandalism. With his help, I presented a proposal that contained factual information about how I was going to accomplish my plan for large, complicated artwork that I had no experience in making, telling very accurately what my idea would cost.)

Mason Nye is a muralist who often works on a very large scale. I met him as I was passing through Grand Central Station, headed for my day job. There he was, up on a scaffold, painting a temporary shed that had been erected while building construction was going on. What was wonderful, as I looked, was that Mason was painting likenesses from Grand Central's smoke-covered ceiling onto the plywood shed. For those of you who may have never seen Grand Central, the high, arched ceiling four or five floors above you, decorated with images from the stars in the sky—with celestial, mythological beings drawn over them. So, there were bears and goats and warriors and maidens, all flying through the skies, marked by the stars that were positioned to inspire these heavenly creatures. They are outline drawings painted in gold on a bed of blue, neither

cerulean nor azure nor ultramarine, but somewhere in between. And Mason had got them perfectly! If you looked up, you saw the gigantic originals, dimmed from years in a train station. If you looked around, figures from above were translated into fresh, life-sized replicas, that covered construction paneling and made what could have been grim surroundings prophesy what the station would become when it was redone. I wanted to hug him!

Mason has created temporary imagery, which will be destroyed when work on the station is complete. Projects like this are not new to him; in fact, he considers this kind of work a career choice. He says that making art for a specific purpose is a better use of his time than making paintings that must wait until a collector chooses them. A project like this one is one of the different ways to think about your work, making it fulfilling and useful as well.

Temporary murals have been around for a long time. When a part of Rockefeller Center was being converted for a new client, the owners employed a muralist who worked in colors similar to the famous buildings', while behind the plywood facade, real changes occurred. In another manifestation, a temporary interior mural was acquired from a muralist in Spain and re-created, according to his directions, inside a modern skyscraper on the Avenue of the Americas by a local graphics company. An abstract mural of vibrant coloring, the painted walls actually wound around viewers as they passed through the mural site.

If you see construction going up in your area, don't be shy about inquiring if the owners have considered using temporary murals to help create enthusiasm for the project. Try to locate the person who is in charge of media relations and enlist his or her help. You will probably need to create a model or maquette in order to pitch an idea.

Country Clubs, Swim Clubs, Field Clubs

Your area of recreation may not seem very likely as a place to find a market for your art, but read on. Mary Pat Dorr is a native

of Manhattan Beach, California, and besides being an avid photographer, she also has responsibilities as a wife and mother.

When the newly formed Manhattan Beach Country Club began building its clubhouse, it hired Mary Pat to record, with photos, the building as it progressed. Funding ran short before the project was complete, but Mary Pat made a deal with club's building committee. After the clubhouse was finished, Mary Pat installed some of her work in a hallway at the club. "It isn't a huge selling situation at the club," says Mary Pat. "People who go to the club aren't there to buy art–but it's a wonderful opportunity to become known. I get maybe one call a week on the photographs, but I'm also up for a big project with a law firm in downtown L.A. to do all of the artwork in their space–a $35,000 opportunity that came about from showing artwork at the club."

Besides her involvement with the country club, Mary Pat is a volunteer at her kids' school, and that, too, has had an effect on her art career. One of the school's projects to raise funds is an annual house tour called the Sophisticated Snoop. Mary Pat offered to photograph the homes on the tour and ended up loaning some of the home owners art photographs for their empty walls. Of the seventeen pieces she loaned one home owner, fourteen were bought! "Imagine showing my photography to twelve hundred people in two days. There's not a gallery in the world with that kind of traffic." Mary Pat *is* in a gallery, too, but that's not slowing her down as she finds markets for her work. "You really have to understand your work," she says, "before you can find a home for it." She says that she began shooting portraits of families, and now that accounts for about 40 percent of the photography sales. "I advertise in the local paper, always on the same page in the same place, so people know where to find me." She also got into photographing sports events including a ten-kilometer run that is held in Manhattan Beach every year. One of her shots was sold for the following year's program and a large color poster was printed, too. Many runners came up to her after the race to see if she got their picture. Now she does sixteen hundred photos of the race and sells them the same day at

a fair the town holds. "I really think, as an artist, you have to find your market," she says. "Look behind doors, go where others don't go, figure out what you have to do and do it."

Libraries

One of the places where people spend their spare time is the public library. This also means they have time to look at art and to consider buying *your* art. Because libraries are built expecting to need more space as their collections grow, they usually have extra room—room which can hold a temporary exhibition or an audience for an artist's lecture or workshop. A foyer, entrance area, hallway, or mezzanine can be busy enough to be safe for exhibiting, yet quiet enough for contemplation and enjoyment. Many libraries have large glass cases just waiting for an enterprising artist to suggest how they might be used.

Many libraries across the country already have in place artists' exhibitions and lecture series for their patrons. You should check for flyers the next time you go to your library; they'll be near the entrance or by the circulation desk.

Large public libraries, like the New York Public Library, have exhibitions of photography, books, and artwork as well as a full-time staff and a budget to curate them. These shows are reviewed in all of the major papers and draw large audiences. Wherever you live, there will be a library near you. You may have to investigate to find out what opportunities are already available and what you will need to suggest.

Finding the right person to speak to about exhibiting is crucial—and it may not be the librarian. At the Port Washington Library, in Long Island, New York, a committee regularly meets to review proposed exhibitions. This committee made up of friends of the library, plans the calendar of exhibitions months in advance and works independently of the regular library staff.

Don't neglect specialized libraries, such as those at science centers, military installations, museums, or historical societies. Even

where there is no regular exhibition program in existence, special events come up, such as a visit by a famous writer or retired general. These may be a good reason to propose a showing if your work can be tied in with other festivities.

One of the best opportunities may lie at a university or college library. At Rutgers University in New Brunswick, New Jersey, the Mary H. Dana Women Artists Series is a major exhibition program juried every February. Its aim is to help increase the visibility of women artists in the United States, and it is widely supported by companies in the area, such as Johnson & Johnson. The selected artworks are hung in the Mabel Smith Douglass Library, which recently celebrated the program's twenty-fifth anniversary with an elegant catalog and several special events and receptions. For information regarding this series and application deadlines, write to:

Women Artists Series
Mabel Smith Douglass Library
The State University at Rutgers
New Brunswick, NJ 08903

Library exhibitions can be a fine way for artists to be seen and reviewed, making you better known in your local area, which can lead to other opportunities. Most expenses, such as trucking, hanging, and publicity may be yours, but it's still an option worth looking into.

Restaurants

No matter where you may be reading this, there are restaurants nearby. A growing market for art, these eating establishments come in many different shapes and economic levels. The topic of restaurants comes up in lots of conversations throughout this book, so you'll develop an even more complete picture as you continue to read of the part restaurants play in new markets.

Let's start by saying that popular-priced eating places are opening up the fine art market. Nowhere is this more evident than in

the Boston-based chain called Au Bon Pain and it's sister chain in the Midwest called St. Louis Bread. Tony Coleman, vice president of visual communications, says, "When Au Bon Pain started building new restaurants, most of the art was purchased from artists who had already made work that fit into our design scheme. Recently, however, we have been working more from the concept, hiring artists who can create work especially for us. We have been seeing artists' representatives because that way we can review the styles of lots of people at one sitting.

"This work is designed to be appropriate for the look we want to project. In the St. Louis Bread restaurant in Chicago, we worked with several artists and even had their creations turned into wallpaper, completely covering the walls. This kind of store design is becoming more the way large chains are choosing to work now, for chains from The Limited to Starbucks Coffee. For artists who want to work with large chains they might either work through an illustrator's representative or contact the person who is in charge of visual communications and ask to have their portfolio reviewed." (Check out the restaurant commissions mentioned by Sue Turconi in chapter 7, by Debora Meltz in chapter 2, and BJ Peterson's interior design slant to art in restaurants in chapter 4.)

Art and Food

Artists are already aware of the conflict inherent in having art and food in the same space. Be sure that your art is well protected by hanging it high enough above the tables to avoid the accidents that will inevitably happen. Cover the works' surfaces with acetate or glass to avoid food stains. If you are putting your work into a restaurant on consignment, you may not be able to get them to insure it, in which case, explore a floater policy or a rider on your home insurance plan.

Framing Shops

In my neighborhood, there is a frame shop whose widows always tastefully display black-and-white photographs with elegant black frames. The owner is John Esty and his custom framing shop at 636 Hudson Street, New York City, is one of the most attractive framing establishments you are likely to see. We talked about how his window exhibitions came into being.

PH: John, what happens first—do you get work that you find attractive into the shop to frame, or do you have some frames that you want to show off and you look for work to put in it?

JE: What happens is that there are lots of photographers in my life now that aren't represented in galleries. They need a venue for showing their work. They sell a lot here. The way it works is, whatever a photographer wants for the work is what the work sells for. I don't take a commission.

The buyer can purchase the work framed or unframed. We are selling about five pieces a week from the photographs in the window. The buyer purchases a print of the photograph in the window. I am interested in all kinds of work. The problem is that beginning artists come in with the prices of a known artist. They want $1,000 for a print. The pieces that are selling here range between $100 and $300 a print.

PH: Do you find that there is a limit to what the people in this neighborhood will pay?

JE: Not really. If they like it, they say great, I'll take it.

PH: Have you seen the connection between people buying the work and then having it framed here?

JE: Definitely.

PH: Who are you showing now?

JE: Two women, Barbara Perrino and Kathy Kennedy. Besides the work in the window, they brought me portfolios of more of their work to show in case a would-be buyer is interested.

PH: So then, even though there are only four pieces on view, there are more for people who show an interest. Do you use mostly one size of artwork?

JE: Yes and no, it depends on the work. I find that in America, in retail shops, the philosophy is that more is more. To me, less is more, and more is more is way too much. I'm concerned that the shop is comfortable and that the work has room to be effective.

PH: You have very beautiful iron easels for the work in the windows. Were they made for the shop?

JE: Yes, and the large easel in the store, as well.

PH: Are you going to concentrate on photographers?

JE: No, other media would be great. I'm looking for sculptors, painters. But I just haven't found artists with work that is as sophisticated as the photographs I've been showing. The size and everything else has to do with my taste.

PH: Artists who might consider a framing shop for an alternative exhibition space will find that it's very important for them to consider what kind of shop it is—that there is room for their work to be shown properly, well lighted, etc.

JE: Yes, definitely. There has to be a real rapport between the artist and the framer for exhibiting to come off well. I found with certain artists that their work would sell well, and when I'd sell it and need

more, they would promise to bring more work and then never show up. Artists have to be ready to go into a retail situation before they actually go.

PH: And yet, artists cry about the deplorable state of the art world, when, in fact, they may be bringing some of it on themselves. A good idea of what is expected of them is part of what makes the whole thing work. Is this your first shop or did you have one before?

JE: This is my first. Initially, I was looking for a loft.

PH: Did you bring a lot of business with you?

JE: Yes. I had been working for galleries and museums for about fifteen years. Also, corporate accounts, designers, architects.

PH: John, you've given us a lot to think about.

From the interview above, you may have been able to gain two or three important ideas about your art and the possibility of showing it in frame shops. Keep in mind that:
- The size of the shop is itself important. If your work is too large to fit in and be shown comfortably, look for another venue for your work.
- Your price should be realistic. The $100 to $300 range John mentioned can be met by approximately five buyers per week. That represents $500 to $1,500 per week. This amount may be easier for photographers and printmakers to factor into their output than painters who may work much more slowly.
- The artists discussed here also provided John with portfolios. The work in the portfolios may have been more expensive than the work exhibited in the windows. Hence, although most of your work may be more expensive, the window pieces can act as what the garment trade would call a "loss leader" to entice sales of the more-expensive work in the portfolios.

- Artists have to be ready to go into a retail situation. This means following up regularly and not suddenly disappearing right when the merchant needs more of your work.

Another idea involving a chain of framing shops is called Art Faire. Each year Aaron Brothers frame shops in southern California sponsors Art Faire. The company invites twenty artists to showcase and sell their work during a five-week event in ten of its best store locations. Entry is by slides of work and all work shown must be for sale. The artist is asked to provide a description sheet for each slide submitted as well as an artist's statement. Artists are advised to be prepared to exhibit thirty pieces of unframed work, which will be displayed on easels in a prominent area of the store. Works that are sold will be rung up at the store's register and a check sent to the artist. Aaron Brothers takes a 10 percent commission on any work sold.

The timing of Art Faire varies each year, but inquiries can be made by calling 213-725-6226. Slides should be submitted to:

Aaron Brothers, Inc.
1270 South Goodrich Boulevard
City of Commerce, CA 90022
Attention: Jenny Davidson, Special Events Coordinator

Finding markets within businesses that already exist is a smart way to work for several reasons. There is usually an existing site for the business, with a phone number and someone there to answer it and take messages for you. In the case of art fairs, advertising is widespread and much of it, free to you. Crowds of potential buyers are provided, and if you are embarking on showing work for the first time, you can watch others who are more experienced.

Be sure whatever the market, that your business/calling cards are complete and up-to-date. Buyers often need time to think over a potential purchase and will need to reach you once the fair or exhibition has ended.

Chambers of Commerce

Stanley Hura (my pal from design school) says that people in smaller locales shouldn't forget the local chambers of commerce. "When I go to a new town to work, I just call the chamber of commerce to ask for artists. The result can be good or bad, but I think any artist should send the chamber a packet of slides. In fact, I'm sure they get calls like mine all the time." The Greenwich Village Chamber of Commerce and the Society for Historic Preservation sponsors the Greenwich Village Heritage Festival, with tents along a main street featuring arts and crafts, poetry readings, and food supplied by local food merchants and restaurateurs. If your town doesn't have such events, then maybe it's time you brought up the possibility. These are the kinds of activities you should urge local chambers of commerce and historic organizations to sponsor to create business that benefits everyone. By including genuine artists, craftspeople, and musicians from the community, the organizers can succeed in setting a high standard for street events in your town.

Cruise Ships

Almost all vacation or cruise ships have art auctions on board and they are well-attended events. On an average ten-day cruise, about seventy pieces per day will be sold. The unfortunate side of this for artists is that these are almost all offset prints. Very little original artwork is offered. However, officials who operate art auctions on Royal Caribbean, Princess, Celebrity, and Crystal lines told me they look for artists whose work will reproduce well, so this may be a market where you could prosper.

The system works like this: The cruise line first buys original artwork and tests it out on a cruise. If it is well received, the cruise line will then sign a contract with the artist that allows them to make prints of the work for sale. It is important to understand that selling the original artwork does *not* mean that piece can be reproduced for sale. A separate contract must be signed giving them the right to print *and sell* editions of your original. Also, it is a one-time sale

and there are no royalties involved. Cruise lines rarely buy already printed limited editions because the quantities are usually too small for their use. However, when the lines buy from an artist, they come back often and buy originals repeatedly.

Typically, cruise lines find artists at expos. Another approach is to send them slides with an SASE. One art auction company where you can send slides is:

Park West Gallery
29469 Northwestern
Southfield, MI 48034
800-521-9654

Outdoor Art Fairs and Indoor Expos

F airs in this country have a long tradition as an opportunity for artists and craftspeople to offer their wares to the public. I think everyone loves going to a fair, whether it's a one-day festival in a small town or a five-day, blocks-long phenomenon in a major city. Let's take a minute to think about how fairs might make an artist's selling job a little easier.

For one thing, people come to a fair with money, already half thinking that they might find something they absolutely must have. The temporariness of the fair makes decisions occur faster. Better decide now before it's gone forever! While they might only tuck $20 into their pocket, most people carry a credit card or checkbook that they can use for anything more expensive. All of this works in the artist's favor. Then, there's the romance of a fair—finding the unexpected, the one of a kind—which is so unlike most people's daily lives, where uniformity is sought, even expected. It's a venue where the uniqueness that artists are blessed with can really shine.

Fine art is often sold at these occasions, and at fine art prices.

Happily, the best information for artists regarding the nation's art and craft fairs is readily available from *Sunshine Artist* magazine, a Florida publication. *Sunshine Artist* is published twelve times a year and should be on a newsstand near you. (If not, call 800-597-2573.) One of the best features of *Sunshine Artist* is its state critics section, which reviews the fairs near you. The critic for each geographic area discusses how well the fair was promoted, how the artists were treated, attendance versus the last year, and other helpful information. All of this can help you decide if a fair is for you and which one you'll try. Each year, the September issue of *Sunshine Artist* rates the fairs and names the two hundred best based on a vote by its subscribers. A *Sunshine Artist* "one of the two hundred best" is an accolade that all of the fairs covet. Another great thing about this magazine is the advertising! All of the equipment you will need to put up and sell your work is described. By the time you have studied one issue, you'll know lots more about fairs and what to expect when you enter your first one.

Some of the largest fairs in the United States are listed below, along with an address and telephone number. Dates change from year to year, so call or write for the latest information.

Sausalito, California
Sausalito Art Festival
Sausalito Chamber of Commerce
P.O. Box 566
Sausalito, CA 94966
415-332-3555

Denver, Colorado
Cherry Creek Arts Festival
P.O. Box 6265
Denver, CO 80206
303-355-2787

Boca Raton, Florida
The Boca Raton Museum Art
 Festival
Boca Raton Museum of Art
801 West Palmetto Park Road
Boca Raton, FL 33486
407-392-2500

South Miami, Florida
South Miami Art Festival
6410 Southwest Eightieth Street
South Miami, FL 33143
305-661-1621

Atlanta, Georgia

Arts Festival of Atlanta
999 Peachtree Street NE, Suite 140
Atlanta, GA 30309
404-885-1125

Stone Mountain, Georgia

Yellow Daisy Festival
Stone Mountain Park
P.O. Box 778
Stone Mountain, GA 30306
770-879-5569

Louisville, Kentucky

St. James Court Art Show
St. James Court Association
P.O. Box 3804
Louisville, KY 40208
502-635-1842

Ann Arbor, Michigan

Actually three fairs within walking distance of each other, this event deserves to be seen before you decide where to send admission entries. A reporter at the *Ann Arbor News* described differences in the fairs: "The Street Art Fair seems to have more fine art, while the Summer Art Fair generally features crafts and more affordable fine art. The third fair, the State Street Art Fair, acts as a bridge both geographically and conceptually between the other two fairs." You really can't go wrong, whichever one you choose, since all three are at the same time and claim a combined attendance of five hundred thousand visitors, who tend to move among the three fairs.

Ann Arbor State Street Area Art Fair
State Street Art Association
P.O. Box 4128
Ann Arbor, MI 48106
313-663-6511

Ann Arbor Street Art Fair, Inc.
P.O. Box 1352
Ann Arbor, MI 48106
313-994-5260

Ann Arbor Summer Art Fair
Michigan Guild of Artists and
 Artisans
18 North Fourth Avenue
Ann Arbor, MI 48104-1402
313-662-3382

Rochester, Michigan

Art and Apples Festival
Paint Creek Center for the Arts
407 Pine Street
Rochester, MI 48307
248-651-4110

Minneapolis, Minnesota
Uptown Art Fair
Uptown Association
1455 West Lake Street
Minneapolis, MN 55408
612-823-4581

Kansas City, Missouri
Plaza Art Fair
Plaza Association
450 Ward Parkway
Kansas City, MO 64112
816-753-0100

Albuquerque, New Mexico
Southwest Arts Festival
Arts and Crafts Festival
525 San Pedro NE, Suite 107
Albuquerque, NM 87108
505-262-2448

Rochester, New York
Corn Hill Arts Festival
Corn Hill Neighbors Association
133 South Fitzhugh Street
Rochester, NY 14608
716-262-3142

Cleveland Heights, Ohio
Cain Park Arts Festival
City of Cleveland Heights
40 Severance Circle
Cleveland Heights, OH 44118
216-360-9221

Lancaster, Pennsylvania
Long's Park Art and Craft Festival
Long's Park Amphitheater
 Foundation
P.O. Box 1553
Lancaster, PA 17608-1553
717-295-7054

Pittsburgh, Pennsylvania
A Fair in the Park
Craftsmen's Guild of Pittsburgh
340 Bigbee Street, #2
Pittsburgh, PA 15211
412-431-6270

State College, Pennsylvania
Central Pennsylvania Festival of the
 Arts
P.O. Box 1023
State College, PA 16804-1023
814-237-3682

Wickford, Rhode Island
Wickford Art Festival
Wickford Art Association
36 Beach Street
Wickford, RI 02852
401-392-0227

Park City, Utah
Park City Art Festival
Kimball Art Center
P.O. Box 1478
Park City, UT 84060
801-649-8882

Bellevue, Washington
Rest of the Best Festival
Craft Cooperative of the Northwest
1916 Pike Place, Suite 146
Seattle, WA 98101-1013
206-363-2048

Madison, Wisconsin
Art Fair on the Square
Madison Art Center
211 State Street
Madison, WI 53703
608-257-0158

These fairs pride themselves on their longevity: most are in their third or fourth decade, two in their fifth, and one is over sixty years old! You can check *Sunshine Artist* for how many return exhibitors are expected and how many applications to show were received last year. This is a big help in estimating your chances for getting in.

Fairs start planning far in advance, with jurying taking place very early. Many fairs will want to see a photo of your display equipment along with slides of your work. You will probably need to plan at least a year ahead of your first fair date.

Sue Turconi is a five-year veteran of outdoor art fairs who lives in Venice, Florida. Sue is an art teacher in a local college, but on weekends she has what she calls "an Outward Bound experience" with art fairs. (Outward Bound is an outdoor camping and "roughing it" experience, and I soon saw why Sue made the comparison!) Sue started participating in art fairs in New Jersey when she lived there.

"At first, I didn't spend money buying display materials, because I wasn't sure I would keep doing art fairs," Sue explains. "I looked at other artists' display items, and since I'm good with my hands, I built my own first set. It cost me $75. I also bought a tarp. Later, I sold that setup and bought another one. You never know how the weather will turn out, and sometimes it's pretty rough. I got a tent with the display stuff for $1,000. Other artists might have a more expensive outlay, though. For instance, potters might need more sophisticated display setups and jewelers would need glass cases that lock.

"I soon discovered that what would sell in the Northeast, wouldn't sell at the fairs in the Midwest or Southeast. I'm a multi-

media artist, with painting, photography and printmaking in my art. Most of my prints are monoprints, so everything is an original work. When I started out, I learned a lot from *Sunshine Artist* magazine. I've done fairs in Milwaukee, Atlanta, Tampa, and Winter Park. Also in Short Hills, Summit, and Hackensack, New Jersey. My favorite fair is in Winter Park, Florida. I know exactly who my customers are—they are twentysomething or early thirties, married, but don't have children yet. They are still fixing up their homes and have disposable income.

"My works range in price from $40 to $3,000, but my best sellers are between $100 and $300. I take a portfolio of work with me. Sometimes, artists will get commissions from showing a portfolio, including work for restaurants. I've done works on canvas, also works on paper, which I mat and offer with a frame and glass. These seem to sell better and I think it's because they are more packaged. A student told me once that she thinks these do better at art fairs because we're a packaged society. Unfortunate, but probably true.

"When I first go to a fair, I like to arrive the day before it will open, so I can check out the town and see if the fair has been publicized. You get what is called an artist's packet, which has all of the rules for the show. It indicates where your space is, and sometimes you can set up your tent the night before the show opens. In Milwaukee, they set up three big tents, like circus tents, so you don't have to think about using your own."

Sue likes to do the demonstrations that art fairs often sponsor for customers. The fair's promoters invite certain artists to give a demonstration, pay them (usually $100), and provide a volunteer to sit in the artist's booth during the demo. Sue says you usually get a sale out of the demonstration at the end. "That's because people love to see how an artist works. The fee that you're paid will cover your rental on a space. Also, from these demonstrations, I've been invited to do workshops, which is more income."

Sue's work incorporates both representational and abstract elements. "If you're competing for prize money, though, realism is probably better," Sue says. Why compete? Certainly, for the funds—

Sue said that some competitions offer as much as $1,500–but also because winners are automatically included in next year's fair without having to go through the jurying process. At some fairs this inclusion is for three years.

Artists get to know each other on the art fair circuit, Sue says, and the fairs' promoters often sponsor a party for the artists on the final night. "We sit around and compare motels in various places where we've shown. We're usually so tired though, from setting up and working all day and then taking everything down, that we don't party that much."

What does she usually make in a weekend sale? "Totally unpredictable," Sue says. Does she work with a partner? "Nope, all by myself."

Sue still goes to New York to see what's happening in SoHo and to visit the museums. For a while, she was in a gallery in New Jersey and not long ago the director asked her to bring several small artworks back to the gallery. Sue declined, pointing out nicely but firmly that she didn't see why she would want to pay a commission on works she could sell herself. "Thanks," she said, "I'll just keep selling my stuff on my own."

Several artists who also do outdoor fairs had differing points of view. Some types of artists seemed to do better than others, so maybe it's worth trying to figure out why. One artist from Ontario has been coming to a New York fair for thirteen years. "Some years were more profitable than others," he said. This year, he pointed out, the fair officials had allowed the sale of mass-produced prints very cheaply, which made his artwork a harder sell. "People come to me with these prints for which they paid $6 and they are fairly large works," he said. "How can I compete when my little works (approximately 6 inches square) have to sell for $50?"

Another artist told me that she actually had less time to create new work when she was on the road doing several fairs. She warns other artists to beware of thinking that a lot of money can be made quickly. "Say you make $1,000 from a fair. That sounds great, but if you figure that the booth fee was $250 and then you had to pay

for a hotel and expenses, you may walk away with $450." Other elements can have an effect, too. "For every fair where you do well, the next three fairs will be rained out or have a competing sports event on TV or maybe the promoters didn't advertise the right way, so your overall average isn't that hot." This artist has been doing fairs for twenty-five years and, to her credit, has managed to make her living from sales of her work.

Art fairs have pros and cons that both deserve to be considered. "To be fair," she said, "you make a lot of friends at the fairs, and I have had return business from one year to the next. The artists I meet are great, too, and I get to catch up with everybody's family doings and so forth. It would be easier to do this with a husband or wife to help you, but I do it alone."

One of the artists who does particularly well at art fairs is a painter of pets who can get enough business from a fair to keep her busy for several months. She has an attractive brochure to hand out along with a price list for different types of work. She offers oil paintings, pen and ink sketches, and note cards, which she says cover her booth expenses. She also gets return business as the owners' pet families grow. A sketcher of people's homes might also do well, as this seems to be a purchase people can decide to make later, after the fair, when your brochure is still with them. (For more on this idea, see chapter 12.)

The Blair County Arts Foundation in Altoona, Pennsylvania, has another outdoor-fair opportunity that artists might want to consider. The foundation's annual fair is held on Pennsylvania State University's Altoona campus, and is a typical example of local support for the arts. Fine art as well as a craft market, demonstrations, performing arts, and children's activities are featured, with the fine art being juried by three professors from Carnegie-Mellon University in Pittsburgh. Check with your state, county, or municipality to locate opportunities like this near you. This is a good way to gain name recognition and a local constituency as well as make connections with nationally known art institutions, which may later lead to exhibiting in university museums.

Closer to home, you may want to look into group studio visits, which involve other artists in your town or neighborhood. As afternoon walking events, these can appeal to families and are best planned for the seasons of spring or fall. As a market, they are guaranteed to be stress free and will probably present better opportunities for sales of small art purchases, while opening the door to more significant purchases later. Business cards are a must here, since they can be carried away and referred to later.

I've just received an invitation to such an event from another artist who was in our bank show (see chapter 12). He has a studio in Brooklyn but spends much of his time upstate in Hudson, a small town in Columbia County. From this flier, it looks as if the whole town has gotten involved in what is being called the Hudson Arts Walk. Occurring on a Saturday from 12:00 P.M. to 4:30 P.M., it includes chamber music performances by groups of two, three, and four musicians along main streets and within a hotel and church. A map guides visitors to the artists' open studios—there are fifteen in this event—and also group exhibitions at fourteen other sites, including galleries, antique stores, an Amtrak station, community gallery, a hotel, and a hospital. A children's art and crafts tent, set up at the corner of two intersecting streets, offers mixed-media construction (puppets, toys, and sculpture), portrait painting, clock making, and sidewalk pastel drawing. A trolley provides free transportation to all of the art and music sites. Within larger cities, this kind of event has been staged successfully in artists' neighborhoods—such as SoHo's Ten Downtown Festival a few years ago—making this a good way to create a feeling of cultural vitality and introduce artists to their neighbors for urban or country dwellers alike.

Art in a Barn

Not long ago, I heard about an enterprising art lover in Potomac, Maryland, who realized the plight of Washington, DC-area artists without gallery connections for selling their work. She bought an old barn, left the straw intact for atmosphere, and hung white sheets

on the walls where artists could hang their art. Being well connected in Washington, she passed the word that on Sundays she would be having a "salon" for art lovers. She even baked brownies. From what I have been told, the place is packed, with all her friends coming to buy art and meet the artists. Maybe you have a friend with a barn?

Indoor Art Fairs

Artist Nancy Egol Nikkal recently participated in ARTexpo–at the Jacob Javits Convention Center in New York City. She talked about her approach to the massive art event for this book:

"I went into it looking for representation outside New York City. I knew from visiting an ARTexpo the year before, that the location of your booth is extremely important. I think it was good that all booths were at least ten feet square, as the smaller booths in earlier years didn't seem to do as well as the ten-foot ones.

"The fair's advisors tell you to come with one large major piece of artwork to anchor down the feeling of the booth. Mine was almost six feet long. It went across the back. I also had a closet built and planned to bring out work a little at a time. You'll need more work than you think you do. Otherwise, it looks sparse. I had twenty pieces framed for the fair, as well as having work shrink-wrapped. I did a catalog, with eighteen color reproductions. I gave them out judiciously to dealers and prospective buyers. I figured out that they cost me $3 each.

"I am from New Jersey and I also wanted to build a local patron base. At the fair I met people who lived nearby and wanted to come to my studio. Most of my contacts were with representatives and dealers from outside New York. I sold only wholesale–to galleries and reps. My work isn't good for reproduction, although other artists I spoke to got offers from companies who wanted to buy and then reproduce their work. The artist in the booth across from me had come from St. Louis. She was approached by furniture companies from North Carolina that do model rooms for their furniture and wanted to decorate with her work. The best part for me

was approaching people and getting information from them. I was good at that and I didn't think I'd be."

"There was a lot of preliminary work involved. I had to register to pay New York sales taxes, but since I didn't sell anything retail, I didn't owe any tax. You have to complete sales forms whenever you sell something. You could use a regular sales book, but I had NCR forms designed for me with triplicate pages. Then, the expo had booth design advisors and I worked with them. It was very helpful and they told me what furniture I'd need. They recommended a table with a skirt for storing things behind. That proved to be very necessary over the life of the fair. I also made an inventory list for myself. Fair officials do not allow you to have any prices showing, so you must mark them on the back or keep it on a list. ARTexpo also requires you to get insurance. You can get a rider to your homeowner's policy, which, I think, turned out to be the best deal financially.

"The show's planners offered to sell a mailing list of prospective ARTexpo attendees, but I didn't buy that. I did make a card and sent it out to about three hundred people from my own list. ARTexpo also gave twenty-five free passes to give out to your best trade customers. I didn't make the best use of those, because by the time I got them, I was too involved with the show. However, looking back, I'll make better use of them next time. Also, discount admission tickets were given to exhibitors to give away."

I asked if, all in all, she had made her investment back? Was it worth it?

"It was definitely worth it and I did make my expenses back plus some more besides. All of the artists I spoke with felt it was worthwhile. It *is* expensive. The ten-by-ten booth with lights was $4,000. The catalog was almost $6,000, but I designed it to be used for sending out after the show, so I'll be able to get use out of it for some time. I think artists know that you have to invest in some things, and a show like this can do a lot for your career. I got several commissions. I got representation in a wonderful gallery in Singapore. I also got some very good representation from around the United

States and signed good contracts with them. I did *not* get New York galleries, but there are lots of other places to sell art."

Would she do it again?

"Yes, there are several other big art shows around the country that I'm also interested in, though I think it's important to watch them first to see that they're well run. If they aren't, you could really lose on the investment."

For future show dates of ARTexpos, contact:

Advanstar
7500 Old Oak Boulevard
Cleveland, OH 44130
216-826-2885

Giving Art to Charitable Causes

Not long ago, my local public television station was holding yet another fund-raiser for what is certainly a good cause—its continued existence. The station was auctioning items, which included artwork that had been donated by various artists. That started me thinking about fund-raising and art.

There are lots of reasons why artists should and do contribute their art to charitable causes. From saving the whales to public television, we all have causes that are dear to us and deserve our support. Many times it is easier for us, as artists, to contribute artwork rather than funds to the causes in which we believe.

Often, however, we are hesitant to contribute because we are unsure of the tax effects of contributing art to a charitable cause. The Internal Revenue Service rulings on donations are sometimes difficult to interpret and apply to your own situation. For example, if you attend the event to which you have donated a piece of artwork, your status in the eyes of the IRS may be affected because you are being entertained. The rules can be daunting, even if you have the best intentions in the world. With all of the possible roadblocks, however, contributing is still a good idea. If you have questions concerning the tax implications of contributing artwork to

charity, call the IRS at 800-829-3676 and ask for publications 526, 551, and 561. These will help you to understand what constitutes a charitable (nonprofit) organization and how to determine the value of an artwork.

Beyond the obvious goodwill of helping the charitable cause, and the good feeling it gives you inside, there are other benefits which the artist may reap as a result of making charitable contributions. Among these are beefing up your mailing list and meeting new contacts who have the income and the interest to collect your work in the future. A third benefit is free publicity, a fact not lost to gallery owners, who often encourage new artists in their gallery to get added exposure by contributing to charitable events.

Last year a nonprofit artists' group to which I belong held a benefit art raffle as a fund-raiser. The group invited two hundred artists to contribute one artwork each to an event that took place one evening in a gallery. Tickets to the event were $200 each and only two hundred tickets were offered for sale. Wine and cheese were served, and the artwork was well exhibited and lighted.

The benefit auction worked like this: each piece had a number and the artist's name. Before the auction began, attendees were invited to roam among the artworks, which were exhibited attractively on the gallery walls, making a short list of five or ten works they would like to own. As the auction began, the attendees' names were drawn one at a time from a hat. The attendee who was drawn first was invited to select the piece of art that he or she liked best, and it was his or hers. If your name was chosen, you would have to select an artwork quickly.

The possibility for artists to gain the attention of future collectors definitely existed. Since there were the same number of attendees as artworks, everyone received a piece of art as a prize. The process of selecting art to own—with no price tag attached—was very different from viewing art in a gallery. At least one artist reported a studio visit and sale from a collector who had wanted, but had been beaten out of, her artwork.

If you're one of those artists who complain of not knowing any

collectors to whom you can sell your work, this kind of event is the perfect place to meet them. If you belong to a nonprofit artists' group, you'll be amazed by the goodwill and support you will receive from the community's commercial galleries.

The artists' group that sponsored this event had given the artists special name tags that identified them as artists. Mingling with, and being introduced to collectors all evening, gave each group a better understanding of what the other one looked like. There are many collectors who like to know the artist whose work they collect. Of course, the artists who had thought ahead came equipped with business cards and produced them with an invitation to "drop by the studio sometime." It was certainly an opportunity to take advantage of the spirit of the evening.

Another thought: this was not the time to offer a minor or underdeveloped work of art. Artists who gave more important or larger, more colorful works were favored in hanging location, as might have been expected. One artist made a major donation of a new piece and was favored by having it displayed opposite the elevator, the first work of art visible as everyone entered the gallery. This piece was among the first few to be chosen when the auction started.

For the shyer artist, there was at least the opportunity to watch other artists as they "worked the crowd." In short, everyone had something to gain.

Many artists had obviously thought through the event carefully and had guaranteed the choosing of their work by "preselling" it to people who already were collectors of their art. By selling event tickets to these supporters, they were assured that their work would be chosen early and find a home. Obviously, this is a way to ensure that your work won't be left alone on a gallery wall as the evening progresses. The only drawback possible here is that a collector might get a piece for the price of the ticket, eliminating any sale benefit for the artist. One hears of such an instance now and then, but it did not seem to be a deterrent to the artists I observed.

Approximately 20 percent of the artwork had been solicited from

"name" artists. I would have expected this work to go first, once the auction started. However, this was not the case. In fact, there seemed to be greater interest in the work of emerging artists, where instinct among the gallery owners who attended (and there were lots, which is a whole other reason to participate!) promised some new names would soon be showing up on gallery walls. Another benefit was that the event was put on in a gallery that was for rent in a prestigious art building. The works were exhibited for a week before the auction. Emerging artists gained a good résumé credit for a show at a known address.

As the total membership in our nonprofit group is close to fifteen hundred artists, the two hundred artists for this event had been preselected (from their slides in the slide file) by an outside curator. Next year, a different group of artists will be invited, to assure fairness.

Go ahead, give a piece of your art for a good cause–and get some unexpected but delightful results!

■

New Government Opportunities

ecent controversies involving the National Endowment for the Arts (NEA) have caused Congress to reduce the NEA's operating and funding budgets by 40 percent. Many artists naturally assume, therefore, that federal and state governments are currently unsympathetic to all art and all artists. While it is true that many art programs, such as the touring exhibitions that the U.S. Information Agency sponsored, are no more, I suggest that you owe it to yourself to read on.

Did you know, for instance, that NASA has an art program? Or that the Smithsonian Associates commission artists every year? That you can go and live in the National Parks and make art? That art collections at the Federal Reserve Bank Headquarters, the U.S. Navy, and the U.S. Marine Corps are alive and well? That art programs exist at the U.S. Air Force, the U.S. Army, the National Academy of Sciences, and the Department of the Treasury?

Both federal and state governments offer opportunities for artists to show their work in the public spaces that abound in their offices. In many cases, it is merely a matter of figuring out whose

permission to get or where a showing of your work might prove most advantageous. (Note, however, that to qualify for most government art programs, artists need to be citizens of the United States.)

Many artists think that their state art councils can do very little for individuals, but look closer. Often these organizations are invited to mount exhibits in community centers that get lots of traffic and give the artists showing there high visibility. By becoming an artist member of arts councils in your city and state, you may receive exhibit information months before it reaches other artists. At the end of this chapter you will find the address and phone number for your state arts agency. Give the agency a call, offer some volunteer time, and ask the people there how you can work with them. Get on the mailing list. Put yourself into a network that's helpful and beneficial as a career builder. By working with art groups, even on a volunteer basis, you will see flyers, hear news of opportunities, and become your own walking advertisement. With funding cuts and budget trimming, these groups will appreciate your participation and helpfulness and repay you with information that can help you make career decisions.

Another way to broaden your audience is by participating in slide registries (which are described in greater detail in chapter 11). Slide registries are operated by arts organizations and artists' groups to offer curators a chance to view the work of local artists. Many will welcome including your slides, sometimes for a small fee. They are a wonderful opportunity to have your work shown often, and it would be foolish not to take advantage of any slide registries in which you could be included. Make a list of where these are in your locality, and make it your business to stop by every few months to refresh your slides, put an updated résumé in your file, and chat with the person who runs the registry. Ask questions, such as who's been using the registry lately, which artists' slides are getting the most attention, and what future art events the organization is planning.

Working with Local Government

For good examples that you can apply to your own situation, I went to the offices of New York State Senator Catherine Abate. She is typical of the elected officials in state government who can help you to exhibit your artwork. She and her staff recently sent out invitations to constituents to attend an evening of art at her New York City office. The staff had created a theme exhibition around the district she serves, showcasing its diversity and vibrancy. Works by six artists, selected from slides at a nonprofit slide registry, were on view. The opening was attended by about one hundred guests, wine and cheese were served, and a jazz group entertained. The event received good press coverage and art was sold. There are several reasons why it would be a good idea to try this in your senator's home district.

For example, it would be a chance to meet people, including elected officials, who may later be able to offer your pet project their support or endorse you to places where you need a reference. Other reasons are that it would help you to gain names for your mailing list (you're always complaining that you don't know people to whom you can sell your work—the senator can deliver them for you!), earn an exhibition credit to put on your résumé, and take advantage of press coverage (your name may not get a reporter to the event, but the senator's will!). Regardless of where you live, officials would be interested in such a project because on a symbolic level it gives them a chance to say publicly, "We're behind you and we support the arts."

For more information at the state level, contact the main "league of arts" type organization in your state capital. Ask if it has a directory of arts groups in the "capital region." I found such a volume in my state, called the *Capital Region Arts Directory*. I suggest that you make it a project to familiarize yourself with those organizations that hold exhibitions in the capital city and may make calls for proposals.

Here's another idea for state-level involvement: find out who is the director of your state art collection. The "collection" may con-

sist only of portraits of former governors, but this is still a good person to know. Every state has someone who mounts exhibits in the capitol and other public buildings, gives art tours to visiting dignitaries, and maintains artwork that has been donated or bequeathed to the state. This person might not be part of the state arts agencies with which you are familiar. Try calling your state capital city and asking for the state government phone number. That would be the switchboard through which state senators' offices can be reached. Then ask for "the curator's office" or the "state historian's office." You'll have to do a little sniffing around, but eventually you'll hit on the right person, I'm sure.

Dennis Anderson is that person in New York State, and his title is Director of the Empire State Art Collection. He told me how his office works: "We do have one- and two-day festivals on the Capitol Complex grounds, but it is hard to provide adequate protection for the collection. This collection is made up of ninety-two works, which were acquired between 1962 and 1970, and includes paintings, sculpture, and tapestries." He also gives tours, speaks on public panels, and sends out calls for proposals for new art, such as an Adam Clayton Powell Memorial to be erected in Manhattan.

Where might such calls for proposals be seen? Of the several places Mr. Anderson mentioned, nonprofit art publications are probably the easiest for artists to find. (Another good reason to subscribe to newsletters! See chapter 11.) Artists should also scout out the *Contract Reporter*, a monthly announcement of all state contracts to be given out. A copy of this paperback should be available in your local public library. It will give the exact details that the state will require on a proposal and the date when it will be due. Part of identifying new markets involves watching out for new projects and then completing proposals that can win them for you!

Back at the federal level, here are programs that are currently in operation.

The State Department

Art in Embassies Program
U.S. Department of State
Room B-258
Washington, DC 20520-0258

The Art in Embassies Program borrows art from galleries, museums, and artists for a three-year period to place in our embassies around the world. Artists who loan work get a fine credit for their résumés and wonderful contacts for their careers. Artists have made contacts and sold work as a result of showing their art through this program. Dawn Zimmerman of the State Department works with ambassadors and their spouses to select works that will become part of the household for the ambassadors, who often live far away from anything that looks American. Three full-time curators make appointments with new ambassadors and spouses to be sure that the art sent to the embassy will be in a style that they like and are comfortable with. "All arrangements for packing and shipping the art are taken care of through the State Department," says Zimmerman. "Either someone from the staff travels with the art, or arrangements are made by our embassy in the host country for experts there to hang the work in a professional manner."

Zimmerman says as people give or bequeath art to the State Department, it is always acquiring more art. Only about 10 percent of the collection belongs to the State Department; 90 percent is on loan. The State Department also takes care of restoring loaned works, if necessary, and cleaning them before they are returned. I asked Zimmerman whether the office ever visits artists' studios or alternative spaces in search of the right piece of art. She responded, "Yes, absolutely. When an artist who is being considered lives in the area, we go to see them with our ambassador or the spouse. If something new is requested, we go to the alternative spaces in this area."

THE ARTIST'S GUIDE TO NEW MARKETS

The Art Bank

The Art Bank
U.S. Department of State
2201 C Street, NW
Washington, DC 20520-0258
Lisa Kuhn, Director

The Art Bank program manages the Department of State's domestic fine arts program, which exhibits a collection of contemporary American art in offices of the department and its annexes, the U.S. Arms Control and Disarmament Agency (ACDA), and the U.S. Agency for International Development (AID).

The Art Bank began as a pilot project in 1983 with five bureaus and has grown to twenty-eight participating bureaus with more than one thousand artworks in the collection. The artworks are on exhibit in the offices of the department officials, reception areas, conference rooms, cafeterias, and snack bars.

The collection consists of works on paper by twentieth-century American artists and includes original works on paper (watercolors, woodcuts, and pastels) and limited-edition prints (lithographs, woodcuts, intaglios, and silk screens). The artworks span a broad range of styles, subject matter, and techniques. The artists, from the lesser known to the well established, represent every geographic region of the United States.

A bureau or office interested in subscribing to the Art Bank program contributes money to a common fund for the purchase and framing of the art. When a member bureau desires new art or wishes to exchange the art currently in its offices, a staff member may make new selections from the Art Bank's inventory, without additional costs to the bureau.

The Art Bank program supports the department's mission by promoting cultural diplomacy with the many foreign visitors to the department. Art is a natural means of communication between people of diverse backgrounds and cultures. Together with diplomacy, art allows for dialogue with peoples of other countries; it il-

lustrates the distinct culture of our own country, and it helps build bridges of common understanding between countries. To apply to the program, send slides to the address given above.

Robert Mangold	Louise Nevelson	Jackie Ferrara
Mary Miss	Robert Irwin	Frank Stella
Robert Arneson	Ilya Bolotowsky	Jenny Holzer
Louise Bourgeois	Marcel Breuer	John Chamberlain
Dale Chihuly	Rosemarie Castoro	Dan Flavin
Yvonne Jacquette	Sol Lewitt	Isamu Noguchi
Patsy Norvell	George Rickey	James Rosati
Richard Serra	George Segal	Joel Shapiro
George Sugarman	Jack Youngerman	

General Services Administration

GSA Art-in-Architecture Program
Eighteenth and F Streets, NW
Room 7308
Washington, DC 20405
Attention: Susan Harrison, Chief

The names above are probably familiar to you if you follow the worldwide art scene. What may have surprised you is that they, along with many other artists whose names may not be as well known, have all participated in the General Services Administration's Art-in-Architecture Program.

Art in federal buildings has been an American tradition since 1855 when Congress commissioned frescoes to be painted in the committee rooms of the House of Representatives in Washington, DC. Today the General Services Administration (GSA) acquires art for federal buildings through the Art-in-Architecture (AIA) Program. This is a public process whereby the GSA sets aside one-half of 1 percent of the estimated construction cost of a federal building for

the AIA project. The GSA then invites five community representatives, five art professionals, and the project architect to make suggestions to GSA about the type and location of artwork to be commissioned. After reviewing artists' portfolios, the panel recommends three to five artists to the GSA, which selects and contracts one of the nominated artists. The artist prepares a proposal—drawings, a model, specifications, or other graphic display of the concept of the artwork—which is reviewed by the community participants who give their final recommendations to the GSA. Following acceptance of the proposal by the GSA, if the artist accepts the commission, a fixed-price contract is negotiated and the artist begins fabrication of the artwork.

Artworks commissioned by the GSA are diverse in style and media. They include sculpture, mobiles, bas-reliefs, water sculpture, earthworks, lightworks, assemblages, murals, photographs, frescoes, and crafts such as mosaics, tapestry, ceramics, and fiberworks. Contract award amounts negotiated for AIA projects include all costs associated with the design, execution, and installation of the artwork. For further information please write to the address above.

U.S. Department of Transportation – Airports

"It's an airport manager's dream: brighten a dreary concourse, advertise the regional quality of life, and earn lots of goodwill—for no cost and virtually no effort. It is in fact, a revolving art exhibit . . ."

–from *Airport Services Management* magazine, May 1985

The Department of Transportation is in charge of our local and international airports. Many of these offer art exhibitions, most often by regional artists. In fact, there is classical music in our airports now as well as bluegrass, permanent art and historical collections, walls of photographs, antique posters, and string quartets.

As Americans travel more frequently, they also spend time waiting for a flight or meeting a connecting one. Airports have found

that offering information about the special qualities of their region is good for tourism. Many times permanent artwork was placed in the airports at the time of their construction using the One Percent for Art program under the U.S. Department of Transportation.

Some airports have specific contact people for exhibitions, and below I have compiled a list of airports and contact information to help you explore the possibility of showing your work at airport spaces. These exhibits are sometimes mounted in locked glass cases, most have provided for good security, but you should determine exactly how and where your art will be presented before you decide if this format is for you.

Artists' Airport Alert

Several airports told me that they have discussed placing art exhibitions in their terminals but no decision has been reached. If this is the case at an airport near you, I urge you to contact your local arts organizations, which may not be aware of these discussions. Local art schools and colleges can also help influence the airport's decision to get art exhibitions started, and you might ask local politicians to lend their support by sending a letter to the airport's governing officials.

Arizona

City of Phoenix Sky Harbor International Airport
3400 Sky Harbor Boulevard
Phoenix, AZ 85034-4420

One of the outstanding airport art programs in the United States, Sky Harbor International Airport has a permanent collection of 145 works, including ceramics, murals, paintings, photographs, metal sculptures, textiles, and mosaics as well as sixteen spaces for changing exhibitions in four terminals. These range from small cases to large gallery-sized areas. The airport offers pedestals with Plexiglas covers and movable walls, and showcases arts, crafts, cultural institutions, and tourist attractions such as the Grand Canyon and the

Petrified National Forest. The city of Phoenix has a Percent for Art Program, which uses up to 1 percent of the airport's capital improvement budget to either purchase art or to create changing exhibition spaces.

Contact: Lennee Eller, Curator of the Sky Harbor Art Program, at 602-273-2006 or Marilyn DeMoss, Assistant Curator, at 602-273-2742.

Arkansas

Little Rock National Airport
One Airport Drive
Little Rock, AR 72202-4489

The airport is working on plans to exhibit and promote local artists, but sufficient information is not available at this time. Arkansas artists, stay after them!

Contact: Deborah S. Ledwell at the above address.

Connecticut

Tweed-New Haven Airport
155 Burr Street
New Haven, CT 06512

There are no exhibitions in Old Terminal Building due to space constraints. The New Terminal could house some exhibits and there have been discussions about doing so.

Contact: Suzanne Lewis, Deputy Airport Manager, at 203-787-8444.

District of Columbia

Washington National Airport
Metropolitan Washington Airport Authority
44 Canal Center Plaza
Alexandria, VA 22314-1562

The airport opened a new terminal in the summer of 1997. This terminal has an Architectural Enhancement Program that integrates thirty commissioned artworks, including ten floor medallions, eleven balustrades overlooking the concourse, five murals, a bridge sculpture, a sunscreen panel, and two glass friezes. The architect, Cesar Pelli, describes the finished project as "a rich sequel of visual experiences."

Contact: For information on any future exhibitions, contact the airport's public affairs office at 703-572-2700.

Florida

Orlando International Airport
One Airport Boulevard
Orlando, FL 32827-2001

An annual event showcasing Florida's art and artists, called "Up, Up and Away," is held in the Great Hall of the Orlando International Airport. Each January, applications are sent to a list of interested artists. The applications require slides and are juried by a different artist each year. The show is usually held in the third week of May. This year, approximately thirty-eight artists from around the state of Florida were showcased, with an outside judge awarding prizes, and a performance by the Orlando Philharmonic Orchestra.

Orlando International also has a permanent collection of art on continuous display. New work for the collection is purchased from the "Up, Up and Away" show in May.

Contact: If you are interested in participating, write to Cheryl Arnts in the Community Relations Department at the address above, or call her at 407-825-2055.

Tallahassee Regional Airport
Cultural Resources Commission
110 South Monroe, Suite 201
P.O. Box 11086
Tallahassee, FL 32302

The Artport Gallery in the Tallahassee Regional Airport is managed by the Cultural Resources Commission (CRC), the local arts agency for Tallahassee and Leon County. Generally, the gallery holds eight exhibitions per year with an emphasis on local and regional artists. Write for a brochure that explains when to submit slides for the Artport Gallery as well as two annual juried shows and the City Hall Gallery show. Works are chosen by the Arts Advisory Committee, a citizens' committee appointed by the Tallahassee City Commission. Become a member of CRC and get advance notice of exhibition openings, workshop opportunities, and other assistance offered through the CRC.

Contact: For information and submission guidelines, call the CRC at 904-224-2500.

Georgia

Savannah International Airport
400 Airways Avenue
Savannah, GA 31408

Savannah International Airport does not currently have exhibits of art in the airport, but does work with the Savannah College of Art and Design on displays of art in the terminal building. If you are an area artist and are interested, the airport suggests you contact the Savannah College of Art and Design.

Contact: Savannah College of Art and Design, P.O. Box 3146, Savannah, GA 31402-3146

Hawaii

Honolulu International Airport
300 Rogers Boulevard, #12
Honolulu, HI 96819-1897

Although the airport has no ongoing exhibit program, special occasions and commemorative events may also include cultural events, art and craft demonstrations, and entertainment activities.

Contractual restrictions with retail operators preclude the display of art for sale on the airport premises.

Illinois

Chicago O'Hare International Airport
P.O. Box 66142
Chicago, IL 60666

Art is no stranger at O'Hare International. A variety of programs have filled the airport with sculpture, stained glass, and painted park-style benches. Both temporary and permanent exhibitions have brightened O'Hare's busy thoroughfares. Eighty-two photo murals from around the world were exhibited in 1994, complete with a reception and talk by the photographer, Robert Cameron. Paintings to celebrate Chicago's Sister Cities Program have been rendered as postcards, and an attractive postcard book was among the many souvenirs kindly sent to me by airport art personnel.

Contact: Anne Rashford at 312-686-3555.

Kentucky

Regional Airport Authority
Louisville and Jefferson County
P.O. Box 9129
Louisville, KY 40209

The Standiford Art Foundation, Inc. has been acquiring and displaying works of art in the Louisville airport since 1985. Middle- and high-school students participate in an active program that provides materials and guidance in exploring public art in the Louisville area as a way to motivate them to support the arts into adulthood. The foundation is dedicated solely to recruiting patrons to fund commissions and acquisitions for the Louisville International Airport.

Contact: Rand Swann, Public Relations Director, at 502-368-6524.

Maine

Bangor International Airport
287 Godfrey Boulevard
Bangor, ME 04401

This airport has held art exhibits in the past and would consider requests from Maine-based artists with appropriate credentials (professional, previously exhibited, documented record of sales/patronage).

Contact: Bob Zriegelaar, Airport Director, at the above address.

Massachusetts

Logan International Airport
East Boston, MA 02128

Logan International Airport has had a variety of exhibitions, generally small in nature, but does not have a formal art exhibition program at this time. There is interest in setting up a program however, and the airport will probably inaugurate one in cooperation with one of the local museums or the Museum School in Boston. Exhibitions so far have not always been of art, but have included exhibits on sails for sailboats as well as a display of antique cars.

The Massachusetts Port Authority has a public arts program with art installed permanently as part of construction projects. A book by Marty Carlock titled *A Guide to Public Art in Greater Boston, from Newburyport to Plymouth* (Harvard Common Press, 1993) includes information about area airport art.

Contact: For current information on exhibitions write to Ann A. Hummel, Deputy Director of Aviation for Administration, and for information on the public arts program write to Lois Champy, Assistant Director for Planning and Design, both at the address given above.

Minnesota

Minneapolis–St. Paul International Airport
6040 Twenty-eighth Avenue South
Minneapolis, MN 55450-2799

The airport is currently evaluating and making decisions regarding art in the terminal. It is also adding various kinds of art to its buildings. Minneapolis artists, let them hear from you!

Contact: Tim Anderson, Deputy Executive Director–Operations, at 612-725-8380.

Mississippi

Jackson International Airport
100 International Drive, Suite 401
Jackson, MS 39208-2394

Exhibitions have been discussed, but no final decisions have been made.

New Mexico

Albuquerque International Sunport
P.O. Box 9022
Albuquerque, NM 87119

The Sunport in Albuquerque houses a large permanent collection of fine art and crafts by artists from New Mexico. The collection was assembled by the Albuquerque Arts Board with the Percent for Art Program and the Albuquerque Museum. A map is available to help visitors locate each exhibit within the terminal.

Contact: For information about the artists and the artwork, call 505-768-3829 and speak to Jane Sprague.

New York
La Guardia Airport
New York City

At La Guardia Airport, Robin Stewart told me that there are only limited facilities for showing artwork, but that the airport is working diligently to make connections with the artists in its home of Queens County. Nonprofit groups of artists living in Queens have exhibited at La Guardia, showing three-dimensional sculpture and works on paper in the fourteen or fifteen glass cases available there. Of course, I can't discuss La Guardia without mentioning the wonderful permanent murals dating from the thirties and created by the WPA (Works Progress Administration) program, which are on view in the Marine Air Terminal.

Contact: The Queens Council on the Arts at 718-647-3377.

North Carolina
Charlotte/Douglas International Airport
5501 Josh Birmingham Parkway
Charlotte, NC 28214

I received large, glossy posters—announcing two exhibitions and using imagery from each—from Paulette Purgason's office at Charlotte/Douglas International Airport. They were brightly colored and beautifully designed, seeming more fit for a museum than an airport. Local galleries, the Mint Museum's Traveling Exhibition program, and individual artists from the area make up the roster for exhibitions, which usually have a theme, such as a show not long ago of North Carolina pottery.

Contact: Paulette Purgason, Arts Administrator in the Airport Arts and Education Office, at the above address, or call 704-359-4000.

Oregon

Eugene Airport/Mahlon Sweet Field

28855 Lockheed Drive

Eugene, OR 97402

Eugene's Gallery at the Airport is directed by Dena E. Brown and is a program of the Arts Foundation of Western Oregon. The gallery is located in the center of the Eugene Airport terminal and is a permanent space for the exhibit of visual arts reflecting the artistic and cultural resources of the region. An area of six hundred square feet featuring display panels, pedestals with locking acrylic covers, and quality lighting, the gallery sits at the top of the terminal beside the escalator. Visual Arts Resources, an exhibition program of the Lane Arts Council, is currently contracted to professionally install the rotating exhibits. The primary purpose of the exhibitions is to present original artwork by regional artists. Shows are planned around a theme, and artists whose work fits the theme are admitted by juried competition.

Contact: Dena E. Brown, The Gallery at the Airport, 164 West Broadway. Eugene, OR 97401; 541-687-5077.

Portland International Airport

Port of Portland

Box 3529

Portland, OR 97208

The Portland airport displays art on a limited basis in cases in the Airport Conference Center. There is also some permanent art installed within the terminal and along Airport Way.

Contact: The Airport Public Affairs office at the address above.

Pennsylvania

Allentown-Lehigh Valley International Airport

3311 Airport Road

Allentown, PA 18103-1040

This airport has exhibited the work of local resident James Paul Kocsis, an artist whose large (nine-by-six foot) works have been so well received that the airport has asked its Community Affairs committee to look into displaying art exhibits all the time. Artists in the area should work with local nonprofit groups to lobby the airport to establish a permanent program.

Contact: Michael Burris, Director of Finance and Administration, at the above address.

Pittsburgh International Airport

Landside Terminal, Suite 4000

Pittsburgh, PA 15321-0370

Pittsburgh's International Airport has exhibited children's artwork in the past. It is now considering creating a cultural arts area and is conversing with several museums in the area regarding this. Works built into the airport's architecture are by Alexander Calder, Alan Saret, Maren Hassinger, Michael Morill, Robert Morris, Akiko Kotani, Peter Calaboyias, and Jackie Ferrara.

Contact: Lucinda McDonough, Public Relations Manager, at the address above.

Rhode Island

T. F. Green Airport

2000 Post Road

Warwick, RI 02886-1533

Beginning in the early 1980s, the T. F. Green Airport was probably one of the first airports to offer exhibits of regional artists' work. "Much of the art was literally sold off the walls to passengers pass-

ing through," according to Anahid Varadian, Administrative Assistant to the Deputy Executive Director. The old terminal has been demolished however, and with it the celebration of regional artists that was organized by the Rhode Island Council on the Arts. Now that T. F. Green is in a newer and larger terminal, exhibitions should again be possible sometime in the near future.

Contact: For updated information call Randy Rosenbaum, Executive Director of the Rhode Island State Council on the Arts, at 401-277-3880.

South Dakota

Rapid City Regional Airport
Rapid City, SD 57701-8706

Exhibitions at the airport of fine arts and crafts by regional artists are directed by the Dahl Fine Arts Center in Rapid City. There are three to four exhibitions per year in display cases. All works are offered for sale, and contact with the artists is handled by the Art Center curator.

Contact: Grete Bodogaard, Interim Curator, Dahl Fine Arts Center. 713 Seventh Street, Rapid City, SD 57701-3695; 605-394-4101.

Tennessee

Memphis International Airport
Memphis-Shelby County Airport Authority
P.O. Box 30168
Memphis, TN 38130-0168

Arts in the Airport is an ongoing program combining performing and visual arts. It began as a one-time event in May, but received such a positive response that it was expanded. Memphis Symphony Orchestra ensembles perform light classical, blues, jazz, ragtime, and popular selections. Visual arts include paintings, sculpture, and photographs.

Contact: For information call Janice Young, Manager of Marketing and Public Relations, at 901-922-8008.

Metropolitan Nashville Airport
One Terminal Drive
Nashville, Tennessee 37214-4114

Arts in the Airport is an ongoing program of visual and performing arts that began in 1988. Rotating exhibits of visual arts by regional artists are curated by Susan Knowles, and the program is managed by the Greater Nashville Arts Foundation.

Contact: Call Susan Knowles, Curator of Arts in the Airport, at 615-297-1069.

Utah

Salt Lake City International Airport
Salt Lake City Airport Authority
AMF Box 22084
Salt Lake City, UT 84122

The airport at Salt Lake City does not permit its space to be used for temporary exhibitions. However, there very definitely is an art program. As space is rebuilt or remodeled at the airport, the Airport Authority Board has a committee that solicits and selects works by regional artists to be purchased for permanent display. Media includes sculpture, painting, and photography.

Contact: To be put on their mailing list for proposal requests, contact Theresa Rocco at the address above, or call 801-575-2939.

Vermont

Burlington International Airport
1200 Airport Drive, #1
South Burlington, VT 05403

Art exhibits at the Burlington International Airport are managed through the City Arts Office. Contact: Doreen Kraft, City Arts Office, City of Burlington, City Hall, Burlington, VT 05401; 802-865-7166.

Virginia
Richmond International Airport
Box A-3
Richmond, VA 23231-5999

The Capital Region Airport Commission sponsors art exhibitions throughout the year at Richmond International Airport. These are facilitated through community art associations in the Richmond area. Solo exhibitions are not permitted.

Contact: For information, Virginia artists should contact their local arts organization or state arts council.

Wisconsin
Green Bay–Austin Straubel International Airport
2077 Airport Drive
Green Bay, WI 54313

This is another airport where the idea of exhibiting art has come up and is being considered. The airport tells me they have contacted a local museum to discuss whether there is interest and has had inquiries from individual artists regarding sale of work to the airport. Local artists and arts groups, write or give them a call!

General Mitchell International Airport
5300 South Howell Avenue
Milwaukee, WI 53207

The General Mitchell International Airport has an amazing array of art in its permanent collection. Walking tours are available

to see a red, black, and blue sculpture by Alexander Calder, which hangs above the concession area. At Concourse D, the International Peace Through Art Project is on display. A gift from the people of Leningrad, through the American-Soviet Mural Project, *Clay A Healing Way* is a clay mural that was made and sent as a gift to the citizens of Milwaukee. Likewise, a clay mural was made by five thousand Milwaukeeans and is on permanent display in Leningrad's airport.

The Mitchell Gallery of Flight is an air history museum located in the airport. The Friends of the Mitchell Gallery of Flight, a volunteer group, maintains the museum, which tells the dynamic story of aviation throughout the twentieth century.

Besides these permanent installations, the airport does have changing displays for special occasions, such as an organ donor display, drawings from the school of architecture, photos from advertising photographers, and a boys' and girls' club art show.

Contact: To find out what exhibitions are being planned and if your artwork might be included, write to Geri Hayward of the Public Relations Office at the above address.

United States Information Agency (USIA)

The USIA Arts America program, which manages the U.S. government's International Cultural Exchange Program, used to take art exhibitions on tours overseas. Those events ceased as of October 1996. Caroline Croft, the director of Arts America, talked about the program's current aims.

"We are still helping artists who go abroad to exhibit in biennials, such as the one in Venice. Proposals are welcome from nonprofit museums and galleries, but not from commercial galleries or artists submitting their own work. These proposals are reviewed by the Federal Advisory Committee on International Exhibitions. If selected, projects are managed by our Visual Arts Division and funded jointly through Arts International, which has several partners like the Rockefeller Foundation and the Pew Chari-

table Trusts. Also, we aid artists who come to the United States to attend artists' colonies."

Federal Reserve Banks

There are twelve regional banks, located throughout the United States, in the Federal Reserve system. The Federal Reserve Board's national headquarters is in Washington, DC. The Federal Reserve Banks in several locations own fine art collections and have exhibitions, some open to the public, some for employees only. At least three of them have large contemporary collections, most begun after 1980 and containing up to seven hundred works.

In New York, the Federal Reserve Bank is located on Liberty Street in the Wall Street area. Peter Bakstansky, senior vice president, told me about the bank's art program. Previously, the bank had arrangements with the Metropolitan Museum of Art for loans of paintings by artists in the Hudson River school. These are historical works that were painted in the last century, mostly landscapes of sites in the Hudson River valley. However, a recent plan for the bank's twelfth floor, which is open to employees only, calls for works by living artists to be exhibited. Employees of the bank will then vote on which works they particularly like and these will be acquired by the bank. To implement this plan, Mr. Bakstansky has asked the Lower Manhattan Cultural Council (LMCC) to mount several exhibitions over the next year.

A nonprofit council, LMCC organizes and oversees art exhibits in public spaces in lower Manhattan. Jenny Dixon, executive director of LMCC, told me how her organization plans to formulate these exhibits.

"We are making extensive use of slide registries in the area, both in New York and New Jersey. Artists who have slides in the registries are our candidates. Those whose works fit in with our overall exhibition plan are being invited to exhibit works. We are concentrating our search for art within the area where the bank's business is conducted. Once we have decided on works for the exhibitions,

we will set dates for the showings and mount the exhibitions. We are planning to have openings at the site and the artists will be present. They will also have the opportunity to send out an announcement stating that their work is being shown at the Federal Reserve, although the public will not be able to see it." (For more on slide registries, see chapter 11.)

Back to Federal Reserve Banks—although each bank has it's own program that may change at any time, the possibility *does* exist that work by living artists will be sought and shown. Below are addresses of all the Federal Reserve Banks so you can keep up with exhibitions and exhibition possibilities in the future at the Federal Reserve Bank nearest you.

Fine Arts Program

Federal Reserve Board
Twentieth and C Street, NW
Washington, DC 20551
Director of the Fine Arts Program: Mary Ann Goley
(for a taped schedule of exhibitions, call 202-452-3000)

Federal Reserve Bank of San Francisco
101 Market Street
San Francisco, CA 94105
(for tour appointment, call 415-974-2485)

Federal Reserve Bank of Atlanta
104 Marietta Street, NW
Atlanta, GA 30303
404-521-8500

Federal Reserve Bank of Boston
600 Atlantic Avenue
Boston, MA 02106
Cultural Affairs Coordinator: Anne Belson
617-973-3454
(Boston's *Gallery Guide* lists exhibitions held here)

Federal Reserve Bank of Minneapolis
90 Hennepin Avenue
Minneapolis, MN 55401-1804
Art Director: Christine Power
612-204-5000

The Federal Reserve Bank of Minneapolis has recently moved
to a new building. The bank does not currently have an art gallery,
but the bank's collection of art (about 275 pieces) will be added to
depending on their needs in the new space. Artists living and work-
ing in the Ninth Federal Reserve District may have their slides re-
viewed for purchase consideration.

Federal Reserve Bank of Richmond
701 East Byrd Street
Richmond, VA 23219
Art Registrar: Ann Ayer
(for an appointment to visit, call 804-697-8466)

Federal Reserve Bank of Philadelphia
10 Independence Mall
Philadelphia, PA 19106
Attention: Pat Lenar, Public Affairs
215- 574-6257

The Third Federal Reserve district covers part of Pennsylvania
and all of Delaware and New Jersey. It has approximately four ex-

hibitions per year in an area at the bank called Eastburn Court, which is open to the public. These exhibitions focus on art from nonprofit groups that operate within the bank's district. If you are a member of such a group, you may want to propose a show to Ms. Lenar. She plans the exhibitions about one year in advance.

Federal Reserve Bank of Dallas
2200 North Pearl Street
Dallas, TX 75201
Nancy Vickrey, Community Affairs Officer

The Federal Reserve Bank of Dallas undertook an art acquisition program during the construction of a new building in 1994, but the bank does not have a budget for further acquisitions. The bank's art exhibit is accessible to employees, tour groups, those attending bank functions, and by appointment.

The Federal Reserve bank in Chicago neither sponsors art exhibitions nor owns an art collection.

National Parks Service

At eighteen national parks, programs exist for artists to use and enjoy the parks for their own growth and development. Establishment of these programs was proposed by Partners for Artist in Residence (PAIR) Programs in National Parks beginning in 1992. Melanie Parke, a founding member of PAIR, reports that three more parks intend to start programs. They are: Pt. Reyes, California; Grand Canyon, Arizona; and Gates of the Arctic, Alaska.

There are two excellent sources for information about these opportunities. First, a directory called *Go Wild!* by Bonnie Fournier of St. Paul, Minnesota. An artist herself, Bonnie keeps up with all of the changes and new programs. The directory covers everything you need to know about getting a place as an artist-in-residence in some of the most beautiful spots in the world, including who is eligible, housing arrangements, comments from former residents, and more. If you would like some creative time making art out of doors, one of

the parks might be for you. Besides painters and sculptors, these programs welcome composers, videomakers, performers, writers, and photographers. Many require that you set aside some time to speak to park visitors about your work and/or contribute a piece of your work to their programs. *Go Wild!* is available for $15.95 from:

Lucky Dog Multi-Media
Lowertown Lofts Artist Cooperative
P.O. Box 65552
St. Paul, MN 55165-0552

You can also call the Go Wild! hotline, 612-290-9421, for the latest news about residencies. Slide programs about the residency programs are available for creative communities across the nation.

The second resource, *Artists Communities,* a comprehensive book on opportunities in more than seventy artists' communities in the United States, has been compiled by the Alliance of Artists' Communities and is published by Allworth Press. To contact the alliance, write or call:

Alliance of Artists' Communities
210 SE Fiftieth Avenue
Portland, OR 97215
503-239-7049

National Aeronautics and Space Administration (NASA)

For more than thirty years, the NASA Art Program has documented America's accomplishments in aeronautics and space. More than two hundred artists have generously contributed their time and talent to record their impressions of the U.S. space program in paintings, drawings, and other media.

NASA's collection of works by Robert McCall, Andy Warhol, Robert Rauschenberg, and Jamie Wyeth, among others, depicts a wide range of subjects, from space shuttle launches to aeronautics research, the Hubble Space Telescope, and even virtual reality. Bert Ulrich, NASA's curator, says that work in all styles, representational

to abstract and beyond, is welcome. Artists commissioned by NASA receive a small honorarium in exchange for donating a minimum of one piece to the NASA archive, which now numbers more than eight hundred works of art.

Many of the NASA-owned pieces are displayed at galleries, museums, and NASA Centers around the country. The Kennedy Space Center in Florida and Space Center Houston, as well as the NASA Center in Langley, Virginia, have large selections of NASA artwork on display.

Artists interested in participating in the NASA Art Program should send slides and résumé to:

NASA Art Program
Public Services Division
Code POS
Office of Public Affairs
NASA Headquarters
Washington, DC 20546

Also, more than two thousand works have been donated to the National Air and Space Museum, including work by Norman Rockwell. For more information, contact:

Curator of Art
National Air and Space Museum
Washington, DC 20560

Air Force Art Program

While the U.S. Air Force doesn't commission artists, they do have an art collection of eight thousand works that have been donated by professional artists. This might be a great item on your résumé. The artworks portray the people, equipment, activities, and historical significance of the Air Force. They are shown at Air Force facilities around the world and in the corridors of the public spaces in the Pentagon. An exhibition at the Smithsonian's National Air and Space Museum in Washington, D.C. celebrated the Air Force's fiftieth an-

niversary by featuring many of these works. The Air Force also works with the Society of Illustrators in New York, San Francisco, and Los Angeles. The Air Force is currently upgrading its screening process for donated artwork. For more information, contact:

Air Force Art Program
AF/HOI
110 Luke Avenue, Suite 405
Bolling AFB, DC 20332-8050

U.S. Army Art Program

The Army Art Program uses mainly soldier artists who are now on duty. However, once every four years the army commissions a civilian artist to paint the portrait of the chief of staff. If interested, send slides or photographs to:

U.S. Army Center of Military History
Attention: DAMH - MDC
1099 Fourteenth Street, NW
Washington, DC 20005-3402

Be sure to send materials that don't need to be returned immediately, and be sure to enclose an SASE.

U.S. Navy Art Program

The Navy Art Program has a gallery where they exhibit from a collection of about ten thousand pieces, which includes work from as far back as the 1800s. More recently, the gallery has collected artwork spanning the time from World War II to the present. In combat situations, naval personnel who are also artists are often assigned to accompany ships, as one artist recently did to Bosnia.

While a small amount of commissioning of civilian artists has been done, personnel at the Navy Art Gallery say that today this is rare. The program is now being reviewed and changes may occur. Donations of artwork offer an opportunity for artists who work in

specific navy themes. A photograph or slide, along with a letter describing the work, can be sent to:

Washington Navy Yard
Navy Art Gallery
Building 67
Washington, DC 20374-5060
Attention: Curator

U.S. Coast Guard Art Program

The Coast Guard has a volunteer program for art donations operated through the Salmagundi Club—a club made up of artists—in New York City. Write or call:

The Salmagundi Club
47 Fifth Avenue
New York, NY 10003
212-255-7740

The Coast Guard mounts about twenty exhibitions from their collections each year, at museums, Coast Guard events, and elsewhere. The Coast Guard also commissions a portrait of its Commandant, like the other branches of the military services. To be considered for this opportunity, send slides or photos to:

Commandant (G-CP-3)
U.S. Coast Guard
2100 Second Street, SW
Washington, DC 20593-0001

U.S. Marine Corps Art Program

The marines have a collection of eight thousand drawings, paintings, sculptures, and cartoons dating from World War I and kept in the Marine Corps History Center at the Washington Navy Yard. While the center is not open to the public, it is open by appointment to researchers. Artwork is continually added to the collection

by artists in the Reserve Program, and, in fact, reserve artists who went to Somalia brought back renderings of marines serving there. Now, says John Dyer, curator of the art program, the Marine Corps need art that portrays women marines doing the jobs male marines have traditionally done.

The Civilian Art Program uses the work of non-marines, and provides opportunities for qualified women artists to sign up as "temporary marines" and see military life on a nearby marine base, for approximately a month. A small honorarium, travel expenses, lodging, and meals are provided, and your artwork may become part of the Marine Corps collection. The program uses mostly representational art, so if that's what you make, the review panel is interested in seeing your slides. Address these to:

IMA Detachment
c/o John Dyer
Marine Corps History Center
Building 58
Washington Navy Yard
Washington, DC 20374-0580

Smithsonian Associates Program

While the Smithsonian Institute is a national cultural organization that includes *Smithsonian* magazine and several major museums, a smaller program called the Smithsonian Associates operates on a local level, catering to approximately fifty thousand households in the Washington, DC area. Known as TSA, this group organizes living-artist commissions to commemorate events of national importance—such as the end of the Persian Gulf War—with original artworks that are privately reproduced in limited editions and offered for sale to members. Funded by a Smithson bequest, TSA receives no government support.

Smithsonian Associates have commissioned music from composers and may begin a jewelry program. Portfolios and slides are viewed by Gina Popp, curator for TSA. Send these to her at:

The Smithsonian Institution
The Smithsonian Associates
1100 Jefferson Drive
Room 3077 MRC 701
Washington, DC 20560

National Academy of Sciences Art Program

The Arts in the Academy program attempts to demonstrate to those who enter the National Academy of Sciences building the richness of the relationship between science and the arts, and how they compliment each other. Arts in the Academy provides a platform and display space for local musicians and artists. Many exhibits are science related or show innovative use of nontraditional materials by the artists. Exhibits are publicized in local art calendars and many are reviewed. All shows are open to the public free of charge. Send slides to:

Arts in the Academy
National Academy of Sciences
2101 Constitution Avenue, NW
Washington, DC 20418
Attention: Frederica Wechsler, Director

U.S. Department of the Treasury

Every department in the federal government commissions a portrait of its secretary. If you specialize in portraits, you can write to the departments you are interested in, and send samples or photographs of your work for consideration. Although these portraits are usually done only once every four years, each department keeps a file of artists whose work they like, and you might be included.

For the Treasury Department, mail slides and photos to:

Department of the Treasury
Office of the Curator
Room 1225
Washington, DC 20220

State Arts Agencies

At the beginning of this chapter I mentioned how artists could work with their state arts agencies to create a network of information that might be useful for the future. Your state art agency will be listed below.

Alabama State Council on the Arts
1 Dexter Avenue
Montgomery, AL 36130-1800
334-242-4076

Alaska State Council on the Arts
411 West Fourth Avenue, Suite 1E
Anchorage, AK 99501-2343
907-269-6610

American Samoa Council on
 Culture, Arts, and Humanities
P.O. Box 1540
Office of the Governor
Pago Pago, AS 96799
011-684-633-4347

Arizona Commission on the Arts
417 West Roosevelt Road
Phoenix, AZ 85003
602-255-5882

Arkansas Arts Council
1500 Tower Building
323 Center Street
Little Rock, AR 72201
501-324-9766

California Arts Council
1300 I Street, Suite 930
Sacramento, CA 95814
916-322-6555

Colorado Council on the Arts
750 Pennsylvania Street
Denver, CO 80203
303-894-2617

Connecticut Commission on the Arts
755 Main Street
Hartford, CT 06103
203-566-4770

Delaware Division of the Arts
State Office Building
820 North French Street
Wilmington, DE 19801
302-577-3540

District of Columbia Commission on
the Arts and Humanities
410 Eighth Street, NW, Fifth Floor
Washington, DC 20004
202-724-5613

Florida Division of Cultural Affairs
Department of State
The Capitol
Tallahassee, FL 32399-0250
904-487-2980

Georgia Council for the Arts
530 Means Street, NW, Suite 115
Atlanta, GA 30318-5730
404-651-7920

Guam Council on the Arts and
Humanities
Office of the Governor
P.O. Box 2950
Agana, GU 96910
011-671-647-2242

Hawaii State Foundation on Culture
and the Arts
44 Merchant Street
Honolulu, HI 96813-0300
808-586-0306

Idaho Commission on the Arts
P.O. Box 83720
Boise, ID 83720-0008
208-334-2119

Illinois Arts Council
State of Illinois Center
100 West Randolph Street,
Suite 10-500
Chicago, IL 60601
312-814-6750

Indiana Arts Commission
402 West Washington Street,
Room 072
Indianapolis, IN 46204
317-232-1268

Iowa Arts Council
Capitol Complex,
600 East Locust
Des Moines, IA 50319
515-281-4451

Kansas Arts Commission
Jayhawk Tower
700 SW Jackson, Suite 1004
Topeka, KS 66603
913-296-3335

Kentucky Arts Council
31 Fountain Place
Frankfort, KY 40601
502-564-3757

Louisiana Division of the Arts
P.O. Box 44247
41051 North Third Street
Baton Rouge, LA 70804
504-342-8180

Maine Arts Commission
55 Capitol Street
State House Station 25
Augusta, ME 04333
207-287-2724

Maryland State Arts Council
601 North Howard Street, First Floor
Baltimore, MD 21201
410-333-8232

Massachusetts Cultural Council
120 Boylston Street, Second Floor
Boston, MA 02116-4600
617-727-3668

Michigan Council for the Arts and
 Cultural Affairs
1200 Sixth Avenue
Executive Plaza
Detroit, MI 48226-2461
313-256-3731

Minnesota State Arts Board
400 Sibley Street, #200
St. Paul, MN 55101
612-215-1600

Mississippi Arts Commission
239 North Lamar Street,
 Second Floor
Jackson, MS 39201
601-359-6030

Missouri State Council on the Arts
Wainwright Office Complex
111 North Seventh Street, Suite 105
St. Louis, MO 63101
314-340-6845

Montana Arts Council
316 North Park Avenue, Room 252
P.O. Box 202201
Helena, MT 59620-2201
406-444-6430

Nebraska Arts Council
3838 Davenport
Omaha, NE 68131-2329
402-595-2122

Nevada State Council on the Arts
Capitol Complex
602 North Curry Street
Carson City, NV 89710
702-687-6680

New Hampshire State Council on
 the Arts
Phenix Hall
40 North Main Street
Concord, NH 03301
603-271-2789

New Jersey State Council on the Arts
20 West State Street,
 Third Floor CN 306
Trenton, NJ 08625-0306
609-292-6130

New Mexico Arts Division
228 East Palace Avenue
Santa Fe, NM 87501
505-827-6490

New York State Council on the Arts
915 Broadway
New York, NY 10010
212-387-7000

North Carolina Arts Council
Department of Cultural Resources
Raleigh, NC 27611
919-733-2821

North Dakota Council on the Arts
418 East Broadway, Suite 70
Bismarck, ND 58501-4086
701-328-3954

North Mariana Islands Common-
 wealth Council for Arts and
 Culture
P.O. Box 5553, CHRB
Saipan, MP 96950
011-670-322-9982

Ohio Arts Council
727 East Main Street
Columbus, OH 43205
614-466-2613

State Arts Council of Oklahoma
P.O. Box 52001-2001
Oklahoma City, OK 73152-2001
405-521-2931

Oregon Arts Commission
775 Summer Street, NE
Salem, OR 97310
503-986-0082

Pennsylvania Arts Council
216 Finance Building
Harrisburg, PA 17120
717-787-6883

Institute of Puerto Rican Culture
P.O. Box 4184
San Juan, PR 00902-4184
809-723-2115

Rhode Island State Council on the Arts
95 Cedar Street, Suite 103
Providence, RI 02903-1034
401-277-3880

South Carolina Arts Commission
1800 Gervais Street
Columbia, SC 29201
803-734-8696

South Dakota Arts Council
230 South Phillips Avenue, Suite 204
Sioux Falls, SD 57102-0720
605-367-5678

Tennessee Arts Commission
404 James Robertson Pkwy.
Parkway Towers, Suite 160
Nashville, TN 37243-0780
615-741-1701

Texas Commission on the Arts
P.O. Box 13406
Capitol Station
Austin, TX 78711
512-463-5535

Utah Arts Council
617 E. South Temple St.
Salt Lake City, UT 84102
801-533-5895

Vermont Council on the Arts
136 State Street, Drawer 33
Montpelier, VT 05633-6001
802-828-3291

Virgin Islands Council on the Arts
41-42 Norre Gade, Second Floor
P.O. Box 103
St. Thomas, VI 00802
809-774-5984

Virginia Commission for the Arts
223 Governor Street
Richmond, VA 23219
804-225-3132

Washington State Arts Commission
P.O. Box 42675
Olympia, WA 98504-2675
360-753-3860

West Virginia Division of Culture and
 History
Arts and Humanities Section
1900 Kanawha Boulevard East
Capitol Complex
Charleston, WV 25305-0300
304-558-0220

Wisconsin Arts Board
101 Earl Wilson Street, First Floor
Madison, WI 53702
608-266-0190

Wyoming Arts Council
2320 Capitol Avenue
Cheyenne, WY 82002
307-777-7742

Licensing
Your Work

Don't forget the publication opportunities beyond magazines. Many artworks are bought to be used on greeting cards, post cards, fine art posters, and calendars. An excellent guide for artists wishing to publish artwork is *Publishing Your Art As Cards, Posters, and Calendars,* Revised Edition by Harold Davis. (Published by Consultant Press, Ltd., it can be ordered by dialing 212-838-8640.) This down-to-earth handbook takes you through the legal and business forms you will need to know about, and includes three appendices listing important publishers for major fine art posters, calendars, and postcards. Mr. Davis gives excellent advice on how to find a publisher for your work and a brief lesson on the economics of publishing. You'll be introduced to the offset printing process, which has always been somewhat mysterious to artists who are usually more familiar with the smaller-scale studio printing process. A glossary will help you understand the terms used, and a list of resources includes periodicals that will familiarize you with industry trade

shows. This book is also a big help if you are thinking of publishing your own artwork.

Jewelry, Luggage, Linens, Needlecraft, Playing Cards

Your art may lend itself to licensing for hundreds of other items you may not have thought of. Marilyn Moore's *Guide to Licensing Artwork*, ($15.95 from Kent Press, 203-358-0848) can help you decide if licensing might be right for you. Having worked on both sides of the negotiating question, she's a good advisor for artists who aren't even sure if their work would sell as a licensed product or not. She provides good sample forms to help protect a newly licensing artist. A particularly strong appendix lists manufacturers who license artwork and what types of artwork they seek.

Artist Penny Feder sells her artwork to a greeting card manufacturer. She started by going to the National Stationery Show, which is held each year in May at the Jacob Javits Convention Center in New York City. "Look for cards and stationery that your own artwork could fit in with," Penny advises. "Then make inquiries about how the manufacturer works. Some will talk to you right there and some will ask you to send slides."

One of the best things about licensing your work is that you usually get to keep the original after the transparency is shot. There are several ways to work with card companies, from selling your images for a flat fee to selling them and collecting royalties as the cards are sold. "For first-time artists," Penny says, "many card companies will want to buy an image, with the right to reproduce it for several years. Fees like $250 to $400 per image are common. If they are buying a transparency from you, you should expect to pay $50 to $60 to have the transparency made. Be sure to figure that into the price you are asking. The company may be able to use your work as is or they may ask you to redo a piece using different proportions. All of this should be weighed into a sales price of, say, $250, when the transparency and the redo may eat any profit."

With these conditions in mind, here is a list of several of the large markets that host these shows. Call to confirm the dates of shows you want to attend.

Atlanta, Georgia
Americasmart Atlanta
800-285-6278

Charlotte, North Carolina
Charlotte Merchandise Mart
704-333-7709

Chicago, Illinois
Rosemont Exposition Center
847-696-2208

Los Angeles, California
Los Angeles Convention Center
213-689-8822

Miami, Florida
Miami International Merchandise Mart at the Radisson Center
305-261-2900

New York, New York
Jacob K. Javits Convention Center
212-216-2000

For a complete guide to trade shows in the United States, covering tabletop, gifts, home accessories, greeting cards, and stationery, see *Gift and Decorative Accessories* magazine (approximately $39 for a one-year subscription that includes a special Buyers Directory issue, published by Geyer-McAllister Publications, Inc., 800-309-3332).

Contracts

When card and stationery companies offer you a contract for the use of your artwork, have someone who is familiar with the publishing industry look it over and negotiate it on your behalf. A lawyer or someone familiar with the business can negotiate effectively for you and get the most equitable terms. You can also contact the Graphic Artists Guild for its *Handbook of Pricing Guidelines* (published by North Light Books), which will give you a fair idea of current pricing.

■

Markets Far Away and Closer to Home

One of the more fascinating and underexplored places where you can sell and show your artwork is the international market. Artists, afraid of problems involving great distances, often leave the international market to galleries and private dealers. But there *are* ways to take advantage of this opportunity. To learn much of what an artist needs to know in order to show abroad, I recommend the *Art Diary International,* a thick annual paperback published by Flash Art Books and available for about $30 through major bookstores that sell international books.

Art Diary International lists galleries by city with information about hotels, restaurants, and where to buy art supplies. It also lists art warehouses, publications, and museums and gives addresses and phone numbers, so you can plan ahead. It deals with major international cities and is a great guide for the traveling artist. It's also a handy size to take with you when traveling.

Working in the International Market

Now let's look at how the international market applies to you, the artist, and where you can find help.

Contracts with galleries or representatives who will act for you in other countries should always deal with certain issues, among them: the national currency that will be used for all transactions (foreign exchange rates can put you at a disadvantage), how all payments are to be made (cash, check, credit card, wire transfer, etc.) and on what schedule, where any disputes will be resolved, and what country's laws will prevail.

Scott Cohn, an attorney who regularly deals with the U.S. Customs Service was a guest on a panel I hosted a few months ago. Scott works on import-export matters for his clients, which include a large auction house that deals in the arts. He helped me a few years ago when I was trying to get a painting to Europe.

Scott has also served as a Volunteer Lawyer for the Arts. This organization exists in many U.S. cities and provides legal advice to artists and arts groups. Call their New York office for a referral to the office nearest you (212-319-2787).

For our panel discussion, Scott gave an overview of how to deal with the Customs Service and the necessary steps an artist should take when shipping work into or out of the United States. He stressed that artists should remember what he described as "The Four Ds:"

- Declaration
- Documentation
- Description
- Dollars

Whether shipping work out or bringing it back into the country, Scott says, "It is extremely important to properly declare all items to U.S. Customs, which is a federal agency that won't hesitate to impose harsh penalties for failure to comply with its requirements."

"Declaration" refers to declaring, or disclosing, to Customs all

of your imported articles so it can make a determination as to the admissibility of the articles and the applicability of duty rates or other restrictions.

The declaration process requires "Documentation" to clearly show Customs what is being imported and what its cost or value is ("Dollars"). This declaration process is also referred to as the "entry" process for imported articles.

Interestingly, not only articles acquired in a foreign country need to be declared, but also any works that you created while overseas. Customs will consider these to be foreign-origin imported articles! This includes sketches, paintings, photographs, sculptures, etc. Most original works of fine art are eligible for duty-free treatment, but must still be declared as described above.

Some works of art are subject to duty at the rates applicable to the materials that make up the piece. It is very important to try to obtain duty rate information, as well as data on restricted or prohibited articles prior to departing for a trip if you expect to return with items you have purchased or created overseas.

Scott outlined the basic requirements to make or file a U.S. Customs declaration (entry). The following documents are generally required.

- A bill of lading, airway bill, or similar shipping documentation that evidences the right of the importer/consignee to make entry.
- A commercial invoice, obtained from the foreign seller if you bought the artwork outside the United States, which shows the U.S. dollar value and description of the merchandise; or, other documentation indicating a value and description such as a bill of sale, statement of fair retail value, etc. If the articles are being consigned, this must also be clearly stated.
- Packing lists, if appropriate, and other documents necessary to determine whether the merchandise may be admitted.

If Customs finds that the stated value is insufficient, or that a different rate of duty applies, an increase in duty fees may occur.

Most articles of U.S. origin, which are returned to the United States after having been exported, may be reimported duty-free. Similar duty-free provisions exist for articles that have been previously imported and upon which duty was paid, as well as additional duty-free provisions for specified articles for the use of institutions established for religious, educational, scientific, literary, or philosophical purposes, as well as for the encouragement of the fine arts.

If an imported article is intended to be used or displayed in the United States for only a temporary period, the duty-free provisions usually require exportation within a one- to three-year period.

If an article is exported and somehow becomes more valuable while overseas, duty might be required on the additional value added in a foreign country upon reimportation, or even on the full value if the article has advanced in value substantially.

Well, then, what about sending art internationally through the mail?

According to law, Scott offers, "Shipments by mail that do not exceed $1,250 in value, whether commercial or noncommercial, are entered under a mail entry prepared by a Customs officer after the Postal Service submits the package for Customs inspection. The parcel is delivered to the addressee by the Post Office and is released upon the payment of the duty that is shown on the mail entry accompanying the package. A postal handling fee in the form of postage stamps will be collected from the addressee at the time the package is delivered.

"A commercial mail shipment in excess of $1,250 in value is forwarded to the Customs office nearest the addressee. Customs notifies the addressee of the arrival of the parcel and the location of the Customs office where an appointment to complete the Customs formalities may be arranged. Customs clearance will require the filing of an entry in the same manner as for shipments arriving by vessel or air freight."

Many types of merchandise are considered prohibited from importation into the United States based on various international trea-

ties or other U.S. or foreign laws. For example, there are specific prohibitions against the importing of pre-Columbian artifacts from certain designated sites in South America and elsewhere. In addition, certain countries are part of an international convention on cultural property whereby they assert certain patrimony/ownership rights in cultural or archeological items.

In addition to Customs requirements, Customs also enforces the laws and regulations of other agencies such as the Consumer Product Safety Commission (CPSC), the Food and Drug Administration (FDA), the Fish and Wildlife Service (FWS), etc. Accordingly, articles that may be considered potentially hazardous may be restricted by the CPSC or the FDA. For example, certain ceramic ware is subject to testing for lead and cadmium content, unless it is established that it is purely decorative in nature. As another example, articles containing any amounts of animal skin or fur will be subject to special FWS declaration and documentation requirements.

Customs can aid the artist in watching for copyright infractions as artworks are entering the United States. For this to occur, the artist must first apply for and receive a copyright on an artwork or a group of artworks from the U.S. Copyright Office. For a fee of $190 per registration, Customs will itself record the registration issued by the Copyright Office and will observe and contact the rightful copyright holder if they suspect a copyright has been infringed upon. Their vigilant participation in this will continue for twenty years or until the copyright expires.

It is important to obtain accurate information and documentation and to make accurate representations to federal agencies such as U.S. Customs.

Your international sales can build a following that will provide you with a means to keep making and selling art in foreign areas even if you are not having major sales at home. An artist I know has had such intense interest in his work in Germany recently that he has been spending most of his time there.

The Artist's Internet

Janet Disraeli is a consultant in San Diego who has been selling art nationally for twenty-five years. Her business, called the Art Collector specializes in three areas: sculpture, sales to churches of religious and liturgical artifacts (such as banners, stained glass, and special furniture), and sales to corporations and private collectors. Janet has long felt that there was a lack of good resources for the kind of artworks sought by the many architects and designers who work on building and renovating churches. She has spent several years building the connection between these designers and builders and artists who make this type of art. More recently, she has decided to open a division of her business on the Internet. Here's how she plans to run it.

From a Web site, she will present artwork from artists that she feels meet the Art Collector's standards for professional and salable quality. Each artist presented will provide three slides and may write up to two hundred words about his or her work. No specific prices will appear with the work, but a price range will be given to help the viewer have an idea of the cost. Viewers may ask for a certain type of artwork, such as painted sculpture. The Web site will then show them every artist's work that falls into that category. Or if a viewer chooses a broad category, such as simply sculpture, then the next screen will give a choice of figurative or abstract works, then works in different types of media, and so on.

Outside of the Internet, Janet will be reaching thousands of potential clients by direct mail, using mailing lists for thousands of architects, interior designers, decorators, landscape architects, and the like. The mailing will invite these professionals to view the work the Art Collector has chosen to show at its Web site. Of course, many Web cruisers will find the Art Collector's page on their own, but by doing publicity outside of the Internet, Janet is ensuring that a core of professionals will be aware of the site. She also has an Internet specialist on her staff who will publicize the Web site on the Internet through links to other Web pages.

At the end of the Web site, directions invite the viewer to send

for further information by fax, phone, or e-mail. From here the story is more familiar. After getting inquiries, the Art Collector will forward slides of work by the artists that interest the potential client. The client may then narrow them down. Sale of any work is handled by the Art Collector and commissions are expected to be about the same as when art is sold by a consultant.

The artist is protected throughout the process, as no address or phone number is listed. Naturally, the work you show on the Internet should be representative of your style, but it need not be available for sale. If there is interest, the Art Collector will contact artists for slides of work that is available for sale. Interested artists may send slides to:

The Art Collector
4151 Taylor Street
San Diego, CA 92110
619-299-3232; fax: 619-299-8709

Remember, the Art Collector has a selection process for the work it represents. If your work is selected, there is a onetime fee of $200 to $300 to have your work mounted on the Internet. This is considerably less than other Internet art gallery offerings currently being mailed to artists, which often require a monthly fee. Be sure to consider these costs carefully, as some Internet resources charge a monthly fee.

The Artist Online

As we head into the twenty-first century, many resources we used to see on paper are now available on the World Wide Web. Here is a partial listing; more art sites being added every day:

Art Dealers of America: *www.artdealers.org*
Art Magazines: *www.enews.com/ren-room/art/art.html*
Art Museum Listing: *www.figi.com/iar/indexes/comp.museum.html*
Art Now Gallery Guide On-line. For the address, call 908-638-5255.

Artists Space: *www.avsi.com/artistsspace*
ArtNet News: *www.teleport.com/~cedarbay/index.html*
artnetweb: *artnetweb.com/artnetweb/index1.html*
Arts Wire: *www.artswire.org/Artswire/www/awfront.html*
ARTscope Internet Gallery: *artscope.com*
ArtsEdge Kennedy Center: *artsedge.kennedy-center.org*
ArtsNet: *www.artsnet.heinz.cmu.edu*
Artsource: *www.uky.edu/Artsource/general.html*
Christie's: *www.christies.com/Christie.html*
Contemporary Art Site: *www.tractor.com*
Echo (includes Whitney Museum): *www.echonyc.com*
Fine Art Forum Resources: *www.msstate.edu/Fineart_Online/art-resources*
Foundation Center: *fdncenter.org*
Journal of Contemporary Art: *www.thing.net/jca*
Los Angeles County Museum: *www.lacma.org*
Metropolitan Museum of Art: *www.metmuseum.org*
National Association of Fine Artists: *www.nafa.com*
Potomac American Gallery: *www.michelangelo.com/potomac*
Sotheby's: *www.sothebys.com*
Urban Desires: *www.desires.com*
Voice of the Shuttle: *humanitas.ucsb.edu/shuttle/art.html*
World Wide Arts Resources: *www.concourse.com/wwar/defaultnew.html*

Search Engines

alta vista: *www.altavista.com*
Infoseek: *www.infoseek.com*
Lycos: *www.lycos.com*
Yahoo!: *www.yahoo.com*

Part II
Your Creative Edge

CHAPTER 11

Getting Competitive: Stuff You'll Need

Business people are constantly reminded to keep their skills up-to-date in order to stay "marketable." I think this applies to artists, too. We chafe a bit at the word "marketable," but maybe we can find a replacement—"desirable," how's that? Yes, in order for your artwork to stay or become desirable, you must keep your presentation skills up-to-date. It also helps if you learn to connect with other artists, art groups, and high-profile organizations that have the ability to help you along. You are much less likely to sell art by keeping to the studio than if you are out and about where art is being discussed and plans for exhibits are being formed.

Making it easy for you to keep up with those people who might someday buy art from you is important, too. You'll have to decide how you want to keep up with these prospects, but you'll certainly want to get their addresses organized for large mailings. Don't forget those who have already bought your work, as they will often buy again and they now have a stake in your success. We don't give our previous buyers enough attention. More than almost anyone else,

137

they can add to our sales figures with a minimum of effort on our part.

Stay in touch with all of them. I suggest you set aside a campaign week or a designated period of time for organizing these addresses and, whether you do it on your computer or keep a list on index cards, *get it done*. If there are certain names that you always contact, mark them with an asterisk so finding them will be faster.

Like any other small business, you'll need to make investments in yourself and your art because you are the business. Investments worth making are the purchase of a computer, some organizational software (see later in the chapter), and professional photography of your artwork. Good framing is always money well spent. It enables you to raise the price of your artwork and increases the likelihood that it will be sold. Last summer, a neighbor stopped by my studio on her way to her vacation house in Martha's Vineyard. She offered to take a few pieces of artwork with her and show them to some shopowners she knew there who might take them on consignment. Unfortunately, she came at the last minute and I had few pieces framed. Things like this happen every day, and it helps to have a few things framed and ready when such an opportunity arises.

As some of you may know if you have written to me with questions or comments, you may or may not get a response. I confess to you now that in the past this was usually because your note or the piece of paper with your name and address simply slipped off my worktable, never to be seen again. To be honest, my correspondence was haphazard and the cracks into which things fell were getting wider all the time. Those of you who sent me e-mail had better luck because it all stayed in the computer and I couldn't lose you.

I can confess this now because, happily, my problem has been solved. The solution is called ACT!, a software package from the Symantec Corporation. An item in a newsletter by someone I respect described ACT! and prompted me to call for information (800-441-7234, 10:00 A.M. to 8:00 P.M. PST). This is software that

organizes you and sorts you out. ACT! and other similar "contact management" programs, as they are called, were designed originally for salespeople, to help them stay in touch with their many contacts and maintain records of the last contact (meeting, call, or letter) with a potential customer and its result. ACT! can accomplish a lot for artists. By putting all of your art contacts and prospects in one place, you can't lose important slips of paper with leads you meant to follow-up.

Some artists don't like computers, but they are part of the world we live in now and if you don't have a computer, you'll be using some other form of recordkeeping system that also wasn't designed for artists. So here go more suggestions for using hi-tech equipment to make, and stay in touch with, your art world contacts.

Curators, past art buyers, newsletters to which you subscribe, suppliers–all can be held in your computer as part of a database (source) that you would create in ACT! Once you've entered them all, the names pass before your eyes whenever you scroll down the total list, and nothing goes unnoticed. You can decide to put something off until a later date, but it is an active decision, not something you forgot to do. You can group contacts for a particular event, for example, while at the same time leaving them as individual contacts. You can also make a timeless to-do list that will roll over with each day, but doesn't have to be taken care of right away. When you're ready to make a call, the phone number appears along with a notation of what the call concerns. You can write a letter, or several copies of the same letter, and tell the computer who should get them. Then, while you are printing them, it will ask if you want to keep a record of the letter with the contact's history. By saying yes, you will avoid wondering later if you told so-and-so about a certain event or art sale you made. For busy artists, who may have a daytime job "on the side," you can print a list of things you need to do, with phone numbers included, at the start of your day and carry it with you. I am amazed at how much more I get accomplished doing this.

I'll admit I had to modify some of the choices the program of-

fered me. For instance, my phone calls are about following-up on slide packets, checking exhibition dates, or asking who the new person is that I should be addressing–not, as ACT! had listed, topics like getting the order, shipping the goods, or asking for a repeat order. But it's simple to customize these options to fit your art life.

ACT! is easy to install and costs about $140, and the price includes ninety days of free tech support and sixty days to return the program for a full refund. Symantec can also be reached through the online service CompuServe, which has a library of ACT!'s frequently asked questions (GOSYMANTEC).

Entering information into my database (104 contacts and prospects) took almost two weeks and is definitely the slowest part of using ACT! The program will hold thousands of contacts, which can be easily added or deleted. Large national computer retailers like CompUSA offer a training class for ACT! and there is an *ACT! for Dummies* paperback available in bookstores. The software's manual is well written and comes with the original kit.

ACT! can readily instill a sense of guilt if you don't do the things you said you were going to do. A box will appear and, almost like Mom, ask you if that task was completed successfully. Of course, you can lie to the box.

Even if you haven't invested in a computer yet, I'm sure you have thought about it. When you finally buy one, keep this software in mind. Other software with similar features are:

- Avantos ManagePro, 800-282-6867
- Elan Software's Goldmine, 800-654-3526
- Day-Timer Technologies' Day-Timer Organizer and Day-Timer Address Book, 800-225-5005
- Lotus Organizer, 800-553-4270
- Microsoft Schedule Plus, 800-426-9400
- Modatech Maximizer, 800-804-6299
- Netmanage ECCO Professional, 800-457-4243, 800-221-4010
- Outlook Software's Schedule It!, 214-774-0708
- Softkey's Day Planner Pro, 617-494-1450
- Starfish Software's Sidekick, 408-461-5800

It's good to be aware of what these tools can do for you and what you can accomplish with them. As always, it helps you to know all your options. By using these types of programs, you'll always stay on top of your other art—your art business.

Brochures

A colorful brochure about you and your art can help bring sales inquiries and exhibition possibilities to your door. Producing any kind of brochure will cost you a considerable amount of money. That's why I asked someone who knows about brochures to help: Dennis Duffy, a printing and reproduction guru who has helped hundreds of artists with the design and production of their postcards and brochures.

Dennis is the contact person for artists who use the Carl Sebastian Colour facility in Kansas City, Missouri. (For a free catalog, samples, and prices, call 800-825-0381.) Sebastian Colour makes postcards and other promotional materials, as well as brochures, and has no trouble working with out-of-state artists. The company is very accessible by phone, your phone calls are returned, and you'll receive a proof to approve before printing. I asked Dennis a number of questions concerning the printing of artists' brochures.

PH: What points need to be considered before embarking on a brochure?

DD: I find that most artists have very specific ideas about how they want their brochure to look. The process usually begins with an exchange of ideas over the phone and layouts being faxed so that we can give the artist an estimate of the cost and a timetable.

PH: What considerations should go into planning the size of the brochure the artist wants?

DD: The size depends on the amount of material the artist wishes to present. Nine by twelve and eight by nine inches are popular because they fold evenly to fit in a standard business (#10) envelope. These sizes will create a four- or six-panel brochure. We make a concerted effort to help the artist find the best possible layout to fit his or her budget as well as image. This can mean placing all of the full-color images on one side of the brochure, with one or two colors on the opposite side for the information and credits.

PH: What about different kinds of paper—high-gloss, matte, or a linen-weave finish? Which one is best?

DD: To a large extent, that will depend on the subject matter in the artist's work. You might want a matte finish for works with a somber tone where a high-gloss finish would detract. Or a high-gloss paper for geometric art, where any texture might detract. Similarly, if you are a sculptor, working in stone, a matte-finish paper might echo the stone's surface.

PH: What weight of paper works best for a brochure? Can this affect mailing costs?

DD: The paper weight and ink absorbency will have an effect on mailing costs. We typically print brochures on one hundred-pound paper (this means that a ream, five hundred pages, will weigh one hundred pounds) and apply a coating to both sides. You want it to be heavy enough that what's on the opposite side doesn't show through.

PH: What common mistakes do artists seem to make when they produce a brochure?

DD: They may need assistance with the mechanical aspects. Once they create a rough mockup, they will need to get camera-ready art produced, proofread, and send the materials to us. (Note: It's im-

portant to proofread very carefully. Errors occur where you assume that you've carefully checked the text, and we artists are often so wrapped up in the images that we forget to pay enough attention to this part. I once put the wrong year on a postcard. I had to reprint, and my card costs doubled!)

PH: How many photos can be used, and how do you want them—as slides, prints, black and white or color, or a mixed batch?

DD: Again, that may depend on the purpose for the brochure and the subject matter. We can use slides, transparencies, or color prints as well as original flat art for reproduction purposes. Black-and-white images are usually reproduced as halftones, but we have had photographers who asked for their black-and-white photos to be color separated, as is done for color photos, because they feel that the imagery comes out clearer this way. As for how many photos will be integrated into the piece, that's up to the artist. Electronic files provided on discs are a recent development and one way of providing us with camera-ready art.

PH: What about the use of color as a background? Does this add to the cost?

DD: The most cost-effective color background is created as a screen build, that is several colors printed over each other. For darker colors, we would print color over color, building up the base, darker each time. A solid black background is achieved by mixing 100 percent black with 40 percent cyan (blue). A black brochure with a lighter colored text can be very striking, too. (Note: Artists should be aware that heavy ink coverage usually costs more and may require scoring the paper before folding, which is also an extra charge.)

PH: What kinds of typefaces are usually chosen?

DD: Typeface is strictly up to the artist and varies with each piece. Something easy to read, such as Times Roman or Helvetica, is a common choice. Computers offer so many kinds of typefaces now that an artist can play around more and see the results before he or she has to select one.

PH: Are brochures always mailed out in envelopes, and how can you judge correct fit?

DD: Brochures can be mailed with a dot adhesive closure or a staple, but they are usually sent in an envelope, mainly to protect the piece. We advise the artist to shop around locally for an envelope to avoid shipping costs. If, however, they want us to provide an envelope, we'll do it. We'll also help plan for a size adjustment to fit the envelope, if requested.

PH: How can you tell if a brochure is a success? What percentage is a good response?

DD: Of course, it depends on how many pieces are mailed. My company would be delighted with a 2 percent response from our catalog mailing, which is sent to a diverse prospect base. If you only sent out ten pieces, a single response would be 10 percent, but that would still only be one call. If you mailed one thousand pieces, 10 percent would be one hundred calls. An artist mailing to a more streamlined target base will enjoy a much better response ratio. You can tell if there is interest within a week of your mailing. Telephone queries and questions will tell you that your piece has been received.

PH: Now for the cost. What should an artist expect to spend for a brochure?

DD: At Carl Sebastian, $1,700 to $2,300 for 2,500 copies of a three-panel brochure printed on both sides, depending upon the size.

PH: How about pictures of the artist? What have you observed about this?

DD: We've featured pictures of an artist standing before his or her work in a shop, sitting with a dog, out in a natural setting, or with family. A brochure is like a show. It provides general information and tells how to get in touch with the artist. It also might tell background information, such as how the work came to be. Whether it is to introduce the artist or to celebrate a particular group of work, it should speak clearly, with one voice.

I decided to look further and put out a call for artists' brochures. From the samples I received, it was clear that artists' brochures can be used many ways. First as a mailing piece for a single event. But also as marketing tools for reaching possible art collectors. Not long ago I received a batch of brochures that were used much like a postcard would be. They were printed on one side only (which made them less expensive) and allowed them to be posted on walls throughout SoHo as well as mailed. They were about eleven by fourteen inches and folded in half, and folded in half again. One of them had a gallery address on the back, so it was probably sealed with an adhesive dot and mailed without an envelope.

Another thing I soon came to see was that the whole idea of brochures changes from artist to artist. Some sent me what I would call catalogs, but after reflecting on this I can see how they might be considered a selling tool as well. Some used heavier paper, almost card stock, which gave the pieces a more permanent ("should be kept") feeling.

I noticed that the most appealing brochures left open space and didn't try to fill every inch. The printing was in a larger type (at least 10 point) so that it didn't look dense on the page. There was an airy quality that was very attractive. Inquiries were invited in a straightforward way, usually with a sentence across the bottom of the last page saying, "The artist invites inquiries." A fellow arts writer,

Debora Meltz, encloses a separate SASE with her brochure, which gets mailed back to her if there is interest.

With brochures, artists are walking a fine line between commercial and artistic. That doesn't mean a brochure can't be both, but artists should be sure to stay away from heavy-handed marketing and tread lightly, lest you risk damaging your aesthetic reputation.

Here's another thought about using a photo of yourself–a closeup seems to work best. I think this may have been evident first in classical musicians' photos. Because it is impossible to show what they do (sing or play an instrument), they opted for friendly up-close shots that clearly connect the subject and the viewer. Study their publicity shots next time you attend a musical event or pass a concert hall and you'll see what I mean.

One of the most intriguing artist pictures I've seen was of a female artist holding her toddler on a stool in her studio. Both of them were laughing. I hate those profile shots of the brooding artist staring off into the distance. They look so dated, like book jacket photos from the 1940s. That wouldn't entice me to make inquiries!

My neighbor, who is now putting together a catalog, points out that photographs of the artist seem to appear rarely in catalogs, while they almost are always part of a brochure. Catalogs and brochures are two very different animals. A brochure should invite the viewer to become interested enough to contact you. You're evident participation in the piece, and a photo of you, is more necessary. On the other hand, a catalog traditionally celebrates the work and can and should present the work independently of you, the artist. I think this is because catalogs begin as accompaniments to exhibitions and are prepared by the organization or gallery sponsoring them. Because of the obvious expense they require, catalogs tend to place more emphasis on the *value* of the work than a brochure, with limited space, is able to do.

Catalog Tip

Have you ever noticed in a catalog that the pages seem to have a matte finish, but the art on the page seems to shine? This is achieved by a process called spot varnishing. The reverse, spot varnishing around the art, can be highly effective for heightening the dryness of an art form like pastel. Processes like spot varnishing will add to your cost, but its good to know about them in achieving the final effect you want. Ask your printer about the cost and your options.

Your brochure is not the place to mention the price of your work. Rather, it should be a moodsetter, a way to entice an inquiry. I've seen brochures by artists who included poetry if it was appropriate to their theme. Sometimes a quotation might be an apt starter, too, but be sure you credit your source.

For your first brochure effort, you may want the services of a graphic designer. Many of you have been trained in graphic design already. You know about layout, spacing, and where a photo can give a real punch to a page or pamphlet. For artists who lack a background in graphic design, it may be worth what it will cost to get the help of someone who does it all the time, even just to hold your hand through the process. There are several areas where a graphic designer may be able to help you do a better job. One of these is color reproduction, which can be very complicated.

When you send a postcard or brochure to press, it will probably be printed on one large sheet with other items. Because the pressman will try to balance the color in all the pieces, compromises in color will have to be made. A graphic designer working on your brochure can accompany your work to the printing press and can say if the proofs are too red, need more yellow, etc. Especially when you are sending several color photos for one brochure, having a graphic designer there to give guidance while it is being printed can be important. Of course, there is a cost factor. But all in all, it's a question of care. A graphic designer is trained to manipulate items

on a page. Processes like spot varnishing will make an artwork stand out. Since graphic designers deal with such matters every day, they can bring their skills to your project.

When you meet with a graphic designer to discuss your brochure, you should bring good slides; clean, sharp copy (the text that will go into the finished brochure); and a clear idea of who the brochure is meant to reach. For instance, is it a prestige brochure designed to be a work of art in itself, which you may be mailing to museums and wealthy collectors? Or is it for a wider range of different prospects? Before you start investing, you should have an idea of how highly designed you want your piece to be. In turn, the graphic designer will be able to give you an idea of how size, number of reproductions, number of colors employed, and other factors will affect the cost and the design of the brochure.

The art you choose for a brochure should reflect one aspect of your work, in order to avoid a "group show" look when, in fact, you are the only artist. Many artists work in several styles or types of art almost simultaneously. Collage, prints, and drawings may all come from a single artist. However, they are rarely shown together, except in a retrospective. To make a strong impression, it is a good idea to keep to a single type of work, especially given the limited size of the brochure. Multiple similar images concentrate and reinforce your style. Think of Monet—see what I mean?

Eventually, as I'm sure you've guessed by now, you may need more than one brochure—one that introduces your *oeuvre* or overall style and another that focuses on a particular style or medium—to have maximum impact. But brochures are definitely market stimulators. No doubt about it.

Postcards

While we are on the subject of stimulating your markets, let's not forget the use of postcards. If you're having an exhibition in the near future, the right postcard can reach potential buyers, art consultants, the art press, and just plain well wishers. Even if you're not

scheduled to exhibit, you can certainly make use of a well-designed postcard as a market stimulator.

The importance of good postcards was brought to my attention after I received a phone call from someone who had seen one of my postcards pinned to a wall above someone else's desk in a museum. She contacted the owner of the gallery where the show had been held, who, in turn, called to alert me that a collector was interested in my work. This gallery owner wasn't after a commission, either—just doing me a kind favor. The show announced by that card had occurred more than two years before the call. Although the collector was quite taken with the card, she never saw the show. There are many reasons for devoting time and attention to the design of your postcards, and the primary one comes through in the example just given: *many more people will see your card than will ever see your show*. A card with a strong visual image—your artwork—will enhance office walls and living quarters all over town and beyond, making your exhibition continue long after the last painting has been removed from the wall.

Another thought: suppose your work has changed a lot. People who are familiar with your work may expect to see seascapes, only to find that you are now into knotted ropes and conceptual art. Nothing wrong with that, except that people are creatures of habit and might need a little time to absorb the change. Your new postcard will give its recipients time to digest the latest development in your work and adjust to changes at their leisure. When they see your work in person next time, the change won't carry with it the surprise that the unexpected can often bring. Art consultants and others who have pigeonholed you and your work will see that you have more than one side. Ask your postcard printer to run some of your cards with blank backs and you can use them for correspondence for years to come.

The technology of printing cards has changed much in recent years and as a result prices have been reduced considerably. Where a four-color card once cost in the neighborhood of $800, many companies today offer high-quality color cards for less than $100.

If you only need several hundred cards for a mailing, this is a windfall, allowing you to have more images printed in limited quantities for future use. Two good postcard sources are:

Modern Postcard
6354 Corte del Abeto #E
Carlsbad, CA 92009
800-959-8365; fax: 619-431-1939

Carl Sebastian Colour
436 East Bannister Road
Kansas City, MO 64131
800-825-038

Where Are You Going? Where Do You Want to Be?

We artists often give away control of our careers when we leave the future up to others. By building a network/card file system of leads to various markets, we have a way of empowering ourselves. Through the design and use of proposals as a selling tool, we come to see the whole world as a stage for showing our work. Grants, large arts organizations, and galleries were once the engines for moving artists' careers. The ivory towers that were at once both an artist's protection and imprisonment are gone now. Today's budget cuts in many programs at the National Endowment for the Arts, as well as increased competition for gallery representation and the weakened state of many galleries, have forced artists to find new methods for shaping art careers that are flexible and self-sufficient.

Build your career and expand your choices. Ask yourself where you will be when your next project is completed. Will you have established some big-name friends, including corporations, who can be called upon to extend themselves on your behalf?

After an exhibition I curated at a bank in SoHo had ended, I needed several VCR monitors for a panel discussion I was to host at an artists' chat group. I remembered the VCRs we had used in the show at the bank and wrote to see if I could borrow them. The

bank said yes, I got the VCRs I needed, and we are on great terms to this day. Suppose you need a reference for an upcoming project. High praise from a bank or large corporation is the best reference you could get, and if you've worked successfully with them in the past, you will be much more likely to receive it. These are several reasons why you want to keep in touch with people from places where you have done successful work.

It's encouraging to see that many art schools are now offering basic art business courses along with studio classes. Obviously they are meeting a demand that has been voiced by both the established art world and prospective students. Arts councils, too, are carrying their share of the load of educating artists, though some are doing a better job than others.

As the art world changes, we must, too. Let's consider the areas where we need to keep up-to-date. The following are ways to become and stay current.

- You should keep up with new artists' materials. Even if you choose to sculpt in stuff that's been around for years, potential art buyers with whom you come in contact will feel more secure purchasing your work if they feel that "this artist really knows his field."

- Young buyers are particularly impressed with how thoroughly you've researched your specialty, and you might find something new you'd really like to try out. Periodic trips to the art supply store, when you have time to chat with the personnel, will keep you current. Order catalogs from supply houses that offer them. One favorite I recommend is Bark Frameworks' Preservation/Conservation Framing. Their *Picture Framing* magazine supplement has lots of good information on environmental factors, paper, materials, and techniques. Send $3 for shipping and handling to:

Bark Frameworks, Inc.
85 Grand Street
New York, NY 10013

Another favorite is the current catalog from Talas, a company that specializes in glues, artists' book supplies, and new solvents. Send $5 for shipping and handling to:

Talas, Inc.
568 Broadway
New York, NY 10012

Bear with their shipping and handling charges. Believe me, you'll keep these two catalogs forever.

- It is not a good time to appear to be a starving artist. Better to be a rising star to which your buyers will want to hitch their wagons while your work is still affordable, before your prices zoom heavenward and your work becomes impossible to acquire.

- When studio time is slow, or you are away from your work, use the time to think about topics you'll want to mention in conversation with others you meet. This came home to me not long ago, when I received a call from an art world acquaintance whom I rarely see. We talked for a few minutes, I congratulated her on her recent grant, and it was only after we had hung up that I remembered that I had wanted to tell her about my new project!

- As I've said before, one of the best ways to stay current in the art world is by subscribing to lots of newsletters. By perusing them at odd moments, such as on the bus or while you're stuck in traffic, you will be on top of topics to discuss and ask questions about when you see others in the arts. I've found the information they offer will easily repay the small investment they require and also give you the feeling of being connected when you may be suffering from a feeling of isolation—a frequent complaint among our lot.

All the ideas mentioned here won't improve your artwork. Only studio time will do that. They won't make you trendy, either, but they will give you an edge over artists who are still doing everything

the old-fashioned way and who, whenever they meet you, always grouse about the art world. Come to think of it, that's out of date, too.

Tell Me About Your Work

Does an inquiry like this throw you into a panic? It used to make me completely tongue-tied. I think artists often have a very hard time explaining their artwork. For me it was difficult because it was a struggle to find the right words and because I cared about it so much. To this day I know artists who get teary-eyed and mute when queried about their art. Nevertheless, sooner or later you will find yourself asked to explain in a thousand words what your art is all about.

Why is it so painful? Maybe because artists are visual people. Strong eye-hand coordination enables us to work with an object or idea until it appears perfect. But perhaps because we've worked so hard on polishing our visual sense, we've neglected our verbal abilities.

A good goal would be to strengthen your verbal skills as they relate to your visual ones. Talking intelligently about your work–its content, the technical approach you have evolved, your use of color, anecdotes about how a work was created–can open many doors. It can produce more sales, arouse art world interest, or simply establish or strengthen your credibility with the public as a serious, thoughtful, eloquent artist.

We all know at least one artist who always has volumes to say about his or her work, and the words seem to flow effortlessly. This was brought home to me one night, a few summers ago, as I watched a television program spotlighting art in local neighborhoods. Several artists whose projects were being discussed were introduced. Within minutes it became clear how well they could talk about their art. Granted, they were well rehearsed for the broadcast, but I was devastated, thinking how poorly I communicated about a subject so terribly important to me. We are often alone for long hours in

the studio and this, among other reasons mentioned here, may account for our seeming inability to interact with people as easily as others do. Verbal spontaneity withers. Introspection, much as one loves it, becomes an albatross.

After mucking about in this depressing marsh for a day or two, I decided it was up to me to bridge this gap. I was looking for a nuts-and-bolts, inexpensive way to polish up my act. I decided to conscientiously start talking about my art *out loud.*

Since this idea scared me to death, I figured I'd better begin with strangers. Why fall on your face in front of people you know? A good available audience, I thought, might be senior citizens. I cooked up a talk stressing everyday language and simple facts about how I made my work. I avoided the baroque language of art school and the vague dressed-to-impress lingo from the art magazines. I used slides to demonstrate the talk and practiced in front of a full-length mirror. Finally, I called a nearby nursing home and asked to be connected to the activities office. I introduced myself and launched into my idea. I proposed a short talk about my work, to last thirty minutes, with time for questions at the end. The activities officer was pleasant, but unable to offer me any pay. I said that as this was a new project for me and I needed feedback, I would be willing to give the talk gratis. We set a date and I found myself committed to speak in public, but not without apprehension.

How did it go? Well, some people fell asleep. (Later, I learned that this often happens at an after-lunch program.) Some people had difficulty hearing me. This we remedied with a microphone, with which, I confess, I was not entirely at ease. But most of the audience loved it. They asked good questions and I learned a lot.

After that, I went to every nursing home I could find. The questions people asked tended to be similar, so I got pretty good at answering them. The activities offices would print up colorful circulars describing me in very flattering terms. (Ask for extra copies—they are good additions to the back of your portfolio.)

Next, I tried the public library, which offers senior-activity programming in the afternoons. I was paid $50 for a talk lasting ninety

minutes and was invited back for paid speaking engagements at four other branches. The talks had some ups and downs. Attendance depended somewhat on the weather, and at times only three or four people showed up. Once, a thunderstorm made much of my speech inaudible. Little by little, though, it became easier to do. I'd pick out someone who looked friendly and make eye contact, speaking directly to him or her until my initial nervousness was gone.

The most important thing these talks did was give me confidence. This kind of audience is usually seated informally and is casually dressed. Very often these groups convey a sense of gratitude that you've come to talk to them and this prompts me to try to be as good a speaker as possible. Many times people came forward and asked to be put on my mailing list.

But the benefits haven't stopped with love and admiration. The nursing home at which I made my debut later sponsored me for a grant to paint murals in its dining room. From all of the organizations where I have spoken, I have received glowing letters telling me how much they appreciated my talks. These letters on official stationery provide valuable evidence of my community involvement, and I've included them in various grant applications as backup documentation. A whole new category has opened up on my résumé. Called "Lectures and Talks," it gives me something else to broaden the conversation when I approach a gallery owner or museum curator.

Books on public speaking can help with the form of your talk. Although it is not essential, you will find that having your own slide projector is helpful in ensuring that your slide carousel will fit properly, and extension cords are handy so the cords can reach outlets. Double-check to see that your slides are in the order in which you plan to use them and inserted so they will appear right side up.

If you create at least two lectures a month, I predict that in six months or less you will have conquered any reticence you feel when asked to talk about your work, and you will have gained the practice necessary to speak both eloquently and easily. You will also write better letters and artist's statements.

To be a self-sufficient artist, one simple tool you already have, but may not have thought of, is a telephone directory. How are you listed in your telephone directory? Are you listed so that dealers, collectors, and curators can easily find you—by the name that appears on your work and on your postcards?

Most well-known artists are listed. They don't necessarily list an address, but they don't want to be inaccessible either, and neither should you. I once got an interview with Joyce Kozloff, known for her artwork in public spaces, by searching through the phone directory. In fact, she answered the call herself.

Another way to stay in the public eye and easily promote your work is by using business cards. Making and using them is usually a project that we plan to take care of someday, but it often gets put on the back burner when another, bigger project comes along. Whether you want to design the card yourself or opt for a standard format, *having* them isn't enough. Carrying them at all times has got to be a habit, like carrying your drivers' license or other identification. People to whom you give a card will put it in their address book and keep it. You won't get lost. If you list your phone number, but its a home number and you'd rather not receive business calls there (with your German shepherd baying in the background), offer at least one other way you can be reached, such as e-mail or a studio address. You might want to rent a mail box (they're not terribly expensive now) for dealing with art business, and put its address on your cards.

An annual newsletter that brings everyone on your mailing list up-to-date on your activities is a good idea. You might want to send it out during the year-end holidays when people like to receive greetings from friends far and near. Keep it short, but include all the activities you want them to know about. Be sure to mention jurying experiences, art associations you've joined or in which you are an officer, and don't forget that artists' lives are exotic and different from those most people lead. If you've traveled to interesting places and visited museums or landmarks that have inspired your work, tell them. Of course, you'll want to mention sales, exhibitions you

took part in, corporate showings, and upcoming events. If you adopt a chatty, friendly tone and avoid the hard sell, they will be glad to hear from you and have good feelings about you. (Do not mention how hard times are or how much you may need funds, even if this is so!) Make these contacts the bridge between you and your prospective buyers and you'll see that it will make the selling of your work go easier when the time comes for the big push.

Don't wait until you are faced with an upcoming exhibition to prepare a mailing list. Chances are, you'll be so bogged down with framing, hanging the show, doing the publicity, and all the other required tasks that the mailing list will be the last thing to get your attention. Instead, do it now, while you have the time to give it attention and construct it so that it will to serve you well in the future.

Slide Registries

You may think that slide registries are rarely used, hidden away resources that do not deserve your time. But I think that slide registries are one of the great underutilized resources that we artists have. Consider this: a whole group of largely nonprofit organizations that at no charge (or a minimal one) to you, will act on your behalf, showing your work to curators, gallery owners, private dealers, and potential buyers. What would that service cost you if you had to construct it and fund it yourself? Yet we always have something more glamorous to take care of, and if there is something we don't have time to do, this is usually the area that has to wait. Like a good résumé, though, slide registries are out there working for you, an unpaid employee, while you may not have the time to handle these aspects of your career.

There are several preparatory steps you will need to take before going to the registries near you. First-rate slides of your work are essential. I find that the cost of having slides made is less daunting if I can get them done as I finish each piece of work. If you suddenly have a bill from your photographer for slides of twenty art-

works, that is going to take a real bite out of your budget. You should analyze whether you can have dupes made for less than the photographer is charging you.

Next, you have to tackle the labeling process. It is important that your labels are thorough, accurate, and legible. *Measure* those paintings, don't guess how big they are. Decide which twenty slides will comprise your ideal slide sheet, then make multiples of that ideal set. You will likely find that substitutions are necessary, but stick to the original plan as long as you can. Make as many sets as you can. *Never* send out your original slides, as you will need them again to make more duplicates and you won't want to be held up waiting for their return before you can send more out. I've gotten slides back up to two years after they went out. That's putting others in control of your career, which they may often seem to be, anyway.

If you have decided to take your own slides, maybe it's finally time to read up on how to do the best job. There are several very good books on the subject, among them, *Photographing Your Artwork: A Step-By-Step Guide to Taking High-Quality Slides at an Affordable Price* by Russell Hart. (North Light Books, Cincinnati, Ohio, 128 pages, $19.99). How about taking advantage of a class or seminar specializing in art photography? Or call a photographer whom you know and arrange for a tutorial or one-on-one session on how to capture your work at its very best.

The Best Slides

Artists traditionally dislike slides of their work. Don't expect the photographic reproduction to match your original. On the other hand, by correctly lighting your artwork, getting the best film type and correct F-stops, and eliminating unnecessary background distractions, you can produce slides that will serve your work well at the slide registries and can get positive results for you.

The next step in preparing to leave slides at a registry—and this is true whether you are dropping them off or mailing them—is to

update your résumé. This means not only listing details of your last show, but a current phone number, address, and zip code. If you are moving, list both old and new addresses, giving an effective date for the new one (e.g., "After November 1"). As a curator, nothing is more frustrating than finding an artist whose work you want to use in a show, then discovering that he or she has disappeared. Even if you are unsure of where you'll be, put a "can also be reached through" phone number on your résumé. It is more professional and you won't miss an important call.

If you have a standard slide sheet–one that is identical in terms of the slides you've included–it's a good idea to prepare a slide list, giving the titles, measurements, and media of all the works. In visiting registries as a freelance curator, I've found that the easier it is to look, the more inclined I am to do so. Include a copy of your slide list and résumé wherever you leave your slides. These are the parts that may disappear from your folder at the registry first, so stop by every three to six months to be sure that all the parts are still there, providing up-to-date replacements if necessary.

Find out the days and times that the registries are open to accept new slides. One person is usually in charge of the slide file, and you should make every effort to get his or her name and to make a favorable impression. These individuals can be of great help to you and it's worth the small amount of time it takes to talk to them and develop a good relationship. Although they are often interns or volunteers, they sometimes curate shows of works from the slide files and they could include your work. They'll appreciate your attention, too.

The last step in getting your slides into a registry is the most important. This is something to which I've given a lot of thought lately. You'll receive a form from the registry concerning where your art fits. Categories will be listed, such as painting, drawing, and sculpture, that are fairly straightforward, but also others that are more ambiguous, such as mixed media and collage. Ordinarily, I would check one of these, perhaps collage, since my work is largely collage with painted backgrounds. But think about it. How many

curators come into a slide registry planning a show strictly of collage work? Don't you think that more of them are curating a painting show? Am I not cutting myself off from their consideration by isolating myself in a marginal and much less used area called collage? Put another way, whose slides have a better chance of being seen, an artist who puts his slides in a popular category like painting or the one who chooses a category like collage or mixed media? It may seem like a minute point, but I believe we control our careers more than we think, so let's carefully consider where we put ourselves and how we classify our work. If the guests at a registry don't see our slides, it may be because of the category we've chosen for them. Take an extra set of slides and ask if you can put your work into more than one section of the files. Check off more than one category for your work.

Also, most slide files are set up so that two of your slides are put into a mixed carousel, allowing the viewer to see the work of many artists at one sitting. That way, they can weed out work that is not of the style or content specifically sought. You will need to bring two of your best slides for the carousel, as well as for your sheet of twenty works. Be sure that those two are included again on the sheet of twenty, so that they are visible in both places.

A recent development has occurred in slide registries and requires us to think about how new technology is tapping us on the shoulder. A note in the nonprofit newsletter that arrived the other day was a wake-up call, no doubt about it. It said that the organization's artist slide file would no longer be accepting slides. From now on, the organization would like to receive artists' images on Kodak PhotoCDs. Now I know a CD when I meet one, but a Photo CD to hold images? Nevertheless, as artists we have to live with the technology of today, so I set about finding out exactly what this was, how to make it happen, what it would cost, and what pitfalls I would have to avoid. I know this arts organization, and if it was converting slide files to CD-ROM images, this major change implied that many museums, curators, and other exhibition spaces already wanted work presented that way.

The *slide* registry is actually becoming a *digital* registry, where artwork is viewed on a computer with CD-ROM capabilities and Kodak PhotoCD Access Plus software. The computer allows the viewer to search for different categories of art and retrieve the images easily. The organization that I heard from has plans for a two-year transition period during which they will hold both slides and CDs, gradually phasing out the slides. At my request, the arts organization sent me a new artists' file application form. They explained over the phone that reading this application would answer many of my questions.

Here is how a Photo CD is made. You can either take slides or uncut slide film to a full-service Kodak dealer who will transfer them—actually scan them—onto a CD or to a drop-off photo facility, which will send them to an authorized lab for scanning. Uncut slide film is cheaper to scan than mounted slides. Later, you can add additional slides to your CD if you retrieve it from the registry and drop it off again with the new slides.

Each CD can store up to one hundred images. Full-service dealers take about two days to transfer your slides; a drop-off dealer takes two weeks, but is less expensive. Prices range between $1.50 and $5.00 for each slide, and it will pay to shop around before dropping off slides. The first place I tried wanted $2.50 per slide and gave no price break for making up a second CD; the second would cost as much as the first. This is an element on which artists will need to follow up, as we may need multiple copies of CDs, and right now, slide sets get cheaper when you order more at one time.

To locate the Kodak dealer nearest you, call 1-800-CD-KODAK. Kodak is on the Internet, too, at *www.kodak.com*.

Obviously, one pitfall to avoid is having your slides recorded on the CD in the wrong orientation. Clearly mark slides with an arrow to indicate the top. If a slide is stored in a sheet the wrong way, correcting it is a small matter. On a CD, this small correction is not possible, so mark the tops of all your slides carefully and recheck them again before you leave them with the dealer. Likewise, be sure it is evident, for each side, which side is the front.

To see artists' work on CDs, the viewer arranges for time on a computer at the registry and can first see two images of each artist's work from the arts organization's master disc. Clicking on a selected image allows more of the same artist's work to be retrieved. Artists are advised to choose the two images that they want to have shown first. Unlike slides, this does not mean that you have to provide a second pair of these images for your main cache of images. The organization is able to copy your two selected artworks onto their main disc and at the same time leave them on your disc with your other work. I had felt assaulted when I was first confronted with a strange method for storing my imagery, but the more I learned, the more positive I became about having artwork on a CD.

Slides of our work are very important to us as artists, although a slide is certainly *not* the work itself. This is why artists often hate their slides. They are, quite simply, a necessary evil for sending our work beyond our studio doors. We find fault with the photographer who shot them, blaming that person for the flatness (which is inevitable), the light, the color. Elements like light, color, and texture are what we artists strive to convey, and the time we've spent making the artwork makes us all experts. When the camera records our work, often the characteristics the camera erases are those which *make* a painting. Maybe the PhotoCD will have a luminous quality that was missing when our work was projected onto a screen. Let's hope that the computer and CD won't just place yet another instrument between the artist and the viewer.

Self-Promotion

In an age of specialization, when bookstores are filled with books on how to write the best résumé, it is clear that we artists need to be very savvy and very aware of the small elements of difference that can help our work to be seen. There is a *best* way to accomplish the tasks we have as artists, and that way changes as we understand more about how the process works. We owe it to our work to do everything we can to give it the exposure it deserves.

Consultant Ilise Benun, in her newsletter *The Art of Self-Promotion* (800-737-0783), says there are four main elements to marketing: market research, promotional materials, mailing lists, and follow-up. While she focuses on business rather than the arts, many of her suggestions make good sense for artists, too.

For artists, market research is not always a matter of going to the library to consult a directory of associations, although there are times when this is a solution. More likely your list of prospects grows from functions you've attended, business cards you have collected, and sales your work has produced. Don't forget that art associations often have mailing lists for sale, which include critics, independent curators, and corporate art directors whose addresses would take lots of effort to amass for yourself. These are usually updated regularly, which also makes them a good investment. A mailing list is always a work-in-progress and it is a good idea to set aside a few minutes each week to keep yours up-to-date.

To a large extent, when planning the promotion of your work, the content of your mailing will depend upon whether you are just catching up or publicizing a particular event. Certainly, a return address on everything is essential. It will enable you to update your list based on anything that is returned.

Following up is not necessary if you are just announcing an event, unless it was mailed to press or broadcast media. Then you will want to make phone calls to be sure of coverage. You may, however, wish to send a note to someone who has admired your work. You can even devise a form note on your computer for establishing a relationship so that this task is made easier, too.

You should always include a handwritten note mentioning where and when you have met or the name of the person who suggested you contact the receiver. If you are making a cold call—calling or writing to someone you don't know—you will perhaps want to mention that he or she has a reputation for interest in the arts. Include images of your work—old postcards from past shows are great for this—a résumé, a current price list, and an invitation to visit your studio to see the artwork in person.

Sending something on paper is always better than saying it, because it can be read when the recipient has time to pay attention, unlike at parties or openings, where there is too much diversion. Here, a follow-up call is important, but keep it short. If you're not sure how contacting prospects will work, start with a few—five is a good sampling—and then analyze the results. Like everything else I suggest here, you'll learn what works best for you as you go along. Go over your own performance and polish the parts where you might have felt uncomfortable. It goes without saying, the more you do it, the easier it will become.

Selling work from your studio allows you to present yourself as you wish, and make a friend of your visitor. There is no commission to pay and you are always more comfortable and at ease in your own space. Think of it as the chance to meet new friends who are interested in your work. Often I find that an immediate sale may not occur, but months later I will get a call from someone who has made a studio visit and now has made a decision to brighten up a living space or office. Maybe they just need to do something nice for themselves. It is your mission to start a dialog that may be a long time in coming to fruition. Plant a lot of seeds.

Addressing the self-promotion issue is largely a matter of deciding how and when you want to promote your work. I think to become completely self-sufficient, the artist has to think like a freelance public relations person. Not a day should go by that you're not on the lookout for newer, more concise ways to present yourself and your art to your buying audience. I say "freelance" because in that situation, one is only paid when a new idea is produced. Pretend that you have this client—you—who will only reward or pay you for new ideas. You'd be surprised how many good ideas you can come up with!

Not long ago, I had a conversation with an artist who also curates exhibitions. She has always made a large number of studio visits and, like me, enjoys seeing how other artists go about presenting their work. When we spoke, she was marveling over a recent studio visit she had made.

"He (the artist) treated his work so well," she exclaimed. "Like it was gold–the way he touched and carried it, how he displayed each piece. It was like watching something increase in value before my very eyes!"

For some of you, this will not be astonishing news. For others, it may sound like some ephemeral stuff to which you've never given much thought. They say the best way to sell a house is to bake bread as prospective buyers pass through the rooms. The wonderful aroma will create an atmosphere that helps flatter the thing being offered for sale and creates in the mind of the buyer an image of living in that house and having wonderful home-baked bread. Deceitful? Not at all. Does it heighten the chances of a sale? You bet it does!

In preparation for this book I was led, again and again, to my dictionary to research words like "mystique," "aura," "intuition," "spiritual," and "magical." A person or organization about to buy a work of art is not buying merely the supplies that we have put into it. They perceive in the work some special feeling caught by the artist with which they identify. One of the fallacies of the IRS regulations for donating artworks to museums is that the artist donating his or her own work may take credit for only those supplies he or she used to make the piece, while an art collector who donates the same painting can receive credit for the full-market value of the work at the time it is being contributed. (This is another reason to trade works with other artists, as you then become a "collector" and can claim the full-market deduction otherwise denied to you.) Both conditions, however, are falsehoods, since the real value of the work lies somewhere between the cost of supplies and the market value, in some mysterious place that has been convincingly and movingly reached by the artist. Otherwise, all paintings would be equal, and we know this is not so.

Certainly, a successful painting will succeed whether shown in an alley or in an elegant museum. However, the viewer's ability to successfully enjoy it would be much diminished in the alley. You owe it to your work to create the best possible conditions under which it may be seen.

As artists, we know the nuts and bolts of what goes into our work and what holds it together. Perhaps we are less mystified about our creations than we want our buyers to be. As any of you who have recently had work framed will attest, when framed, the work takes on a slightly different personality. (Likewise, as we have discussed, when it's photographed and in slides.) Now, I am the first to champion showing work that is unframed as well as work that is framed, but for the sake of this argument, bear with me. The framed piece is "dressed up," it has an alert, front-and-center air about it. It is always a surprise to me when I see my work after it has been framed. As if, before, it had promise, but now, suddenly, the laundry has put starch in it.

It is important, too, to treat your work lovingly. Another friend of mine was recently asked to bring in his work to show to his "day job" boss, who had heard that this employee was also a painter. The boss had seen slides and the prospect of a sale seemed imminent. The day of the appointment, my friend hurriedly put several small works in a shopping bag and took them to his employer. He later told me that the boss didn't seem particularly impressed when he looked at the actual work. It could have been for many reasons. Maybe the timing wasn't good. But it also might have been because the works weren't wrapped in any protective packaging or because the shopping bag was from a discount store. And where had the work been shown? These subtle factors cast an atmosphere around your work that may devalue it. Why do you think diamond dealers always show their wares in velvet cases and on a piece of satin in comfortable surroundings where they first invite the viewer to sit down? What is there about removing the beloved item from a glass case that encourages us to believe that it is very precious? Some of it is the anticipation. Mounting anticipation, carefully orchestrated by the seller. Do not discount the element of creating an aura about your work. Plainly and simply, we are talking here about the value that you instill in your art, and the bottom line is dollars. We all admire artists who can sell their work for higher prices and it is time to think about what elements give

that work its increased value. Part of that is the way you treat it and present it.

My nonprofit artists' group, Art Initiatives, has an annual salon show, which is a great opportunity to watch artists arrive with their work and see how they handle it. Some of the work is so well packed, it looks as if it were ready to cross the Himalayas. Other artists seem to run in with their pieces uncovered and flying uncertainly behind them. If they arrive to show their work to prospective buyers in this way, I can understand why they are perceived as less than serious about art. It would be hard to keep a straight face when told that the work was priced at several hundred (or several thousand) dollars. If showing more attention to how and where you present your work—and wrap it and carry it and store it—alters the price you are paid for it, isn't it time to address these issues?

I recently visited an art storage warehouse, specifically to see if they had special viewing areas for works stored there. Say a painter has a work stored, and suddenly a prospective buyer expresses an interest in the piece. To avoid removing the work from storage and taking it elsewhere just to show it, the warehouse provides an area where the art can be shown. The day I visited, a Brancusi was about to be shown. The room I saw was painted gallery white and had lighting as fine as any museum. It was also quiet, away from the typical cacophony of warehouse noise. Visits by collectors had obviously been very well planned to ensure that the work would be shown at its best.

This is not to say that the content of the work will in any way be improved and certainly there are times when ideal conditions don't exist. I recall Dorothy Miller, who was curator of painting and sculpture for many years at the Museum of Modern Art in New York City, telling me about her first visit to see a then-unknown Frank Stella. His works were so large that in order to move them, Stella had to carry them out into the hallway and back into his apartment again. She recalled this incident fondly, and Stella's creative genius was soon recognized, making such maneuvering unnecessary.

Back to my first friend's studio visit. She was impressed, not only

by the way work was shown—with professional hanging equipment in place on the wall, as opposed to one lone nail, which usually causes a work to shift about unevenly—but also by the way the work was put away after the showing. "Not just tossed, or stashed hurriedly with a minimum of care," she told me. "His work," she continued, "was finished and complete from the backside, too."

For some reason, there is the mistaken impression among artists that paintings can be raggedly stapled to a stretcher on the back, or allowed to flap loosely in a haphazard way. Obviously this is part of the *La Bohème* idea of the artist seen as devil-may-care attic dweller, which is a hundred years old and now decidedly out of date. Artists who see themselves as professional and ask prices to match, deliver artwork that is finished and completely crafted front *and* back. Certainly, their attention goes first to the front of a canvas, as it should. But professional attention doesn't stop there. Stretchers that are trued—that is, checked with a T-square for ninety-degree corners—and correctly plumbed so that they hang parallel to or flush with the wall, with stretcher keys inserted to ensure that a corner doesn't shift but remains intact, convey to your prospective buyers that your respect for the condition of the piece deserves to be matched by theirs.

Again, the ball is in your court. If you can convey by your actions that you value the artwork that you so painstakingly make, you will probably send this message to viewers of your work. Then, I would suggest, it is probably time to raise your prices.

Proposals: Best Foot Forward

A proposal is a suggestion, a fully fleshed-out thought, a picture of a future event. Whether you succeed or not in having your proposal accepted will depend largely on how well your plan makes the person who receives it *see* what you want to accomplish. It can advance an idea for a show of your work, an artist's talk, a traveling exhibition, an installation of public art, a mural commission, or artwork to be shown in a corporate space, restaurant, subway station, or airport. It can also be used to outline the value of a proposed stay at an artist's colony.

Often when you send out slides and a presentation packet, the person who receives them likes what he or she sees, but doesn't have a place for you at that moment. They admire the slides and file them away. Many times that person is at work on a particular project and in focusing on that project, hasn't the time to figure out how your work might shine. But if you have a suggestion, an idea, maybe he or she can help you. Knowing your own work better than anyone else, it will be easy for you to present ideas for adapting your work

to many situations, such as outdoor exhibitions, installations, or combining it with the work of other artists.

That is why it is also a good idea to know as much as possible about the person or group to whom you're writing a proposal. By knowing, for instance, that an art consultant plans exhibitions for the so-and-so corporation, you can send slides, make his or her acquaintance, and, at the same time, suggest a way to use your work. A more assertive stance can put your work into his or her follow-up folder for further consideration.

In many situations, all it takes to approach a new market is an exact address, the name of the person to whom you are writing, and a good letter of one or two pages sketching out your idea. In these cases, just be sure your proposal is addressed to the right person—the one who will pass judgement on it. In other cases, however, a more measured approach is going to be necessary.

There are several sources of information that you will certainly need access to. Foremost among these is the Foundation Center, a nonprofit service organization established in 1956. It consists of five professionally staffed libraries—in New York, Washington, DC, Atlanta, Cleveland, and San Francisco—that were established to aid nonprofit organizations in their search for the funding they need to operate. These libraries cooperate with over two hundred coordinating collections across the country that offer local access to core Foundation Center materials. These collections are located in libraries, community foundations, and other nonprofit agencies. The center also publishes handbooks and reference guides that you can purchase. (To order a catalog of their publications or for the location of the Foundation Center nearest you, call 212-620-4230.) They also offer many online services. The New York headquarters has developed a user-friendly Electronic Resource Center with computers and printers so that visitors can have access to online information. A user manual has been developed to aid you in searching specific resources. You can visit their Foundation Center's Web site at *http://fdncenter.org* to get an idea what resources are available.

The Foundation Center headquarters is located at:

79 Fifth Avenue
New York, NY 10003-3076
212-620-4230; fax: 212-807-3677

The center also has field offices at the following locations:

1001 Connecticut Avenue, NW, Suite 938
Washington, DC 20036
202-331-1400; fax: 202-331-1739

50 Hurt Plaza, Suite 150
Atlanta, GA 30303-2914
404-880-0094; fax: 404-880-0087

1422 Euclid Avenue, Suite 1356
Cleveland, OH 44115-2001
216-861-1933; fax: 216-861-1936

312 Sutter Street, Room 312
San Francisco, CA 94108-4314
415-397-0902; fax: 415-397-7670

Grantmakers will be seeking art projects that can reinforce or illustrate their pet causes, so you will need to know all you can about the funders you are approaching. (More about this step later in this chapter.) Often, to reassure the funder that you are making good use of their funds, you will need a fiscal agency or "umbrella" group that has a 501-c-(3) standing (as defined by the Internal Revenue Code) as a certified nonprofit organization to act as a go-between for you and the funder. This group will actually receive your grant money and act as your banker, keeping records of how the funds are spent. Many nonprofits will fill this function for you for a fee—usually a small percentage—if you find that your funder requires it. Be sure that the percentage is comparable to what other groups would charge you. Any nonprofit group—civic, religious, etc.—can act for you and does not necessarily have to have anything to do

with the project you are proposing. Their role is merely to account for the funds.

When you visit a Foundation Center facility, notice the periodicals on display. These can help you get the latest word on what types of nonprofit proposals are currently being funded or what's in style in corporate and foundation giving. Look them over carefully, particularly the *Chronicle of Philanthropy, Foundation Giving Watch,* and *Grantsmanship Center* magazine. You may get a new slant on how to present your proposal, and timeliness is very important in funding. Past years have seen important trends in giving, dealing with such issues as the environment, gender, aging, and AIDS research. In a year when the philanthropic community is swept up in a giving flurry for a particular area, a proposal on another topic sometimes doesn't stand a chance. Presented exactly the same way in another year, the proposal may be in exactly the area the philanthropic community wants to fund. This is why it can take a proposal several tries before it succeeds. Proposal panel members may change from year to year, too. I know a writer who was awarded a Guggenheim Fellowship on her seventeenth try.

What type of proposal to use and why depends both on who the recipient is and the complexity of what you are proposing. New arts funders may need to be convinced more than those who have sought out or funded the works of artists before. While a convincing letter would probably suffice for some grantmakers, others will want to see a budget or other documentation to become convinced of a project's possibilities for success.

The One-Page Proposal

A one-page proposal is the most simple, direct way to propose an idea. This does *not* mean it is the easiest to write. Because it is brief, every word must be selected with careful attention to the subliminal messages it may send.

It is essential to know exactly who will be receiving your letter. In the case of large foundations or corporations, this may be a

project officer–the only person who can move your proposal toward acceptance. Sometimes the project officer is the only actual reader of your proposal, writing a summation page that is placed on the top of the proposal so busy committee members can quickly get the gist of the project. Needless to say, what the project officer writes is invaluably important to your cause.

A phone call can give you the name of the person to whom you should address your proposal, but be aware that you may be speaking to that person, so conduct yourself accordingly. You can verify the address and ask about any deadline for your letter at the same time. See if a formal application form exists or if a letter will suffice. Be sure you ask for the person's title and confirm the spelling of his or her name.

Use of certain words and phrases, sometimes called "action words," can help your proposal connote professionalism. A quick look though the list below will familiarize you with current jargon. You may benefit from sprinkling several of these "can-do" expressions throughout your proposal as you describe what you hope to achieve.

- rebuild
- restore
- revitalize
- enrich
- conceptualize
- develop
- institute
- introduce
- act
- translate
- enlist
- persuade
- organize
- envision
- inspire
- renew
- innovate
- initiate
- spark (as in civic pride)
- create
- fashion
- integrate
- plan
- customize
- address
- influence
- attain
- promote
- comment

These descriptive action words can make your idea come to life, sparkling on the page and helping your prospective funder see the finished image you have in mind.

Below (figs. 1, 2, 3), are examples of "calls for proposals" from two museums and a nonprofit art space. They will let you see the

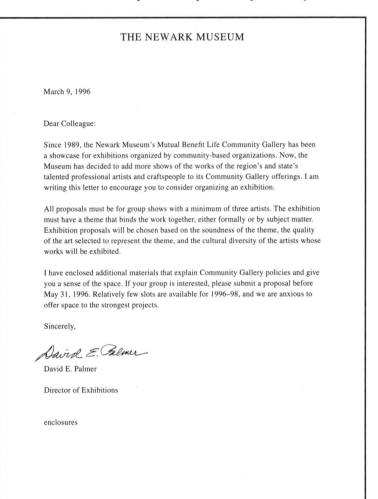

THE NEWARK MUSEUM

March 9, 1996

Dear Colleague:

Since 1989, the Newark Museum's Mutual Benefit Life Community Gallery has been a showcase for exhibitions organized by community-based organizations. Now, the Museum has decided to add more shows of the works of the region's and state's talented professional artists and craftspeople to its Community Gallery offerings. I am writing this letter to encourage you to consider organizing an exhibition.

All proposals must be for group shows with a minimum of three artists. The exhibition must have a theme that binds the work together, either formally or by subject matter. Exhibition proposals will be chosen based on the soundness of the theme, the quality of the art selected to represent the theme, and the cultural diversity of the artists whose works will be exhibited.

I have enclosed additional materials that explain Community Gallery policies and give you a sense of the space. If your group is interested, please submit a proposal before May 31, 1996. Relatively few slots are available for 1996–98, and we are anxious to offer space to the strongest projects.

Sincerely,

David E. Palmer

David E. Palmer

Director of Exhibitions

enclosures

MARY SUE SWEENEY PRICE, DIRECTOR
UNIVERSITY HEIGHTS, 49 WASHINGTON STREET, P.O. BOX 540, NEWARK, NEW JERSEY 0701-0540
TEL 201 596 6550 FAX 201 642 0459 TTY 201 596 6355

Figure 1a.

variety of work being requested and should start you thinking anew about the opportunities open to all artists. Many institutions issue calls for new work every year. Thousands more appear at similar spaces across the country. Check bulletin boards at art centers and college art departments for the latest calls for proposals.

THE NEWARK MUSEUM

**HOW TO SHOW IN THE
MUTUAL BENEFIT LIFE COMMUNITY GALLERY**

Purpose

The Mutual Benefit Life Community Gallery is intended primarily to be used as a space within the Museum where community-based (City, County, State) groups can mount exhibitions. One-person exhibitions are not considered for this space. Exhibitions in the Community Gallery normally remain on view for a period of two months and are scheduled a minimum of one year in advance. The Museum also encourages professional artists from the region and the state to band together to present contemporary art of the highest quality. These exhibitions, which must have a minimum of three artists, should contain works with a common theme, be it formal or subject matter. The Museum may also organize shows for this space on themes relevant to the community.

Procedures

1. Any group wishing to mount an exhibition in the Community Gallery should present a proposal to the Museum detailing the material (or types of materials) to be included. Slides and/or photographs are required. Please send a self-addressed stamped envelope in order for the Museum to return your pictures. Proposals must be received annually, on the dates announced. Notifications will be made in a timely manner. Send your request in writing to: Mrs. Mary Sue Sweeney Price, Director, The Newark Museum, 49 Washington Street, P.O. Box 540, Newark, NJ 07101, Attn: Community Gallery.

2. The Museum's Exhibition Committee will review these proposals on an annual basis. The sub-committee will decide which proposals to accept and develop an ongoing schedule for the Community Gallery.

Special Considerations

Any group proposing an exhibition for the Community Gallery must be able to meet the primary costs and responsibilities of mounting the exhibition. The group must make all arrangements for transporting and insuring the materials on display, with the advice of the appropriate Museum staff. Works must arrive at the Museum ready for exhibition. Installations are the responsibility of the Museum's Exhibition Department.

MARY SUE SWEENEY PRICE, DIRECTOR
UNIVERSITY HEIGHTS, 49 WASHINGTON STREET, P.O. BOX 540, NEWARK, NEW JERSEY 0701-0540
TEL 201 596 6550 FAX 201 642 0459 TTY 201 596 6355

Figure 1b.

If a letter is sufficient for the proposal, explain in the first paragraph why you are writing. This should be followed by details on why you have chosen to write to this particular group, company, or foundation. If the people to whom you are writing have solicited a proposal, this part can be shortened by simply saying, "Enclosed please find my proposal for a series of artist's talks, as your call for proposals dated May 1997 requested." Then, in four or five short sentences, outline your plan, giving where, when, and the relevant details necessary for your idea to be clearly presented. If an exhibition is proposed, be sure to state how many pieces will be included, so that space requirements for the art can be determined. If you know the square footage required, to include it would be helpful. The level of security needed should also be mentioned if it can be determined, as it can affect the budget.

In the next paragraph, explain the unique and timely qualities that your project would address, including ways that make it dovetail with stated desires of the foundation or aims of the corporation. Such aims might include involvement with the community, patriotism, or a desire to celebrate an event important to their customers. You'll be able to determine these by analyzing the types of artists who have been funded by the organization in the past. This information is on the organization's IRS Form 990, on file at the Foundation Center. If any of the recipients live in your area, give them a call and ask for suggestions about how to best approach your prospective funder. Clearly, any organization will have particularly cherished certain ideals, and knowing what these are, you may be able to present your project in a way that reflects them. If you have other well-known sponsors for your project, be sure to mention them here. Don't forget the political friends you made, either (see chapter 9). Their support can be helpful to your proposal.

Finally, explain briefly what funds are needed to realize your project, mentioning any funds already in hand (including in-kind services that have been contributed). Mentioning funds already in hand is to your benefit, even if that amount is small, because it shows that you believe strongly in the project and have already

G

Gaithersburg

A Character Counts! City

CITY OF GAITHERSBURG
COUNCIL FOR THE ARTS

CALL
TO
ARTISTS

1997–1998

PLEASE INCLUDE WITH YOUR APPLICATION:

1. Ten slides of your current work, marked with artist's name, number, title, medium, and dimensions. Be sure to mark the top of each slide.

2. Please complete the list indicating artist's name, slide number, title, medium, dimensions, and year of execution.

3. Current artist's résumé.

4. One page statement about the work and purpose of your show.

5. A $10 application fee, payable by check or money order (no cash please), to the City of Gaithersburg Council for the Arts.

6. All applications must include a self addressed stamped envelope for the return of the slides.

CALL FOR ENTRIES

The Gaithersburg Council for the Arts seeks to promote the "artistic expression and creative excellence from artists in all media." In its locally, nationally and internationally produced art, the Council invites area artists and arts organizations to submit slides and proposals for exhibitions to be displayed in the Kentlands Mansion Gallery.

ELIGIBILITY

Artists and art organizations working in Maryland, Virginia and Washington, D.C. are invited to apply. Individual, two person, group and theme proposals are encouraged. A panel of jurors will select the exhibitors for the 1997–1998 Council for the Arts season.

TO APPLY

Send the following materials by *October 25, 1996* to Alfredo Ratinoff, Gallery Director, Gaithersburg Council for the Arts, 31 South Summit Ave., Gaithersburg, MD 20877-2098. Selection notification will be mailed by November 25, 1996.

Figure 2.

The *Carriage House*
a project space of the
Islip Art Museum

CALL
FOR
PROPOSALS

1997 SEASON

Figure 3a.

INTRODUCTION

The Islip Art Museum in pleased to announce an opportunity for artists to participate in the Museum's project space. The space, an old carriage house adjacent to the museum, is located on the grounds of Brookwood Hall park. Artists are invited to submit proposals for installations including those with mixed media, electronic media (video, audio, projection), performance or interactive elements. Collaborations are also acceptable.

Proposals will be reviewed by a panel of artists and arts professionals. The review panel will take into consideration not only the merit but also the feasibility, technically and financially, of the proposed project.

A limited amount of funds are available for artist's fees. Artist's fees may vary and will be determined by the panel, after a review of each project proposal. Accepted proposals offer a MINIMUM of $500 but usually no more than $800, as an artist fee.

Although it is important that project budgets accurately reflect the direct costs of the proposed project, it should be noted that award amounts will not be based on project costs. Budgets should reflect your proposed artist fee, other projected income and projected project costs.

Selected artists will have the opportunity to work in the space in order to complete the proposed project. Projects will then be on view for the general public. Selected artists will be encouraged to interact with the public about their work either formally (lecture, slide presentation) or informally (open workspace, artist statement).

REVIEW PANEL

HOLLY BLOCK
Director, Art in General, NYC

MARY LOU COHALAN
Executive Director, Islip Art Museum

THOMAS LAIL
Artist (Multi-Media Installation) & a 1996 recipient of a Project Space Award by the Islip Art Museum

KAREN SHAW
Artist (Multi-Media Installation) & Curator, Islip Art Museum

CATHERINE VALENZA
Director of Collections & Exhibitions, Islip Art Museum

MARTHA WILSON
Artist (Performance) & Founding Director, Franklin Furnace, NYC

ELIGIBILITY

• Must be 18 years of age or older.
• Must be a resident of New York State.
• Artists who have already had the opportunity to work in the Carriage House will be reconsidered after a three-year waiting period.

SCHEDULE

Proposal Deadline: April 10, 1997 (Postmark)
Announcement of Awards: May 14, 1997
Installation period: July 12–July 25, 1997
Viewing period: July 26–Sept. 28, 1997

APPLICATION GUIDELINES

■ Limit your written proposal, budget and narrative each to one typed page.

■ Submit seven copies of the written proposal, budget, narrative and résumé.

■ Indicate on the application form which gallery is suitable for your proposal. Please note that your proposed installation may not occupy more than one gallery.

■ Please limit your proposal package to only those materials requested.

■ Slides should be labeled with the artist's name, title of work, medium, dimensions, indication of top, and should be sent in a clear plastic sleeve. Video cartridges must also be labeled with name and address.

■ Slides are limited to four of previous work and eight of the proposed work. Clearly indicate which visual materials are of previous work and which are of the proposed work.

■ Video must be cued to the starting point and during viewing will not run longer than two minutes.

■ In lieu of or in combination with slides/video of proposed work, Xerox copies of sketches, etc. are permissible. The total limit for slides, video and/or Xeroxes of proposed work is eight.

■ Please do not send original or one-of-a-kind material including slides, video, maquettes or illustrations. The museum can not assume responsibility for lost or damaged material.

■ In order to avoid potential conflicts of interest, please refrain from contacting panel members. Your proposal may be disqualified for contacting panel members.

■ Proposals must be postmarked on or before April 10, 1997. It is strongly suggested that you send your proposal "return receipt requested" through the US Postal System.

■ Floor plans are available, however it is strongly advised that artists plan a site visit or attend the Open House planned by the Museum. The Museum is easily accessible by car and the LIRR and is approximately an hour and fifteen minutes from Manhatten.

■ If you are interested in more information regarding the Open House, or if you would like to request a floor plan, arrange a site visit or discuss a proposal, please call (516) 224-5402.

■ Please follow the guidelines; failure to do so may render your proposal ineligible.

Figure 3b.

raised x number of dollars for it. In describing any funds donated or in-kind services—such as printing or trucking—that have been promised, you are conveying that others believe in your plan, too.

Dr. Judy Levine, an expert on proposals and fund-raising in the arts, has taught, written articles, and consulted with over one hundred grassroots and midsized organizations. Her thoughts about the individual artist and what he or she needs to know in order to craft successful proposals are enlightening.

"Think of the proposal process as communication—a dialogue," Dr. Levine says. "In order not to be at a disadvantage, you first need to know whom you are addressing. You don't want to start off on the wrong foot, and first impressions stay with people a long time. Without knowing something about the recipient of your proposal, its purely a chance thing that you'll get funded, no matter how convincing your proposal. You don't want to waste your time. So, you want to improve your chances by knowing as much as possible about where you are seeking funds.

"Every funder has particular things they hope to accomplish with their money. This may even be legally binding, as when the funds that established the foundation came from a bequest in someone's will. That person wanted their funds to benefit certain causes or types of individuals. This is the funder's mandate, their objective. Even if they say they are giving to help needy artists, they may only give to artists who work in a certain style or who have reached a certain professional level. You, as an artist, also have a mandate, to create and exhibit your work."

Drawing two circles next to each other, Dr. Levine labeled one Funder's Agenda and the other Your Art Agenda (fig. 4).

"You need to make the two circles merge partially," Dr. Levine continues. "Where there is an overlap, you and this funder have something in common and *this* is the area you must emphasize when proposing to this funder. Stress the project, not the artist. You want this to say 'Don't fund me, fund my work.' Saying things like 'This will enable me to . . .' sounds like you are asking for money to do laundry."

Area of common interest.
Your proposal should stress this area.

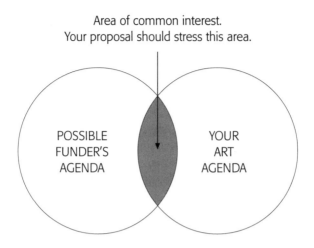

POSSIBLE
FUNDER'S
AGENDA

YOUR
ART
AGENDA

Figure 4.

I asked Dr. Levine if once you've identified ten to twenty pos-
sible funders from the reference material at the Foundation Cen-
ter, they should go on your mailing list and begin to receive
announcements of your events?

She answered: "Absolutely. You need to familiarize them with
your work and your name. When your proposal arrives, it should
be almost a confirmation of things they already know about you. I
hate to send any request in cold. Cultivating is 90 percent of the
proposal process. In the beginning, you can invite them to events
in which you are participating. Ask them for things like their time,
things they *can* say yes to. Then maybe you'll want to request in-
kind services, such as printing your announcement for a show,
which they can give you without money being involved, before you
ask for funding for a project.

"In cultivating possible funders, don't forget the support possible
from your own circle of sources—people who have bought your
work, vendors who sell you supplies, co-workers at your day job,
other family members—all can be helpful in ways that you, and they,
might not have imagined. Just as one of the functions of board

members of an arts organization is to speak up for their group to friends and possible funders, this function can be performed by one of your sources who can write an endorsement letter or make a phone call in your support and say all the good things that need to be said in praise of your work."

Be Clear and Precise

Here's another false step to avoid with a proposal. Don't include information that the funder does not need to know in order to decide whether or not to fund you. It will cloud the focus you want on your request. Individual artists are often guilty of this, so you should review your proposal while asking yourself, "Do they need to know this?" Proposals are not about theory. They are about providing sufficient information so that a funder can see what your project will be and that you are the best one to carry it out.

"If you must supply a budget with your proposal," cautions Dr. Levine, "try to lump like items together and don't break it down into such small categories as pencils. You may be trying to create trustworthiness, but instead may create doubts about your ability to plan and professionally carry out a large project on a budget.

"Have someone else go over your whole proposal, and be tough enough to take their criticism. If they ask you where such-and-such is and you've included it, you may need to give it more emphasis—after all, they didn't see it."

To Use or Not to Use the Lingo

Dr. Levine has one more suggestion, which, by the way, directly contradicts some advice that will be given later about résumés. She feels that the committee that reviews your proposal is likely to be made up of people who do not come from the art world. She therefore counsels you to eliminate any jargon that only an insider would understand. Elsewhere you have been urged to familiarize yourself with cur-

rent art world lingo and use it where helpful, as a kind of "codespeak" to other members of the art world. You should try to ascertain as much about the panel who will review your proposal and decide when to follow and when to ignore this rule.

On page 186 is a sample of a short proposal I sent to the New York Public Library (NYPL) some years ago (fig. 5). Note that the fees for senior activities lectures had already been established by the NYPL and therefore no mention of any cost is included here.

Artists' Communities

Another use for a one-page proposal letter is when you are applying to an artists' colony. Great places to concentrate on your work, meet artists from other fields, and just get away from routine, a colony may be just right for you. The directors will require, however, that you outline for them exactly what you hope to accomplish while you're there. You may not be able to complete an entire project at the colony, but that shouldn't keep you from sending an application.

Below is a list of colonies where you might want to apply for a stay ranging from one week to several months.

Edward F. Albee Foundation
14 Harrison Street
New York, NY 10013

Anderson Ranch Arts Center
P.O. Box 5598
Snowmass Village, CO 81615

Artpark Park Programs
P.O. Box 371
Lewiston, NY 14092

Bemis Center for Contemporary Arts
724 South Twelfth Street
Omaha, NE 68102-3202

Bernheim Forest
536 Starks Building
455 South Fourth Street
Louisville, KY 40202

Cummington Community of the Arts
R.R. 1, Box 145
Cummington, MA 01026

Djerassi Foundation
Resident Artist Program
2325 Bear Gulch Road
Woodside, CA 94062

Haystack Mountain School of Crafts
Deer Isle, ME 04627
207-348-2306

Jalom Artist-in-Residence Program
Callejon Ampola #7
Barrio Cuxitali
San Cristobal de las Casas
Chiapas, Mexico 29230
Attention: Coordinator

Joshua Tree Residency
Studio C-43
P.O. Box 65552
St. Paul, MN 55165

Kalani Honua, Inc.
Artist-in-Residence Program
R.R. 2, Box 4500
Pahoa, HI 96778

John Michael Kohler Arts Center
Arts/Industry Program
Kohler Arts Center
P.O. Box 409
Sheboygan, WI 53082-0489

MacDowell Colony
100 High Street
Peterborough, NH 03458

Millay Colony for the Arts
Steepletop
Austerlitz, NY 12017
518-392-3101

Penland School
Penland Road
Penland, NC 28765
704-765-2359

Peter's Valley Craftsmen
Star Route
Layton, NJ 07851

Potash Hill Arts Colony
33 Potash Hill Road
Cummington, MA 01026

The Ragdale Foundation
1260 North Green Bay Road
Lake Forest, IL 60045

Roswell Museum of Art Center
100 West Eleventh Street
Roswell, NM 88201
505-624-6744

The Seaside Institute
P.O. Box 4730
Seaside, FL 32459
904-231-2421

The Tibetan Aid Project
c/o Kazimieras Joseph
2910 San Pablo Avenue
Berkeley, CA 94702

Triangle Artists Workshop
110 Greene Street, #8R
New York, NY 10012

Virginia Center for the Creative Arts
Mt. St. Angelo
Sweet Briar, VA 24595

Women's Studio Workshop
P.O. Box 489
Rosendale, NY 12472

Yaddo
Box 395
Saratoga Springs, NY 12886

Longer Proposals

On pages 188–9 (fig. 6) is a slightly more complex sample proposal in a more formal voice. You will notice that a project summary style is used at the beginning, adopted from a grantwriting format used often in academic circles.

Now for a biggie! The next proposal (fig. 7) contains many parts and involved twenty artists. It lead to an eleven-month exhibition in the center of SoHo in New York City. It is also an example of how thinking about your art in new ways can open up new opportunities. Many art spaces are now interested in showing "installation" work. Usually three-dimensional and made up of numerous parts, an installation is designed to occupy a particular space within a location. You may have seen calls for proposals of installation projects. If you, like many of us, make work intended for the traditional wall exhibition, you may be wondering how to get your work off the wall and into the installation mode.

Two-dimensional work doth not an installation make–or does it? A film I saw on the work of cutting-edge artist Ida Applebroog gave me an idea. Among her canvases, she had grouped together several pieces of different sizes, some facing in different directions, but all attached. The resulting creations were freestanding combi-

185

ART IN OUR LIFETIME

This is a proposal for an art history lecture series specifically geared to senior citizens and focusing on the art of this century. This series of three slide lectures would be offered at branches of the New York Public Library during the fall of 1992.

The Baychester, Yorkville, and Epiphany branches of the Library have been selected for this series in an effort to reach the large number of seniors in those neighborhoods. To insure maximum attendance, afternoon or early evening scheduling would be most effective. Single-lecture as well as complete-series attendance would also be encouraged.

My approach to speaking with seniors about modern art links events in their own lives to major events/works happening in the art world at the same time. By asking, "Where were you in 1913?" I have had audiences tell me they were in such-and-such grade school in New York City and, yes, they did remember the furor caused by the Armory Show! When the impact of the Armory Show on modern art was related to them, and slides of the works exhibited there were shown, the whole subject gained a fresh immediacy for all of us! Explaining cubism, futurism, and other major art movements becomes relevant when placed in familiar contexts. Using this approach, I hope to weave relationships sparking the interest of seniors to pursue the exploration of art and filling their time in a satisfying and rewarding way.

I have been fine-tuning this format recently, giving talks at several branches of the New York Public Library (in Queens and Brooklyn) and at the Mary Manning Walsh Nursing Home. This summer I will speak at the 92nd Street Y and the Village Nursing Home. The lively question-and-answer sessions following these talks have convinced me that genuine interest has been aroused.

Figure 5.

nations of her work. The pieces may have originally been conceived as individual paintings, but they took on new meanings when combined, becoming multiple stories revealing different aspects as the viewer looked at them from different perspectives. The result was a true three-dimensional installation, sculptural and painterly, creating an around-the-room feeling.

Thinking about your own work in new ways can open up opportunities that seemed closed to you before. By shaping ideas like these into proposals, you can create opportunities that will put your work in the public eye, while at the same time finding new categories for your art. You'll be amazed at the opportunities available in places where you thought you could never fit, and your work will be richer for your explorations.

The clincher to this proposal, I believe, was the video aspect. At a certain time that year, the banks had gone into video-production mode. Every bank you went into had a VCR set up, and while you stood in line waiting for a teller, the VCR was selling you one of the bank's services—IRAs, savings accounts, equity loans, and so forth. Every bank worth its up-to-dateness had a VCR. There was one problem. The banks had not produced programming of sufficient length to keep these VCRs going all day and, consequently, many sat idle, not being used. That's where we came in. We offered to present a video of the artists in the exhibition talking about their artwork, and after seeing them on the video, the viewer could look up and see the actual artwork in exhibition.

The concept was accepted and we were told by many of our competitors over the next year that we won the proposal competition because we had the video idea. This example shows the importance of timeliness in your proposal.

Other Approaches

While I have been speaking here of formal proposals, there are several artists I can think of who make their proposals in a more informal way because the nature of their art suggests it. Here are

Of/In/On Paper

PROPOSAL

SUBMITTED BY PEGGY HADDEN

TO THE RUTH CHENVEN FOUNDATION, INC.

JULY 1991

PROJECT SUMMARY: A combination collage and papermaking project that will yield twenty to twenty-five finished pieces of new work.

I am a painter and collage-maker. My collages grow out of bits of paintings that I have torn up, the painted scraps becoming new compositions even as they leave old ones.

I enjoy a reputation as a bold abstract colorist, and in combining vivid colors with gestural brushwork I have evolved a highly personal and dramatic world within my work. I've attached a current résumé that will provide you with details of my education and professional activities.

Now I would like to take my collages one step further—by embedding these painted fragments that make up the collages into the body of the paper, which is their ground. Until now this ground has been the surface and receiver of my work. Collage has always built *out* from that surface. I propose to build *in*. By combining collage and papermaking in a complex and dimensional melding, I plan to combine object and field. The results, I am confident, will be different and magical. Like bits of silk frozen in ice, this hybrid of two disciplines, one art and one craft, will intrigue and challenge. The artwork coming out of this effort will be innovative and beautiful. It will represent an important move forward in my development.

To make the works that I have described, several elements will be required. A papermaking facility of unusual resourcefulness and ingenuity is necessary. Supplies and technical expertise, as well as large blocks of studio time at the facility are requisite. In researching these requirements, I have been fortunate in receiving advice and recommendations from many

Figure 6.

friends. Exeter Press, a papermaking facility of excellent reputation is my choice for realizing this project. I enclose additional materials that will attest to Exeter's achievements.

An undertaking such as this requires a budget beyond that of which I am now capable. I have begun saving for this project, but I have little discretionary income. For this reason, I am applying for an award from the Chenven Foundation. I do not envision stopping this work once it is begun. Starting the project will be more expensive than continuing it. The cost of supplies to begin and gaining the expertise necessary are onetime expenses. Once these obstacles are behind me, I will be self-sufficient. The size of the grants that you award is compatible with the requirements of this project. In conversation with Lynn Forgach of Exeter Press, I have estimated expenses for this project to be as follows:

BUDGET

20 hours @ Exeter Press (includes two-person technical team)	$1000.00
Supplies (pulp, pigment, additional chemistry)	375.00
Total	$1375.00
Funds now on hand	250.00
Funds needed to complete	$1125.00

It is estimated by Lynn Forgach that twenty to twenty-five finished pieces can be completed in the allotted time.

Receipt of an award from the Chenven Foundation for this project would, I believe, fulfill several of your objectives that are stated in your directions to applicants. Among these are:

- concern for contributing to both arts and crafts,
- concern for artistic merit *and* financial need, and
- concern for how the award will make a difference to the recipient.

I appreciate your consideration of my proposal.

Spare Parts

COLLAGES FROM NINETEEN PAINTERS AND PRINTMAKERS
CURATED BY PEGGY HADDEN

Collage cannot be defined adequately as merely a technique of cutting and pasting, for its significance lies not in its technical eccentricity, but in its relevance to two basic questions which have been raised by twentieth century art: the nature of reality and the nature of painting itself.

Collage has been the means through which the artist incorporates reality in the picture without imitating it.

—Margaret Miller, Museum of Modern Art, 1948*

Forty-three years and a score of art movements later, found objects and fragments, recycled and juxtaposed, still fascinate us. They have worked evocative magic for artists as diverse as Lee Krasner, Jasper Johns, Marisol, Willem de Kooning, and Robert Raushenberg.

The importance of collage for painters and printmakers should not be overlooked. Literally, it allows artists to change the surface of their paintings by introducing "foreign" matter. But it also conveys to mundane objects and materials a heightened significance. Lastly, it acknowledges the artist's sensibility as the selector of these objects.

As we approach a new century, we celebrate the amazing resilience of collage and its importance as a conduit for fresh ideas. For the artists assembled in this exhibition, collage is an urban poetry, its "objectness" at once grasped, yet transformed. The alchemy within the work happens, in part, because the information that the viewer brings to the experience is constantly being updated. As a collaboration between artist and audience, this offers an intuitive and personal joint venture.

Artist/Curator
Peggy Hadden

*From a press release for *Collage,* Museum of Modern Art, 1948.

Figure 7.

PARTICULARS OF THE EXHIBITION

SITE: Marine Midland Bank, SoHo Branch

DATE: March 1992 to April 1993

SIZE OF THE SHOW: 40 to 50 Works

CONTACT PERSON AT THE SITE: Kim Raimondi, Branch Manager

TELEPHONE: 212-274-0530

EXHIBITION BUDGET

At a meeting at the site of the proposed exhibition (Marine Midland Bank in SoHo), Kim Raimondi, the branch manager, discussed the budget design with me. She indicated that for the *Maps and Madness* show, which is installed there currently, the bank was able to assist with expenses. She is hopeful that the bank will contribute to exhibition expenses in the future. For the purposes of the budget, it was her suggestion that expenses that are now known be listed, and further discussion be held with OIA's Director (our umbrella group) when she returns in August.

Being familiar with exhibition budgets, I am aware of the sizable amounts of money that contributed goods and volunteer services can replace. Therefore, I request the Proposal Committee to think of this budget as a working list, flexible in terms of size and detail.

Announcement: card design, typesetting, printing,
 press release, press kits ... $850.00
Mailing .. 700.00
Insurance .. 350.00
Installation costs ... 40.00
Documentation ... 175.00
Opening .. 200.00
Proposal preparation: word processing, phone calls, mailing, etc. .. 110.00
Total ... $2,425.00

Of the total amount shown above, $1,000 is pledged by OIA. An additional amount is expected to be available from an Artist's Space Exhibition Grant (maximum $500). Because of Marine Midland Bank's previous assistance, some financial aid is anticipated.

[*A schedule plan was included at this point. It appears in chapter 13 with more details.*]

examples of two very different artists who dug out niches for themselves and found successful ways to propose and sell their art on their own.

Ellis Furst lives in Wilmington, North Carolina, with her husband Don and their two small children. Don teaches art at the University of North Carolina's Wilmington campus, and Ellis, who has a degree in communication arts from East Carolina College, pursues a full-time art career from their home. Decorators in the area seek her out to create *trompe l'oeil* treatments and faux finishes in the interiors of homes they are designing. She prides herself on being able to match any color with her paints.

But Ellis's real specialty is painting murals inside of churches. She says this work comes to her through listings in church bulletins seeking artists who specialize in stained glass, murals, and church furniture. Since she has small children and doesn't like to be away from her family for too long, most of the churches from which she accepts mural jobs are nearby. Travels in the Middle East and Israel have helped her visualize the subjects and foliage that fill her murals, and she likes to paint her murals in a way that makes the viewer believe they are part of the room. Like her artistic ancestors of hundreds of years ago in medieval churches, Ellis's murals are unsigned.

Rather than preparing a formal proposal, when Ellis is approached for a job in a church, she makes a small maquette and then, upon the committee's approval, one-third of her fee is paid and she begins the project.

Sandra Lee is another artist who has created her own market niche. She has always been fascinated with architectural fragments, and they fill her home. For years she has made sketches of street scenes and neighborhoods, both present and past, and has developed a unique style for pen-and-ink drawings of individual brownstones. Sandra decided there was a market for her sketches of homes and set about using stationery and cards to advertise her services. She invited potential buyers to preserve a room or house or view by having a picture created to keep. Note cards and postcards were

also made available. Sandra has done very well, making a place for her work in many people's homes. Before she began selling her graceful rendering, the market for this kind of art barely existed. Her fascination with architecture and her thoughtful pursuit of the right customers and how she might reach them gave her a unique market for her art.

Following Through

Back to your proposed exhibition. When the opening night finally comes, there are several things you must not forget to do. One of these is to be sure that the right people have been invited. I do not mean the collectors, although I'm sure this crossed your mind. I speak rather of the elected officials, clergy from the neighborhood, and anyone else who could lend credibility to your project. You may not think this is altogether necessary, but, believe me, it will be to your advantage to see that it is done and it can help you in future art endeavors. Think of the next time you'll need a reference—a kind word said about you and your work. These people are on speaking terms with the local press, too, which could give your project a boost with the right publicity. It could impress the corporate funders of your idea to see a community-based turnout for the opening and, by the way, give them some nice mentions in the press, too.

When you start to realize how all of these parts add up, it will be clear what your part is in all this. As artists, we have been outside the system too long and haven't known how to work with community leaders to everyone's advantage.

■

More About Proposals: Budgets, Schedule Plans, and Technical Support

concise and feasible budget can make or break a proposal. Showing that you have carefully scheduled and planned your proposed event– exactly what will happen, where, and when–can make the funder feel secure that you have a grasp of the whole project. By literally drawing a sketch of what will occur each week preceding the event, you can make sure that every part happens in the desired order. This can be the deciding factor in convincing the selection committee of your worthiness as a candidate.

A schedule plan, also called a time line, will help ensure that you don't print your invitations before you have a definite date for opening. As an example, I have taken the schedule plan (fig. 8) used for our group show, *Spare Parts,* the proposal that appeared in the last chapter.

To set up your schedule plan, work backwards from the opening day. Across the top, mark each week before the opening, as far back as you feel the entire exhibition scheduling should go. From

PREPARATION SCHEDULE

	01/15	01/22	01/30	02/07	02/14	02/21	03/01
							DATE OF OPENING
Prepare press release	●						
Mail press release				●			
Check Gallery Guide listing			●				
Press kit preparation, B&W photos, determine what publications to focus on		●					
Studio visits—final determination of work	●	●					
Card printing finished		●					
Mail show announcements			●				
Prepare insurance value list and send back to insurer		●	●				
Works delivered by artists to site						●	
Installation of artwork at site						●	
Final check of installation						●	
Prepare for opening					●	●	

Studio visits will begin about the end of November.

Figure 8.

the example provided, you can determine when your studio visits must be completed and when artists must deliver work to the exhibition site for installation. Don't forget to allow several days for the work to "set," that is, for hanging wires to get used to holding up the exhibited work–or break, in which case, you will have time to repair them. Also, allow enough time so that if you decide that something doesn't work in the exhibition, you can change it.

Your press kit preparation is an important element in the scheduling. It may have to allow time to make photographs of exhibited work, for essays written (by yourself and/or others) to be delivered and duplicated, and for the careful selection of which publications will be targeted to receive the press kits.

Deadlines for listings within certain cultural calendars need to be met and may be sooner than other press materials–be sure to check as these can help your event get an audience.

The *Spare Parts* schedule did not include any plans for catering, as this was provided by the sponsoring organization. If you will be needing to arrange for catering, don't forget wine and other beverages, and arrange delivery with enough time to allow for chilling before they are served. Ice may have to be bought, as well as napkins and paper supplies. Serving implements may have to be bought or borrowed.

What about technical support? If you make your art by yourself, this may seem an unnecessary question, but many artists rely on fabricators, for example, to laminate their photography onto wall-sized panels for busy subway passageways. For these artists, the technical support makes their art possible. The most important decision the artist makes is choosing who will transform their sketch into a reality. This goes for foundry casting of bronze statues as well as the technical expertise involved in creating handmade paper or the careful assembly of stained glass windows. The schedules of the individuals providing the technical support should be determined and factored into your schedule plan.

Eight Reasons Why Proposals Don't Succeed

1. Your technical support (see below) isn't qualified, or your description of their qualifications isn't convincing.

2. Your documentation from prior projects is weak, or your visual aids—that is the photos, video models, or other visuals—insufficiently support the idea you're proposing.

3. You've provided insufficient publicity for your past projects, so funders aren't convinced your project will elicit enough attention to you, your project, and them.

4. The selection committee feels your project won't reach/find an audience. (Can be due to #3.)

5. Your budget is unrealistic. It may be too large or not large enough. (Did you build in a 10 percent increase for delays and inflation?)

6. The proposal is badly written. The actual event can't be visualized by your reader.

7. You failed to do adequate research on your hoped-for funder. The right idea will not fly if the "fit" is not good, that is if the funder only supports other types of requests.

8. You fail to be convincing as the artist who can best bring this project to completion.

One of the more important aspects of a proposal, one that gets a great deal of scrutiny from grantors, is the other personnel or technical staff that is to help bring the proposed event/project to fruition. If you have advanced a proposal for a solo exhibition of your own paintings, then you have only to convince the grantors of the depth and importance of your own résumé.

If, however, you have proposed a group show of twenty artists, the funding source will want you to provide a résumé for each artist. Use this opportunity to strengthen, not weaken, your bid for grant aid. Read over the other artists' résumés and order them beginning with the strongest one first. Remember that you are trying to convince them of the overall strength of the group. This is not a

time for internal competition between you and the other artists you've selected. If they look good, the whole group looks good.

Where you put your résumé depends: it could go at the end (the grand finale, best for the last) or you could place it immediately after your project description (the host introducing the group). Its proximity to the project description links you immediately to the success of the project.

Since a stack of résumés can seem daunting to the reader, I've found an alternate informal method for this section of the proposal. I make a separate short alphabetical listing, giving three to four lines or a short paragraph telling about each artist's unique accomplishments. For one artist, the emphasis may be on his or her travels; for another, teaching experience. I also give the geographical background and educational background for each artist. Varying the emphasis of the accomplishments saves the reader from becoming bogged down in a long list of each artists' career beginnings. I think a proposal's résumé section done this way is appreciated by the readers and helps to keep their attention.

If you'll be using an outside workshop to realize your project, be sure to provide the most professional material available for describing why you've selected that workspace. A shop résumé and printed brochure will be helpful. If the printshop or papermaking facility where you wish to work has an educational program, so much the better. You want to convince the proposal reader that you've chosen carefully and will have expert technical assistance available to you. Be sure to meet with the director of the workshop beforehand to discuss your idea for the project, and be sure that the shop is able to do the work you have in mind. Get prices for your schedule plan, including overtime costs that may occur, and add in a percentage for inflation (usually 10 percent), as your project may be some months away from happening. Also discuss how much time will be required and be sure the workshop will be available to you for that time period. Your finished proposal should mention what technical support staff will be available to you (master printers, in-

terns, etc.) and how many finished pieces will be finished in how much time.

It is a good idea to have a second choice of workshop in mind, although to mention this in the proposal may make your whole idea look shaky. Just keep notes for yourself so outside events don't undermine your plan. To illustrate what I mean, my plans to use a certain print shop were totally upended when its master printer got a teaching fellowship out of the country for six months and the whole facility at home was shut down. Give yourself alternatives to ensure your project's success.

It may help to shop around a bit before selecting a site at which to work, but don't settle for price if the quality will be second rate. You aren't spending your money, and the funding source will not appreciate a shoddy result after you've written a glowing proposal. The funder needs to be assured of the competence of everyone involved in carrying through the artistic aspects of your activity.

Part of your ability to accomplish this project is in knowing where to go for the best assistance–technical and artistic–to see your project through to completion. That you have proposed to work with competent and recognized artisans is a compliment to you. Don't try to save the funder some money by shortchanging your project!

You can also win points with a studio or workspace by knowing what expertise it offers and how to take advantage of working with them. Many such spaces offer blocks of workshop time and technical assistance to artists. Knowing how they operate will help you formulate a project to carry out in their space and will convey a good fit between your talents and theirs.

Your budget need not be long and laborious, but it does need to show that you have considered what will be necessary to complete the project you are proposing. Try to keep it to major headings, though, and omit listings for tape and hanging wire. There are usually about seven major topics that will completely cover any project. There is some flexibility in what these categories are called, but they should include:

- Announcement (card design, typesetting, printing, press release, press kits)
- Mailing
- Insurance
- Installation costs
- Documentation
- Opening
- Proposal preparation

Needless to say, any temporary help you need—for trucking, landscaping, preparing your site, or administrative work such as finishing up written details or making phone calls—should be done by capable personnel. This is not the time to help out an out-of-work brother-in-law or high-school neighbor home for the summer. This is a project that will reflect on your artistic reputation and influence future endeavors that may come your way.

Paying attention to the technical parts of your proposal, such as those covered in this chapter, will give your final proposal a credibility that ensures it will receive serious consideration as a candidate for support and realization. It will also help you once the plan is put into action, acting as a checklist to work against and helping assure a polished finish to your terrific project!

■

Your Résumé: Working or Resting?

n artist's résumé is a unique document that sets you apart from all the other artists in the world. It is an extension of you and may be the first way that someone important to your career gets to know about you.

Sometimes artists construct a résumé in a perfunctory manner, as if it had to exist because it is expected. Professional résumé writers say you don't need a fancy résumé, but one that gives you a chance to get the right kind of attention in the fifteen seconds that the average reader will give to it. Of course, the real reason for a résumé is to convince curators to explore your talent further by looking at your slides. But remember, for every exhibition spot you want, there may be a hundred other applicants. The résumé reader hasn't even gotten to your slides yet–and may not. Say that two artists have résumés with roughly the same information, but one résumé presents the information in a better manner. Who do you think stands a better chance of holding the reader's attention?

A polished résumé can be of enormous help to the artist. A good résumé will present your artistic strengths in the best light and help

ensure access for you wherever it is sent. It can function as an un-paid, round-the-clock employee, going into places where the artist seeks to follow, saying wonderful things that you rarely have the chance or the nerve to say about yourself.

You can learn from your résumé, too—even though you are its creator, its parent. Here's how. Suppose you have competed in twenty juried shows, but have no exposure to a local audience in college or university galleries. Another juried show may be a piece of cake for you to acquire, but will it mean something? Will it get you a new category on your résumé or just another listing in the juried shows section, like the one above it and the one below?

Artists have the rare opportunity to assess their careers and craft them in a way that is not possible for most other people. You can look at your résumé and weigh it, objectively. Ask, What's missing here? Maybe you need to travel, even just on weekends, to broaden the range of your creative output. Or, if your whole creative history has been in making small works, maybe it's time to try a big project. (Like many undertakings, you may have to pay for the first one yourself to prove that you can work in a different scale, but then maybe you can find local funding to support the next one.) To keep your résumé interesting, add the workshops and panels you've at-tended on special topics such as handmade paper or painting on silk. These will show off your inquisitiveness and keep the reader stimulated.

Analyze your résumé and see what's missing—a traveling exhibi-tion, a collaboration, a Web page. Not unlike a cardiogram monitor in a hospital, it can be watched to see how the patient's doing, or what needs to be done next. Use it as both a tool for yourself and a summation to show others. Taking a good, long look at your résumé can help you see both where you are and where you want to go.

Focus on your résumé as it is now. Examine it closely. Is it cur-rent? Does it organize the information about you in a coherent and interesting way? Will it impress the people it should impress? Art-ists tend to be loners; we rarely share information and hence end up reinventing the wheel every time we want to learn something. I

am a secret résumé collector. I always read other artists' résumés when visiting galleries and take one away with me when there is a stack available. I always learn something from them, and I heartily recommend this practice.

Here's an example. I was looking at a show of work by an artist whose approach was very much like my own. On his résumé I found he had exhibited in five local museums that I didn't even know about. This meant two things: (1) I now had five more places to apply for exhibitions, and (2) they had already indicated their interest in work like mine.

One of the problems that gives artists a hard time in writing their résumés is when they are faced with a big gap in their exhibition history. There are many legitimate reasons for this: a sick family member, a new baby, a return to school. Or maybe you had to work intensely at a regular job to earn money quickly for some desired project. Yana Parker, who has written several books on résumés, says to make use of these "gap" situations by creating a functional or biographical style résumé that emphasizes the skills and knowledge you gained at these times. It won't emphasize the "holes" in the way a chronological exhibition list might. As I mentioned before, if you attended workshops or panels that gave you insights or technical help, mention these. If you were a full-time parent during the lapse, you may still have experiences that changed and added to your depth as an artist. I know an artist who discovered and pursued woodblock printing because she could take the blocks with her to the playground and work on them while she watched her children. Look for ways to include these gaps as positive experiences. They can show your continued interest and involvement with the art world, even while your life had other demands. If you were a volunteer for a nonprofit space or did museum tours as a docent, it still conveys a sense of involvement, even if your artistic output may have slowed.

Study other artists' résumés. Are they balanced on the page, or lopsidedly hugging one margin? What about spelling errors or inconsistent punctuation? Is the print size and type style or font easy

to read? Résumé experts suggest using at least 10-point type, and they like a clean font like Times New Roman. Your résumé is not the place for intertwined letters or other touches that make reading difficult and give the reader a headache before he or she even begins. Are there comfortable margins and ample spaces between each section? These enable the reader's eyes to rest. What about using bullets and bold type? Both methods are great for highlighting information and drawing the reader's eye to key points, but experts say to use both sparingly.

Don't read other artists' résumés to be impressed, read them for the hidden information available in them. And don't become distressed by what others seem to have accomplished. Cast an objective eye over the material. What have they done that you've also done, only they've made it sound more impressive? Start a file of résumés that have made a good impression on you, and look at them the next time you're taking a break from your creative work. What was it that first attracted you to these résumés? Were they clean, well targeted? Did certain items seem to jump out and hit you in the eye?

Your résumé should be sent with a cover letter to introduce you and your slides and make the reader want to continue. If you have a friend or experience in common, or if you were referred to the reader by someone, it should be mentioned in the cover letter. Make it your business to know as much as you can about the sponsoring organization and the project for which you are applying. Try to find someone who showed there before and won't mind clueing you in. This suggestion made a very real difference for me once, when my friend Wendy had shown at a university gallery just outside of New York City. I knew from studying my résumé that a college or university show would strengthen my whole career history. When I asked her how her exhibition went, she said, "Great! You know, you should write to the woman who curates that space. She was really nice to me and was supportive to work with, and it's a beautiful gallery space." I did write to her and mentioned Wendy's exhibition and the nice things she had said. Six months later I was mounting

my own show there, and I'm sure it was because my cover letter hit the right tone.

Vital Information

Sometimes a résumé and slides will be passed to another curator, while the cover letter stays behind with the original recipient. Be sure that all vital information, such as your name, address, and phone number, are on each piece of material, including your cover letter. Don't assume that all this information will always stay together.

Nothing is more frustrating for a curator than to find an artist whose work he or she likes and then not be able to locate the artist. This happened to me *twice* for one show I was curating, and I very much wanted to use the artists' work. I never found one of them, and the other one was in Europe and came back to the States the week before the show was to go up. The postcards and press kits had already been sent out, however, and the people in the group were already okayed by the show's sponsor. Those artists missed an opportunity for a show that was on display for eleven months.

Now look at your résumé again. Is the best stuff hidden? I remember receiving a résumé once from someone whose slides had impressed me at a slide registry and whom I was hoping to use in a group show that I was curating. I knew very little about her, so I read her résumé with interest. I read along for about a page and a half full of the usual group shows, when I came upon a major accomplishment. The artist had work in the well-known government program called Art in Embassies, which borrows artists' work and places it in U.S. embassies around the world (see chapter 9). The program has wide recognition throughout the United States among museum staffs and academics. Why, I asked, had that wonderful bit of information been buried near the bottom of page two? It was certainly the most impressive credit on the résumé. Her answer to this question was that it wasn't such a big deal to accomplish in Washington, where she lived.

Sometimes the things that don't impress us will very much impress someone else. For this reason, I recommend that you ask someone whose opinion you trust to look at *where* you've put *what* on your résumé. Be sure that your biggest accomplishments are the ones your reader sees first—put them right up front where they will get the attention they deserve. As my own greatest successes are in the corporate collections area, I've placed that category right at the top under my name and phone number. Never mind that most artists seem to put this section at the bottom of their résumé. The point is, lead with your strongest suit; make *your* accomplishments work for *you*.

In a chronological résumé, each section should begin with your most recent achievements and work backwards, ending with those that happened longest ago. How far back should you go? Yana Parker, the résumé expert, says "About ten to fifteen years is enough—*unless* your 'juiciest' work (experience) is from farther back."

Titles for each section should be in boldface type or italics, so that they stand out strongly. In sections where you have lots of items, such as "Group Exhibitions," you might want to delete less-important shows and call the section "Selected Group Exhibitions." If you're faced with drastically cutting your résumé, so that it fits onto one page—some competitions will not accept a résumé longer than one page—you may say at the top of the page, "Exhibition Highlights."

If you have access to a computer, you can set up a master résumé and subtract or highlight accomplishments, tailoring the résumé to fit the particular project for which it is being submitted. Target your résumé every time—for where it is being sent and the prize for which it is competing. The key points that you would stress in an application going out for a sculpture installation would probably not be what you would want to highlight for a group seeking an artist to make a two-dimensional wall piece. In effect, you are making your accomplishments stand out so that you seem ideally suited to that person who receives you résumé. Remember, however, to target, but never invent, your best accomplishments.

One-page résumés used to be the standard, but I am now see-ing artists' résumés that run to five and six pages. This seems a little obsessive and I doubt that anyone reads them. It also suggests to me that the artist's insecurity is showing, and I'm sure that's the last thing he or she wants to convey. What the reader needs to know are the highlights and the variety of your background. Don't worry if you're short of exhibition experience. A functional or biographi-cal résumé may be more comfortable when you're just beginning to exhibit. Write it in paragraph form, like a short story.

If you feel more comfortable with a chronological format, go with that. If you've studied with a well-known artist/teacher, list that under the "Education" heading–and perhaps begin with it. The same applies if you've worked as Mr. Famous Artist's studio assis-tant. List any art colonies you've attended. In fact, the more recog-nizable names of people and places you can drop, the better. Definitely mention the collectors of your work–this is particularly important to galleries who may be impressed if you happen to have sold work to someone whom they would like to have as a collec-tor. I remember seeing a résumé come alive with one line that said, "Work in the collection of Ronald and Nancy Reagan."

Many artists list their art colony experiences under the heading "Grants and Fellowships."

While the "fellowship" one receives at a colony is usually a com-bination of honor and room and board, rather than money, these experiences–though certainly impressive in and of themselves–might look more impressive under a "Grants and Fellowships" heading than any other.

I remember one artist's résumé, under "Education" said that he was educated privately. What does that mean? Was he from a wealthy family and tutored privately? Or from a poor family and maybe he went to the public library and read up on art history? That's private, too. (And admirable!) You should be sure that your résumé clearly establishes who you are. There's no one right way to construct your résumé. Like your clothes, it has to fit you.

Don't forget to include where you were born. It may seem mun-

dane to you, but to the reader it might seem exotic, or it might turn out to be his or her hometown, in which case you suddenly have something in common.

Include your jurying experiences. People are impressed if you have judged art competitions. Even though you know that you got stuck with the job, your stock still goes up. I've listed several categories that you might not have thought of using for listing your accomplishments. All of these were taken from résumés that I've collected.

- One-Person (or Solo) Shows
- Two-Person Shows
- Touring Exhibitions
- Museum Shows
- Permanent Public Collections
- Private Collections
- Corporate Collections
- Library Collections
- Commissions
- Site-Specific Public Art
- Bibliographies (books and other publications in which you were quoted or listed)
- Publications (magazines that printed articles or other items which you wrote)
- Reviews (articles or other items written about you)
- Catalogs
- Artist-in-Residence Fellowships
- Scholarships
- Guest Speaker Engagements (or Lectures)
- Workshops Conducted
- Studio Visits (groups who came to see you)
- Featured Artist
- Awards (include medals and honorable mentions)
- Consultant (someone asked your opinion)
- Finalist (your almost-accomplishment)
- Broadcasts

- Citations
- Boards of Directors
- Professional Memberships
- Related Experience

Finally, you can even capitalize on your future. List your "Upcoming Museum Exhibition" or "Upcoming Residential Fellowship." There are some nuts-and-bolts rules for producing and presenting your résumé. First, remember to always print it on good-quality bond paper. Many copy shops now sell small packs of bond paper and envelopes, so you won't have to spend lots to achieve a spiffy, first-class look. Second, proofread and proofread. Names, dates, and addresses are especially prone to misspellings, which always make a sloppy impression. After reading through to be sure the information is correct, the easiest way to proofread is to read each line backwards, so that the content becomes unimportant and you can focus on each word. Finally, keep your old résumés and look back at them from time to time. You can learn from things you've done and then discarded. You might even decide to go back to a former style of résumé, deciding after a once-over that it looked pretty good after all. Be your own best teacher and learn from yourself.

Ten Things To Remember About Résumés

1. There is no one "right" way to write your résumé.
2. Make your résumé work for you.
3. Think of your reader, who doesn't know anything about you or your art. When he or she gets your résumé, will it impress them? Choose a résumé style that flatters you. This includes format, typeface, spacing, and information.
4. Is it current, up-to-date, and legible? Is it attractive, as you look at the page overall?
5. Is the typeface easy to read, with spaces between each category? Is the font size large enough to be comfortably read without squinting?

6. Does it include your address, phone number, area and zip codes?
7. Is the punctuation okay? No spelling errors?
8. Is the best stuff hidden? Place your strongest accomplishments prominently, so they are easily seen.
9. Be consistent, with each category chronologically reversed—the most recent events first and earlier accomplishments further down.
10. A résumé is a work-in-progress, and an art résumé is never finished. Give it the same attention in preparing it that you want it to get when it's received!

What the Experts Say

I approached some of the "experts" who get lots of résumés, to find out what they hate. I selected three people: the executive director of a nonprofit gallery space, a former gallery owner who is now a very busy freelance curator, and the director of an information service for artists. What they said drove them wild wasn't what I expected to hear.

One said, "I really hate it when someone mentions their high school alma mater, which they graduated from twenty years ago. We don't need to know that and why do they think we'll be impressed? Maybe if it were the High School of Art and Design or somewhere that stressed art it would be different. But high school art programs are usually electives and they don't graduate someone who is ready to take on the art world. I want to see where they studied *after* high school."

Another's pet irks were, "I hate it when résumés aren't prepared carefully and things are left out, like the name and date of a show, or what was written about it. It should be exactly specific, so that if I happen to have some of the material mentioned, I can go back and check it out. Many older artists are guilty of this, but younger ones should know now that they should keep information about their careers current and write it exactly as it occurred. I just organized a show for an older artist and spent days writing a list of where

and when he did such-and-such. He'd given me a list, but dates were off by a year, or the exhibition's name was missing. Artists should realize that they need to keep their careers in order, so that others won't have to."

The third expert put it most succinctly. "Some serious editing needs to be done once an artist's career gets under way. We don't need to know every little show they've been in, although it's good to have records, so that information should be kept somewhere for history's sake. These six-page résumés, nobody reads them, so maybe just highlight the important shows, if some events have been more minor."

The Right Jargon

Finally, here is a cutting-edge résumé tactic borrowed from the corporate world. Try to use the current jargon within peer groups or particular subgroups. Like animal calls, these seem to signal a level of awareness without which a stranger might seem old hat or out of the loop. Computers can now read résumés and are programmed to look for keywords that can be a clue to the human recruiter of the applicant's "savvy awareness" and "in-ness." While practice in the art world is a long way from reading résumés by computer, human readers are surely aware that some applicants "speak the language" better than others. Look at the "can-do" words listed in the proposal chapter (chapter 12) and see if there's a new way to express ideas that might freshen up your résumé. This is another reason for collecting and reading other artists' résumés. Pick up on the buzzwords. Be sure you grasp their meaning, then use them.

Making Your Day Job Work for You

ccording to statistics from the Research Center for Arts and Culture at Columbia University, only 14 percent of all artists support themselves entirely from the sale of their artwork. For the other 86 percent of us, an outside job is a necessity. Many artists choose jobs in freelance fields, such as graphic design, photo research, or publishing, where they can integrate working at home with time spent making art. For others, temporary work through an agency gives them the flexibility they need. Still others opt for night jobs, keeping days free to make art and reach contacts. But for a lot of us, fringe benefits like paid sick days, vacations, and health insurance lure us into formal job settings.

How we cope in this situation varies from artist to artist. For many of us, the rigidity of regular hours and assigned duties goes against our intuitive natures. Working for and with people who aren't art oriented can be stressful. And we may feel resentful when so many hours of our day are given to activities besides art.

Let's take two artists, Joann and Beth, who happen to be friends

of mine. Each holds a full-time job, thirty-five hours per week, one at a law firm and the other at a graduate school. Both are support-staff personnel, Beth as a receptionist and Joann as a secretary. They both have college degrees and Joann is completing her master's. (Among the best-educated people in the country, artists often must accept poorly paid positions in other fields while pursuing art careers.)

Both maintain studios, Joann living separately from hers, Beth living and working in the same space. Joann is a night person, going to the studio after work and painting through the evening hours. Beth rises at 5:00 or 6:00 A.M. and puts in several hours before getting to work on her 11:00 A.M. to 7:00 P.M. schedule.

Joann has withheld from her employer and co-workers the fact that she is an artist. "To tell them would make me feel vulnerable. I have art in several large museums, yet here I am doing menial tasks. And they might think that my mind is not on my job. Besides, though I hate to say it, I just don't respect them enough to tell them about something that's that important to me."

Beth sees it differently. "I think that knowing I'm an artist makes them see me a little differently. Artists are historically classless, so I'm not thought of merely as a job description. And because the arts seem mysterious to those outside, they often ask questions and are interested in my work."

What about selling artwork at work? Obviously for Joann, this is not possible. Even if it were, her work is quite large-scale and sells for a higher price than her co-workers would likely be able to spend. Beth, on the other hand, takes work to sell at the office several times a year. Last year, she sold a total of ten pieces.

Beth sells her work at the office differently than she does through art consultants. Her office prices ($300 to $700) are for framed works. "The office people want to hang it right away and don't want to hassle with getting stuff to a framer." Her art is also small enough to be portable. Selling it herself, she avoids a dealer's commission. Keeping the work put away until lunch, she then displays it where she can keep an eye on it. Her "handy dandy payment plan" en-

tices co-workers to buy with a deposit. Several repeat buyers have developed, and one member of the firm commissions artwork whenever he wants to give a gift.

Neither of these artists have business hours free to make art-related phone calls. With the exception of lunch hour, gallery viewing must wait for weekends. Let's not underestimate that lunch hour, though. By planning carefully, you can visit a nearby museum. But if your work situation is on the informal side, "lunch hour" may have blurred edges. You may be tempted to stay indoors, but this can make your workday seem even longer. You may get the feeling that you're a million miles from your art career.

Take back your lunch hour! Remove yourself from the work environment. Just because you're not making art this minute, doesn't make you any less of an artist. Revamp your mind-set. Here's an idea. Think of an artist whose work you admire and mentally give them a retrospective. For people who are visually gifted anyway, this can be accomplished even when there's no artwork in front of you. You'll come back to work refreshed, even if you just sat on a park bench.

Being in the business world can help you make contacts that lead to an art sale. One artist whom I know told me of her predicament. "When I had a job, I met people who bought my work. Now that I can paint full time, the only people I see are other artists." Think about it.

Sometimes a job can be so similar to what you are doing as an artist that you have to give it up. I once worked as a freelance colorist for a scarf manufacturer. It seemed like an ideal situation. Working with chips of pure color and all of the shades of each color on the chart, the job was really about understanding what percentage of a whole scarf would be a designated color. In other words, what color would dominate the other colors and "weigh" the most. What I discovered was that my colors at work and at the studio were two complete and separate sets of color, one commercial and the other fine art. While as a scarf colorist I was capable of "punching up" any color combination with the simple addition of a few black

spots, which made any other color they were next to seem more intense, this same gimmick made my paintings look facile and shallow. I finally gave up this temp job for a stint as a receptionist, where nobody wanted my opinion about anything to do with my beloved work.

I can recommend a small book that recently came my way, called *Affirmations for Artists* by Eric Maisel (published by Tarcher/ Putnam). What is nice about this book is that each page is a brief read on a single topic, and you can start and stop almost anywhere and still come away with valuable thoughts. The index is thoughtfully arranged so you can easily find the topic that interests you. While many topics deal with the artist's inner life (for example, intuition, mystery, personal philosophy, nostalgia), Maisel has devoted a section to careers, including pages on the marketplace, business, day jobs, and opportunities. On the subject of day jobs, he wonders how many an artist will have in a lifetime. His conclusion is that it will be too many, including waiting tables, spraying perfume on passing customers, and doing spreadsheets during a secretarial stint. On the topic of opportunity, he notes that it is an artist's job to seek out opportunities and make contacts in the marketplace in his or her role as "self-advocate."

Jobs that bring you close to others in the art world can have beneficial results. Once I had a temp job running errands for a retired museum curator. She called her former museum and arranged a free entrance pass for me. We all know of situations where the assistant to a well-known artist gets a helping hand from his or her famous employer. On the other hand, well-known employers may be totally wrapped up in their own careers or have too many insecurities to give you any assistance. If you are deceiving yourself about help that is not forthcoming, remove yourself to a better-paying and less-stressful job outside the art world. Otherwise, you may become "always the bridesmaid, never the bride."

A look at jobs and artists wouldn't be complete without talking about teaching. Teaching art offers several perks: you get to concentrate on your own field all day long and get paid for it, too. Also,

there is the satisfaction of using the things you were taught and passing them on to students who can find totally new applications for these skills. Many artists say, however, that they are drained and have little energy left after teaching a full day of classes. They also feel isolated from other artists if they teach in a situation where they are the only art teacher. The artist Peter Pinchbeck, who teaches at a community college, thinks that the secret to teaching art and being an artist lies in keeping the balance on the side of being an artist by not teaching too full a schedule. "When an artist teaches too many hours each week, he can get bogged down and have trouble concentrating on his own work. I think it's important to keep teaching down to a manageable number of hours, so that there is meaningful time left for you to work on you own art."

Talking about daily work situations and how artists find this affecting their work is important and informative. We should get past the centuries-old idea of an artist starving in a garret, and it shouldn't have to be a secret that we work to do what we love. Certainly, every work environment is different and some may be downright hostile to the idea of artists bringing art into the workplace. But other opportunities may exist. If your company has an in-house newsletter, they may be delighted to cover an exhibit you're having or mention your art lectures. These press clippings can be used in the materials packet that accompanies your slides. A hallway near the company cafeteria may be turned into a temporary gallery space for your work.

By exploring work situations, I hope I've dispelled any idea you had that you are alone in having to work in order to support an art career. We've even looked at instances where work has some positive aspects. It's clearly easier to endure if you can look at your job as something that can be turned to your advantage. The secret, I think, has to do with not letting yourself be taken over by the day job. Plan a few tasks every day that you can accomplish for your art career, even if it's only getting a letter out. You'll be amazed at how these small steps add up.

Keep a year-to-year calendar and note when certain events, such

as salon shows, calls for new work at nonprofit spaces, and state and local grant deadlines, usually happen. By noting when these things occur on a yearly basis, you can be prepared far in advance and give more attention to these projects, giving you a leg up on other artists around you.

■

Open House
at Your Studio

Potential markets exist in a variety of places, in fact, almost anywhere you look. Once you start looking, you'll be aware of more and more. Perhaps the most natural place to begin is right where you make your art.

Some time ago, I attended an artist's open studio. Knowing of her success in selling her work, I frankly wanted to see how Sumayyah Samaha did it! Here are my observations.

The guests were a mix of forty to fifty people of different ages, including children. The feeling was casual, with music, lots of finger foods, sodas, and wine. There was no evidence of any pressure to buy. But people did.

By presenting a variety of work and mixing older pieces with newer, Sumayyah offered a selection of sizes and price ranges to her guests. In all, about thirty works were exhibited. The work was hung erratically, some pieces higher and some lower, all contributing to a loose and temporary atmosphere. The feeling conveyed was that this work was not permanently installed, but would soon be

going out of the door in the hands of happy collectors. I have been in this artist's studio at other times when she had framed works placed on the floor, neatly stacked against a wall. Other visitors with me were drawn to look through these works, and I realize now that a "ready-to-be-bought" atmosphere was consciously created in both kinds of studio visits.

In organizing the event to occur from 5:00 P.M. to 9:00 P.M., the artist had bridged the natural gap between work and dinner. Guests drifted in and out easily, and things seemed to move fluidly. Week-nights are better for this kind of affair in New York City, as many people go away on weekends. This might not be the case in other areas, where a Sunday evening might be the ideal time for a relaxed get-together.

No titles or prices were posted. On reflection, I am sure this was deliberate. Since prospective buyers were forced to ask about a work, the artist was alerted to their interest. This gave her an op-portunity to talk about the piece more fully. She could mention details that enhanced the work and gave it more background. "Oh, do you like that one? I'm so glad! It's one of the best of my early collages and it led to so much of my later work . . ." You get the idea.

Parts of Sumayyah's work area where guests were not wanted had been neatly blocked off. This was done with plain, pressed muslin that had been stapled across doorways. Sections of wall-board painted white were leaned so that they closed openings. Simple, but these deterrents kept works-in-progress and machin-ery that could have been dangerous, off limits.

Some of the pieces were quite large and Sumayyah had lined up a burly friend to help lift, wrap, and carry them for buyers. I was impressed that she had ready and at hand all the appropriate ma-terials: tape, bubble packaging, and a stapler. No interrupted con-versations while groping around in search of packing materials. This reminded me of seeing, in another artist's studio, a fat roll of brown wrapping paper on a wrought-iron stand, situated directly under his drawing table. My immediate reaction was, "This guy must sell a lot of art!" Maybe yes and maybe no. But he convinced me and prob-

ably a lot of prospective buyers as well. It is important to make it appear that your work sells. Not daily, perhaps, but often enough that you've thought about how to package it for carrying away from your studio.

Once an artwork had been bought, the artist put a piece of white paper tape with the buyer's name on it on the wall next to the piece. As the walls were also white, the result was more subtle than using the traditional red dot employed by galleries to indicate a work has been sold. The tape also did two other things: it committed the buyer to following through with the purchase as the evening concluded, and it kept prospective buyers from falling hopelessly in love with a piece that was no longer available.

My artist friend encouraged taking pieces on approval. Remember, she had invited these people and had a phone number, so she could always track her work down. But she told me later that for her, a try-out period always resulted in a sale—even if the original work taken on approval was not the one that sold. The relationship established in taking an artwork on approval bestows, inherently, some responsibility on the person who does the taking. He or she has borrowed an artwork, causing the artist extra work in packing it for them, in paperwork for keeping track of the piece, and, further, by removing it from possible sale elsewhere. If unsatisfied with the piece, most prospective buyers will bend over backwards, if not to buy something else right away at least to keep up with the artist's future activities. As we are all in this for the long haul, it is good to have a few collectors waiting in the wings who feel themselves to be in our debt.

During the open studio, I did not see any money change hands. Negotiations involving payment for art were kept out of sight. I think this was also part of the artist's desire to keep the atmosphere of the evening light and low pressure to the other guests. Another thought: I believe it is good policy to have, and consult, a price list. You will seem more businesslike about the sale of your work, and buyers won't feel that you are arbitrarily inventing prices as you go along, contingent on the buyer's ability to pay.

Finally, the artist had invited several of her artist friends. This was done, I think, to give her confidence and support. It was also to add color to the evening (we artists are such colorful types!) and to keep the subject of the evening where she wanted it—on art. Of course, she had invited artists whom she knew she could trust not to undermine her evening. We discussed our own work, naturally, but also engaged in many conversations with other guests about her work and were genuinely pleased whenever a work was sold.

By the end of the evening, a significant amount of work had been sold. I think all of the artists who were there were encouraged by the success of the event. It was clear to all of us that Sumayyah had worked from the beginning with a definite plan and had succeeded because she had given every step serious attention. I am planning my first open studio soon. I'm sure it will be a different event from that of my artist friend, but I have learned the basics for having a positive and successful open studio.

For another view of open studios, I asked freelance art dealer Annie Herron to give us her take on artists greeting potential collectors in the studio. Annie is one of the "neo-dealers" cited in a *New York Times Magazine* article about recent changes in the gallery system. She has already run three galleries and now takes groups around to see artists' work in their studios.

PH: Annie, what can artists do to stimulate sales from their studios?

AH: Well, first they have to emit confidence about their work. It's the same for a dealer, if you believe strongly in certain work, you have to exude that confidence. Sometimes collectors aren't that sure about a work and they need to be reassured that it is strong and will last. I don't care what anybody else thinks, if I like an artist's work, I'll say so. If the artist is verbal and can talk about his or her work, so much the better.

PH: What do artists do wrong when collectors come to their studio?

AH: Seem flaky. By this I mean they fail to act committed to their work. You can tell if someone has really put in the hours to develop their work and how far they've taken it. Sometimes, artists act like they're just doing this for now, and have no intention of pursuing it. Collectors can't tell if this artist is serious about an art career or won't be here tomorrow. This makes them skittish about buying that artist's work. Artists should give the impression that this is serious and they are in it for the long haul.

PH: Should artists discuss price in the studio, or wait until later, when they are away from the art?

AH: I think they should be able to discuss price—but they have to do some research and see what other artists at their level are selling their work for. Another thing artists don't realize is that they should start with lower prices. Dealers don't realize it either. Because you can't go lower, later. It can't be done without alienating collectors who bought at higher prices. It's better to start out with lower prices, then raise them. And I don't mean start out at $300 and then raise them arbitrarily. When you have *sold* several at $300, then raise them to maybe $600.

PH: Do you take groups around or only one collector at a time?

AH: It depends. Right now, I'm thinking about limiting it to ten people. With more than that, no one has the opportunity to talk much, to unwind. And the more you can get them to have a cup of coffee and sit in a comfortable chair, where you can really create an atmosphere, the longer you can keep them looking, and the better the opportunity is to sell art.

PH: What about artists setting up their own tours of studios?

AH: Absolutely, artists are doing that more and more, having a tour

among artists in their own building or neighborhood–and people come, from all over, to visit these studios. Its amazing!

PH: What's important in a studio visit?

AH: Presentation is important. You don't want to confuse collectors. It's okay for artists to work in different styles, but don't present everything at once. First show a cohesive body of work. Then take it away and present something else. Show them clearly who you are, especially if they are just meeting you for the first time.

Another thing which works really well is this: whenever you're sending out anything, put an image on it. If the image attracts my attention, I'll drop everything to look at it. This works with collectors too, I believe. Artists should take advantage of any flyer, announcement, book–anything that will hold an image. And you can sway people's attention with a drawing, even a little one.

Some Last Thoughts

This survey of what artists have found and developed in putting together open studios should help you find the best way to have the most natural market possible–right in your own backyard!

It is altogether fitting that we should end up where we started– back in the studio, the place where you can spread out all of your creativity around you in a million ways. Although by now, I hope you are seeing your studio in still another light–as the place where you first begin to bring your art to the collectors. They are waiting for you to show and sell your work to them, right outside your studio door.

Bibliography

Abbott, Susan. *Corporate Art Consulting.* New York: Allworth Press, 1996.

Alliance of Artists' Communities. *Artists Communities.* New York: Allworth Press, 1996.

Carlock, Martin. *A Guide to Public Art in Greater Boston, from Newburyport to Plymouth.* rev. ed. Boston: Harvard Common Press, 1993.

Davis, Harold. *Publishing Your Art As Cards, Posters, and Calendars.* New York: The Consultant Press, Ltd., 1993.

Edwards, Paul, Sarah Edwards, and Laura Clampitt Douglas. *Getting Business to Come to You.* New York: G. P. Putnam's Sons, 1991.

Fournier, Bonnie, *Go Wild!* St. Paul, Minnesota: Lucky Dog Multi-Media, 1997.

Hart, Russell. *Photographing Your Artwork: A Step-By-Step Guide to Taking High-Quality Slides at an Affordable Price.* rev. ed. Cincinnati, Ohio: North Light Books, 1992.

Jacobson, Marjory. *Art for Work: The New Renaissance in Corporate Collecting.* Cambridge, Massachusetts: Harvard Business School Press, 1993.

Mayer, Jeffrey J. *ACT for Dummies.* Indianapolis, Ind.: IDG Books Worldwide, 1995.

Maisel, Eric. *Affirmations for Artists.* New York: Tarcher/Putnam, 1996.

Moore, Marilyn. *Guide to Licensing Artwork.* Stamford, Connecticut: Kent Press, 1996.

Parker, Yana. *Damn Good Résumé Guide.* Berkeley: Ten Speed Press, 1996.

Sikes, Toni Fountain, ed. *The Guild: Art for the Wall, Furniture and Accessories–Designer's Sourcebook.* Madison, Wisconsin: The Guild, Kraus Sikes Inc. (distributed by Hearst Books International), annual.

■

Index

C

N O T E S

Books from Allworth Press

Legal Guide for the Visual Artist, Third Edition
by Tad Crawford (softcover, 8½ × 11, 256 pages, $19.95)

The Artist-Gallery Partnership: A Practical Guide to Consigning Art,
Revised Edition *by Tad Crawford and Susan Mellon*
(softcover, 6 × 9, 128 pages, $16.95)

How to Start and Succeed as an Artist
by Daniel Grant (softcover, 6 × 9, 240 pages, $18.95)

The Artist's Resource Handbook, Second Edition
by Daniel Grant (softcover, 6 × 9, 248 pages, $18.95)

The Business of Being an Artist, Revised Edition
by Daniel Grant (softcover, 6 × 9, 272 pages, $18.95)

Artists Communities *by the Alliance of Artists' Communities*
(softcover, 6¾ × 10, 224 pages, $16.95)

The Fine Artist's Guide to Marketing and Self-Promotion
by Julius Vitali (softcover, 6 × 9, 224 pages, $18.95)

Arts and the Internet
by V. A. Shiva (softcover, 6 × 9, 208 pages, $18.95)

Caring for Your Art, Revised Edition
by Jill Snyder (softcover, 6 × 9, 192 pages, $16.95)

Fine Art Publicity: The Complete Guide for Galleries and Artists
by Susan Abbott and Barbara Webb (softcover, 8½ × 11, 190 pages,
$22.95)

Business and Legal Forms for Fine Artists, Revised Edition
by Tad Crawford (softcover, 8½ × 11, 144 pages, $16.95)

Licensing Art and Design, Revised Edition
by Caryn Leland (softcover, 6 × 9, 128 pages, $16.95)

The Artist's Complete Health and Safety Guide, Second Edition
by Monona Rossol (softcover, 6 × 9, 344 pages, $19.95)

Please write to request our free catalog. To order by credit card, call 1-800-491-2808 or send a check or money order to Allworth Press, 10 East 23rd Street, Suite 210, New York, NY 10010. Include $5 for shipping and handling for the first book ordered and $1 for each additional book or $10 plus $1 for each additional book if ordering from Canada. New York State residents must add sales tax.

If you would like to see our complete catalog on the World Wide Web, you can find us at *www.allworth.com*